Before Mickey

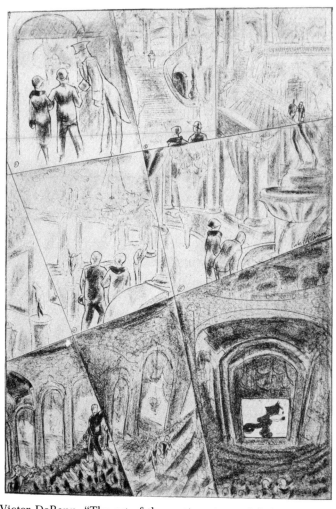

Victor DeBann, "The art of the motion picture," *Life,* December 22, 1927; © 1927.

Before Mickey

The Animated Film
1898-1928

Donald Crafton

With a new Afterword

The University of Chicago Press
Chicago and London

The University of Chicago Press, Chicago 60637
The University of Chicago Press, Ltd., London

ISBN 0-226-11667-0 (pbk.)

Library of Congress Cataloging-in-Publication Data

Crafton, Donald.
 Before Mickey : the animated film, 1898–1928/
 Donald Crafton ; with a new afterword. —
 University of Chicago Press ed.
 p. cm.
 Originally published: Cambridge, Mass. : MIT
 Press, c1982.
 Includes bibliographical references and index.
 1. Animated films—History. I. Title.
NC1765.C7 1993
741.5'8'09—dc20 93-29048
 CIP

For Elise
and
In Memory of Marilyn Crafton

• •
Note to the 1993 Edition

A two-hour compilation video program, *Before Mickey: An Animated Anthology*, is available to accompany this book. The VHS cassette (NTSC format only) contains these titles.

<div align="center">

The Enchanted Drawing, Blackton, 1900

Animated Painting, Porter, 1904

Humorous Phases of Funny Faces, Blackton, 1906

Lightning Sketches, Blackton, 1907

Princess Nicotine (excerpt), Blackton, 1909

Fantasmagorie, Cohl, 1908

Clair de lune espagnol, Cohl, 1909

Little Nemo (with color sequence), McCay, 1911

Gertie, McCay, 1914

Colonel Heeza Liar at Bat, Bray Studio, 1917

Bobby Bumps Before and After, Hurd, 1918

Farmer Alfalfa's Revenge, Terry, 1916

Out of the Inkwell: Perpetual Motion, Fleischer, 1920

'Twas But a Dream, Barré, 1916

Mutt and Jeff in the Flood, Barré and Bowers, 1918

The Gumps in Taking a Ride, Carlson, 1920

Le Garde-meuble automatique, Bosetti, 1912

Mest' Kinematograficeskgo Operatora, Starevitch, 1912

Kapten Grogg Bland Andra Konstiga Kroppa, Bergdahl, 1920

The Lost World (animated dinosaurs excerpt), O'Brien, 1925

Alice's Mysterious Mystery, Iwerks/Disney, 1926

Alice Rattled by Rats, Iwerks/Disney, 1925

The Lunch Hound, Lantz, 1927

Felix the Cat in The Oily Bird, Messmer/Sullivan, 1928

Felix the Cat Dines and Pines, Messmer/Sullivan, 1927

</div>

Produced by Piggyback Productions. Distributed by Direct Cinema, Ltd., P.O. Box 10003, Santa Monica, California 90410–9003. (To order, phone toll-free: 800-525-0000.)

Contents

Before Mickey

List of Illustrations

The qualities of the documents and frame enlargements are commensurate with those of the originals. Film companies, dates, sources, and copyright information are given in the legends.

Before Mickey

Before Mickey

List of Illustrations

Foreword

In 1916 I joined Pat Sullivan, who was animating "Sammy Johnsin" for Universal. He worked alone with one inker, and I did various one-shot cartoons for him. In 1919 I created a character which Paramount named "Felix the Cat." I used the style of Charlie Chaplin and kept him alone in his antics, unhampered by supporting characters. Being a loner, he could roam to various locations, without being limited to any fixed place.

At the time many cartoons were using ostentatious actions and extreme clowning. They were all good, but I decided to try a new angle for variety: I used real life as a background for stories. I gave Felix a personality, using many facial expressions. He would be a pet in many homes and businessplaces, solving many seemingly impossible problems with ingenious picture gags and always leaving a happy ending. He would influence young children by exemplifying kindness and lending a helping hand to others. He would fulfill many wishes, such as forcing the weatherman to send sunshine in foul weather. All this was done by handling a serious theme in a comic fashion.

Looking back, we see a door opening slightly on a road that led to a new field of visual arts.

Otto Messmer

Preface

This is the first book to concentrate on the origins and early development of the animated film, so it ends where many accounts of the history of cartoons have begun: with Walt Disney's first spectacular successes. Even in the most comprehensive studies, those by Rondolino and Poncet, this period has been given short shrift. The authors clearly have regarded the works as being significant as "forerunners," but as having little intrinsic interest. A vague technological determinism hovers over their discussion of cels and studios. Casual statements about the animated cartoon's "obvious" relation to comic-strip art pepper the texts. Seldom is there any discussion of animation's relationship to cinema as a whole; rather, it is treated as autonomous or as a mutant strain of graphic art. Misleading "auteur" and formalist biases have caused about 95 percent of pre-1928 animation to be cast aside as irrelevant. The passing along of anecdotes and hearsay from earlier writing has too often replaced film viewing and documentation.

When I began the research for this book in 1975 I found that the most basic groundwork of locating archival sources, ascertaining dates for films and events, learning the circumstances of production and distribution, and attributing early films had only just begun, led by André Martin, Bruno Edera, and Mike Barrier. Since then work has progressed rapidly, but I hope my book does not create

the illusion that much does not remain to be done. I also hope that historians will go beyond the "mere facts" and study the enterprise of early animation. In this book I have tried to set it against the background of the industrial and cultural environment of the time. It is now clear that the formal structures of the films reflected many sources and influences, including technology, the commercial pressures of the film industry (distributors, audiences, "the competition"), traditions in other popular arts, individual personalities of animators, and the narrative "habits" (shortcut formulas for telling stories in films two to five minutes in length) dictated by the filmmaker's means and expertise. I do not pretend to have unraveled this complicated dialectic fabric entirely, but it is an essential part of the study of the genre.

Some people will no doubt be surprised to learn that there was any animation at all before Mickey. In fact, there was so much that I had trouble assimilating it. No one can see more than a fraction of the thousands of films produced during this period; prints simply no longer exist. But more early animation is available commercially and in research archives than many people imagine. I have viewed as much as possible, and have also paged through dozens of trade journals published in Britain, France, and the United States. The quantity of material necessitated some decisions that might be seen as shortcomings. There are few personal amecdotes about the lives and careers of animators related here. To some extent this is justified by the fact that during the studio years it was assumed that the system, not the employees, was important. Also, forthcoming books by Mike Barrier on the history of animation and by Michael Hobbs on Max Fleischer are expected to fill the gaps. Leslie Cabarga's book on the Fleischers and Bob Thomas's on Disney contribute insights into their lives. Some lack of continuity may have been introduced by not adhering to a

studio-by-studio approach of the type outlined by André Martin in his "family tree" wall chart. But Leonard Maltin's highly readable *Of Mice and Magic,* which appeared as the manuscript of this book was going to the press, seems to be primarily a studio history. For me the major shortcoming is the lack of extended analysis of specific films, but refraining was judged to be a regrettable necessity. And although the book treats a film genre's history, there is no detailed discussion of genre theory.

My documentary-theoretical methods required considerable travel, made possible originally by a Fulbright-Hays Fellowship and assorted Yale University fellowships. Primary research was done in London, Paris, New York, and Rochester.

The gods smile on film historians. As proof, quite by accident I found an apartment six floors above Jean Tedesco's former Théâtre du Vieux Colombier in Paris, scene of so many cinema milestones. Only later (through Lotte Eisner) did I learn that I was living in the old atelier of Berthold Bartosch, the pioneer animator whose *L'Idée* was made in my living room in 1934. This extraordinary bit of fortune prepared me for my continuing luck in meeting people who helped shape my research materially and conceptually.

The length of American acknowledgements is a source of amusement to European scholars; nevertheless, I feel obliged to list those whose ideas and information helped form my thoughts.

Anne Hanson and Standish Lawder gave me initial encouragement. In Europe, Jeremy Boulton, Jacques Ledoux, Torsten Jungstedt, Mlle. Mathieu, Henri Langlois, Frantz and Nicole Schmitt, Jacques Deslandes, the Courtet family, Raymond Maillet, Marie Epstein, Mary Meerson, and Jean Adhémar made my stay profitable. Genevieve Acker and Lotte Eisner made it pleasant.

xx In North America, Ted Perry, Charles Silver, Marshall Deutelbaum, David Shepard, Eileen Bowser, Louise Beaudet, Anthony Slide, Mark Langer, Harvey Deneroff, and Paul Bray, Jr., all performed valuable services for me.

Donna D. Clarke and Caroline Bruzelius translated important texts for me. Other translations from French and German are mine. Very special thanks go to John Canemaker, for lending me documents and reading the manuscript, and to Mike Barrier, editor of *Funnyworld*, who offered valuable notes, comments, and corrections. I am also grateful to the veteran animators who were kind enough to share their memories with me: Al Eugster, I. Klein, Shamus Culhane, Friz Freleng, and especially Otto Messmer. In addition to archival sources, many of the films I studied came from private collectors. Special thanks go to Murray Glass, whose Em Gee Film Library circulates the largest collection of commercially available silent animation. I appreciate his generosity.

The rights to the Felix the Cat character are controlled by Joe Oriolo Productions, Incorporated, and King Features Syndicate.

Dudley Andrew, Robert Herbert, and Walter Cahn have assisted me in many ways. Polly Bobroff unveiled the secrets of word processing to me. My department's front-office staff is not to be forgotten, especially Trina Josephson for her transcriptions. Thanks also to the staff of the MIT Press.

And Marilyn Crafton knows what she contributed to this book, and how thankful I am that she did.

Before Mickey

Before Mickey

Animation: Myth, Magic, and Industry

In December 1927 the New York humor magazine *Life* published a witty drawing that documents the average moviegoer's regard for animated cartoons at the dawn of the talkies (see figure 1, the frontispiece). The eight panels show two typical New Yorkers arriving for their weekly night at the show. The glistening architecture of the picture palace (probably the new Roxy) dwarfs them as they are ushered into the lofty third balcony. When the picture begins, it is not *The Student Prince, Sunrise, Wings, Underworld,* or another current hit, nor does the artist choose to depict Fairbanks, Chaplin, or Garbo. Instead he has Felix the Cat pounce into view, to the obvious delight of the laughing couple. The drawing's caption is tongue-in-cheek: "The Art of the Motion Picture."

Felix's ironic presence punctures the opera-house pretensions of the grandiose theater architecture, with its fake gilt plaster ornamentation and its walls hung with paintings. By implication, the highbrow reputation that intellectuals and critics were self-consciously ascribing to the cinema in the 1920s is also being undermined. Felix, the satirist is saying, is the real "art of the cinema."

At the same time the drawing affirms what it parodies; its very existence indicates the attraction felt toward cartoons by artists of the "modern" persuasion. This bold de-

sign, looking forward to art deco, underscores a conception of film—and Felix—as the imagery of modernism.

Felix's following had grown steadily, commencing around 1922 when *Life*'s regular critic Robert E. Sherwood had already placed the cat alongside Chaplin, Keaton, and Sennett in his pantheon of "cinematographic art."[1] Five years later, by the time of the drawing, Felix had become a ubiquitous fixture of the jazz age, loved by children as a cuddly cat and by adults as a being who shared their own feelings, frustrations, and fantasies, perhaps in his role as a henpecked husband, a doting father, or a philandering speakeasy reveler.

This book appreciates that intelligent and mature adults could participate in a ritual wherein a pen-and-ink representation of a cat is endowed with "real" status at least as great as that of the screen images of human actors. Clearly, audiences recognized their own behavior in Felix's and attributed to him the foibles of the human species. Moreover, they perceived in these animated drawings a personality—not just a character or a type, but an individual with his own quirks of appearance and behavior that distinguished him from all others. Felix's charisma was so subtly defined that he proved inimitable, although the audience was aware of a half-dozen inferior competitors. In the 30-year history of animation this book retraces, the primary concern will be to understand how this individualization process developed to the extent that it did, in the times when it did.

Animation, let alone silent animation, is admittedly a minor branch of the history of cinema. Furthermore, in comparison with mainstream filmmaking in the silent period, it was not commercially important. Film distributors (and alas, until recently, film collectors) tended to regard these cartoons as material better suited for the dustbin than for any other repository. More recently, film scholars have

tended to ignore early animation or to condemn it to the domain of film-buffism. Although it can be easily dismissed as esoteric or trivial, we shall also see that this not-so-serious subject can sustain "serious" consideration from the perspective of film history, cultural history, or industrial history. This is not an easy task. The growth of the animated film was erratic, the quality uneven, and the documentation unreliable. It is a frustrating yet wonderfully variegated area of study, out of which eventually emerges an aesthetically coherent body of work.

Any history must have an arbitrary beginning and end. A terminal event was easy enough to choose. Just when the *Life* cartoon was arriving at newsstands, Walt Disney, a young cartoon producer from California, was in New York learning the unhappy news that his distributor was forcing him to relinquish control of "Oswald," a series he had created. Out of this personal calamity a new mouse character was developed, and when *Steamboat Willie* opened at the Colony Theater in New York, on November 18, 1928, Disney knew he had made the *Jazz Singer* of animation. Soon Mickey, synchronized sound, and color would launch the modern age of cartoons, with Disney swept along as a kind of mass-culture deity in the 1930s. It is understandable that along the way to Disney's apotheosis the earlier achievements of other animators were brusquely swept aside, and that their films were considered obsolete and then forgotten.

Steamboat Willie provides a convenient end bracket, capping the silent period and heralding the glorious 1930s and 1940s, but no similar arbitrary event signaled the beginnings of animation history. No one knows who first discovered that screen motion could be deliberately synthesized by making single-frame exposures. It is likely that many tinkerers had some vague feeling that such a process was possible and may even have made some crude experiments.

Myth, Magic, Industry

However, the earliest date at which animation was first commercially exploited was 1898, and although even this cannot be documented that year will be our starting point.

One certainty is that animated cinema could not have existed before the cinema came into being around 1895. Here I depart from the traditional presentation of the subject, which invariably begins with litanies of "precursors," often extending back to hieroglyphic friezes, Chinese scrolls, or the Bayeux tapestry. There are references to Kircher's 1646 treatise on magic lanterns; to Robert's "Fantascope," which scared eighteenth-century Parisians; to Skladanowsky's rapidly projected slides; to the shadow plays of the Cabaret du Chat Noir; and to a hundred other optical curiosities.[2] But, technologically, the "prehistory" of cinema and animation are inseparable. One premise of this book is that the animated film is a subspecies of film in general. Its history coincides with film history at large, running parallel, weaving in and out. Thus, the old-fashioned attempts to animate pictures at best represent common ancestors, which were soon supplanted once photographic motion-picture-making became available.

The example of Emile Reynaud (1844–1918), who has misleadingly been called "the father of the animated cartoon," illustrates how little the first cartoonists were indebted to this optical tradition. A teacher of mathematics and science, Reynaud thought of a way to improve on the fashionable "persistence-of-vision" parlor toys that had been marketed since the 1830s. Originally created by Plateau and Stampfer to demonstrate the mind's ability to combine discrete images into an illusion of motion, these phenakistoscopes, stroboscopes, and zoetropes all required the viewer to peep through rotating slits. Reynaud's praxinoscope substituted a cluster of revolving mirrors, which reflected drawings on a horizontal band placed inside a revolving drum. Because the viewer did not look through

moving slits, he had an illusion of relatively smooth flickerless motion. Soon (in 1879) Reynaud refined the "praxinoscope theater," in which the moving drawings were superimposed onto scenery inside a little proscenium. This tabletop theater was in turn transformed into an audience-oriented spectacle in 1892 when Reynaud opened his "Théâtre optique" at the Musée Grévin wax museum in Paris. He rear-projected his "pantomimes lumineuses" onto a screen by means of a complicated mirror-and-lens system (figure 2). The images were hand-painted on long strips of transparent celluloid. Because his apparatus utilized many general principles of cinema, and because he projected "moving pictures" to an audience, Reynaud may be justifiably considered a forerunner of cinema. But his actual contribution to the history of the animated film is more romantic than real. Conceptually his programs were not far removed from nineteenth-century lantern shows, and there is no sign that his charming Pierrot plays influenced any of the early animators. Reynaud's method of drawing directly on film had little instruction to offer. It is unlikely that any of the pioneers of animation patronized his productions at the Musée Grévin (which, after all, were replaced by cinematographic projections after about 1900), or even knew of his work.

As many pioneers of animation later recalled, it was not any of these optical devices that inspired them. Rather, it was flipbooks—sequential drawings that produced an illusion of motion when thumbed—that first whetted their curiosity. The widely published motion-study photographs of Muybridge and Marey provided all the data needed for the analysis and reconstruction of movement image by image.

Significantly, the first animated films were concerned with making objects appear to move with a mysterious life of their own—what we would now call tabletop animation.

Myth, Magic, Industry

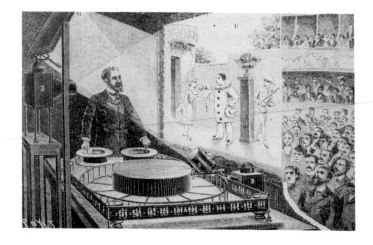

Figure 2.
Eugène Poyet, "Le Théâtre optique d'Emile Reynaud," *La Nature,*
July 23, 1892.

Before Mickey

Chapter 1 peers into this mysterious aura and discovers that it arose from a combination of myth and marketing. It was nearly a decade until "cartoons"—animated drawings—became recognizable. Chapter 2 examines the problematic relationship of these films to other popular traditions, including comic strips, stage, and journalism. Direct iconographic links to precinematic optical traditions are still hard to find. A more important source proves to be the cinema itself and its already embedded "trickfilm" genre, of which Georges Méliès was the undisputed master. Méliès and his imitators capitalized on the selective recording properties of the camera. By stopping the filming at carefully calculated moments, making planned substitutions, and then restarting the camera, they could produce illusions of startling metamorphoses. If any technical predecessor of animation need be identified, it would certainly be the stop-action substitution technique. From it Blackton, Booth, Chomón, and others evolved their own techniques. (Méliès probably never shot any true animated footage.) The iconography and primitive narrative structures of animation grew out of this kind of filmmaking.

Between 1908 and the first world war animation was gradually defined as a cinema genre by Emile Cohl and Winsor McCay, the subjects of chapters 3 and 4. Before then it was a "special effect" and not unlike other effects such as irises and lap dissolves. But with these artists, the technology began to be associated with recurring dramatic situations, narrative structures, iconography, and expectations concerning content. Especially strong bonds with the popular press were forged.

At the same time, the model of "regular" cinema elicited the need for longer and more narratively complicated films. But the tedious manual labor of drawing, modeling, and cutting (depending on which technique the animator chose) inhibited commercialization. Two competing solu-

Myth, Magic, Industry

tions were found, one developed by Raoul Barré and the other by Earl Hurd and John Bray. The latter was more viable, in part because it was protected by patents. This "cel" process would transform animation, in terms of both its commercial range and its graphic qualities. Equally important, though, was the structure of the studio entity itself, one of the concerns of chapters 5 and 6.

Despite the ravages of the war, significant animation work was done in Europe. The internationality of early animation cannot be ignored; chapter 7 provides at least a glance at the major contributors.

Meanwhile, the major American studios were consolidating their personnel and perfecting their techniques. Comic strips provided material to feed the ever-increasing appetite for gag material. After 1918, it becomes increasingly risky to make generalizations about this complicated business. As production costs rose, small producers tended to disappear and three or four major studios vied for the lion's share. A new risk began to loom: The market was being saturated, and the tired gags, recycled week after week, began to lose the audience's attention. During the 1920s the hegemony of the comic-strip hero waned, and characters developed exclusively for the screen, such as Koko the Clown and Felix the Cat, began to thrive. It was no longer a question of technical development; animation methods were being standardized and were reaching a plateau. It was a question of developing characters that audiences would respond to in personal, not stereotypical, ways. This mature studio period was marked primarily by the emergence of the "continuity character series." The characters gradually drifted away from caricatural representations of humans toward representations of animals. Chapter 8 outlines this trend and brings us back to Felix the Cat in chapter 9 for a closer analysis and a summation of the goals and aspirations of the animation artist.

Before Mickey

It would be misleading to present the history of early animation solely as a chronicle of inventions, patents, titles, and anecdotes, although that approach has its place. It is also necessary to analyze it as an ongoing attempt to organize certain concerns and interests shared by animator and audience into an entertaining yet significant structure. Like mainstream cinema, animated cinema exists in part as an orchestration of myths and mores—some treated overtly, others couched in narrative and visual metaphors. For some of us, unraveling this extraordinary communication network in a seemingly simple art form is the most exciting aspect of viewing early animation.

This book argues that the early animated film was the location of a process found elsewhere in cinema but nowhere else in such intense concentration: self-figuration, the tendency of the filmmaker to interject himself into his film. This can take several forms; it can be direct or indirect, and more or less camouflaged. Identifying and tracing the various permutations over the years is a task the animation historian willingly accepts.

To interject oneself into one's film is a fairly audacious thing to do. But this tendency, which persisted throughout the three decades, seems on the evidence of the films' contents and the memories of veteran animators to have been real and conscious. At first it was obvious and literal; at the end it was subtle and cloaked in metaphors and symbolic imagery designed to facilitate the process and yet to keep the idea gratifying for the artist and the audience. Part of the animation game consisted of developing mythologies that gave the animator some sort of special status. Usually these were very flattering, for he was pictured as (or implied to be) a demigod, a purveyor of life itself. This aspect of animation has been perceived by sensitive viewers, and was first expressed by Gilbert Seldes in 1932:

Myth, Magic, Industry

Out of hundreds of animated cartoons, I can recall only two or three which were wholly bad; even the imitative ones and those lacking in ingenuity gave some sort of pleasure. This suggests that something in the form itself is a satisfaction to us. And that satisfaction, I think, is the childish one which the movie as a whole had in its beginning and which long custom and the injection of dialogue has taken away from the photographed drama. It is the pleasure in magic, in seeing the impossible happen. . . . In the early days we looked at a movie and marveled that a picture could be set into motion. Now we do not think of the picture—only of the actors. The animated cartoon shows us in movement something naturally inert, and it is essentially the satisfaction of magic that we get out of it.[3]

Two years later, art historian Erwin Panofsky echoed Seldes's suspicions: "The very virtue of the animated cartoon is to animate, that is to say, endow lifeless things with life, or living things with a different kind of life. It effects a metamorphosis. . . ."[4]

This exhilarating sensation that life is somehow being created before the spectator's eyes arises to greater and lesser extents from all animation, and perhaps constitutes its cinematic reason for being. But a detailed survey will show that this perception does not arise from a mystical "something in the form itself" or from a vague "virtue" of the medium. On the contrary, this genesis theme is the result of the animator's presenting himself in the role of life giver—not mysteriously, but deliberately and (as the history of the medium unfolds) with increasing subtlety and expertise until finally we take for granted that the animator can vivify things that could never otherwise have existed. Part of our enjoyment of Felix and his animated companions depends on our vicarious participation in the ritual of incarnation.

Before Mickey

The Secret of the Haunted Hotel 1

Animation has bred a myth about its own origins that goes, according to the film historian's lore, like this: Animation was virtually unknown until 1907. It was then that *L'Hôtel hanté* opened in Paris. The public response to this first animated film was so strong that all the French producers racked their brains trying to figure out the tricks that made objects move by themselves. After considerable difficulty, the secret was discovered and the history of cartoons could begin.

A close look at this legend shows that at least one part is true: *The Haunted Hotel* was a tremendous success. It was produced by the American Vitagraph company and released in the United States in March 1907. Business was so brisk that almost a year later it was still promoted as one of the company's "recent hits."[1] It was directed by James Stuart Blackton, cofounder of Vitagraph, and photographed by his partner, Albert E. Smith. Like most films of the period, it began with a rather stagey long shot of a weary traveler seeking shelter at a mysterious hotel. Smith and Blackton were unconcerned with the originality of their plot; the idea had been filmed already by Georges Méliès, the French trick specialist, in *L'Hôtel empoisonné* and *Le Manoir du diable* (1896), *Le Château hanté* and *L'Auberge ensorcelée* (1897), and *L'Auberge du bon repos* (1903). In England, G. A. Smith had shot *The Haunted Castle* (1897), and in

America there had been Edison's *Uncle Josh in a Spooky Hotel* (1900). Even long before the movies had been invented the "haunted hotel" had been a stage act at popular theaters like the Châtelet in Paris and at itinerant shows in Europe and America.

The gist of Blackton's version of the story was simply that the usual manual labor around the inn was performed by invisible ghosts (figure 3). All the special effects of the time—lap dissolves, double exposures, and stop-action substitutions—were exploited to their limits. Wires were used to make objects move on their own, a technique of the nineteenth-century stage magician. One scene in particular astonished viewers. It showed a table being set, a wine bottle pouring its contents into a glass, and a knife slicing a loaf of bread, all in large closeup and without any apparent wires. The scene's peculiar flickery, jerky quality enhanced its strangeness. It was animation.

Eager to be the first to gain a foothold on the European market, Vitagraph had opened an office in Paris at 15 rue Sainte-Cécile in February 1907. In April they were ready to take orders for their trickfilm *L'Hôtel hanté; fantasmagorie épouvantable.*[2] It was the custom then to sell copies of films outright to exhibitors, who resold them to second-run theaters and traveling shows at lower prices. Vitagraph's film quickly became the best-selling American movie in France, and in all of Europe over 150 new prints would be delivered.[3] The film was a sensation at the Châtelet, where it ran twice daily from July 17 through July 29, and at the Hippodrome, which with 5,000 seats was the world's largest cinema. France's second largest producer, Gaumont, bought prints and distributed them as its own.[4]

Why was *The Haunted Hotel* a success? An early French director, Victorin Jasset, was the first to suggest that it was because the camera was close enough to the table top to

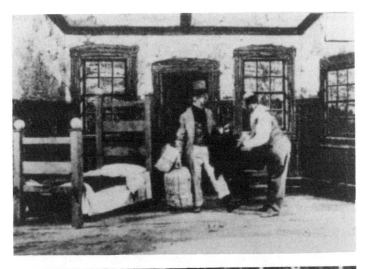

Figure 3.
James Stuart Blackton, *The Haunted Hotel* (Vitagraph), © 1907.

The Haunted Hotel

eliminate the possibility of the usual theatrical tricks: "The Vitagraph film *The Haunted Hotel* was a sensation and rightly so. Abandoning all the tricks of the movies, they had contrived entirely new and totally unexpected combinations of techniques. As we watched, the sharpest, most attentive eye was unable to detect any wires. One had to be informed of the process."[5] Furthermore, the length of the animated sequences gave the audience sufficient time to ponder the trick. Then, too, the film arrived at a time when American things were in vogue, and according to Jasset it was considered the most typically American film yet seen in Europe. Indeed, until World War I the French technical term for animation remained "le mouvement américain."

But there was also a more pragmatic reason for *The Haunted Hotel*'s success. Vitagraph launched the film with a flourish of hyperbolic advertising:

Impressive, indefinable, insoluble, positively the most marvelous film ever invented. Here are some of the mysterious moments in the film: a house which changes into an organ, a table set by invisible hands, a knife which really cuts slices of sausage and bread. Wine, tea and milk pouring themselves. All without the aid of any hand. There is a quantity of other equally strange effects, among them, a bedroom which spins around completely while the poor frightened traveler trembles in his bed wondering what will happen next. A real novelty.[6]

Such ballyhoo was already common in American advertising, but French films were still announced only by title, genre, and length. This unaccustomed aggressiveness would quickly establish Vitagraph's European base, and *The Haunted Hotel* was the company's first marketing test.

There is no question that animation captured the public's imagination in the wake of this American hit. Contemporary press accounts confirm that Parisians were lining up

to see the film just to guess at how the tricks were done.
One of the engrossed spectators was a staff writer for the important weekly *L'Illustration,* Gustave Babin, an admirer of the cinema ever since his friend the poet Armand Silvestre (a personal friend of the Lumière brothers) had introduced him to the movies' hypnotic attraction. In the spring of 1908, Babin went to the Gaumont studios in Belleville to prepare two articles that have since become key documents in the early history of film.[7]

The task of explaining the various trick effects fell upon Anatole Thiberville, a Gaumont veteran since the turn of the century. Formerly a farmer from Bresse, he had begun working for the company when it still sold amateur photographic gear. Despite his detailed descriptions, however, Babin was not satisfied and insisted upon learning the secret of *The Haunted Hotel*:

All *amateurs* and *habitués* of the cinema who know its repertoire have seen those mysterious scenes I mean: a table loaded with food which is consumed, no one knows how, by some invisible being, something like the Spirit of the Ancestors for which Victor Hugo, in his Guernesey gatherings, reserved an empty seat. A bottle pours its own wine into a glass, a knife hurls itself onto a loaf of bread, then slices into a sausage; a wicker basket weaving itself; tools performing their work without the cooperation of any artisan. So many strange marvels that one could see every night for several months. And even tipped off as I was, and as my readers are, I still could not find the last word of the riddle.

Much to Babin's perplexity, Thiberville refused to reveal this trade secret: "'I searched for months, Mr. Babin, and about eight or so ago I found the solution. These films which intrigue you so much are American. They pestered us no less than you. I have just successfully completed the first of this kind [in France]. But as to revealing the mystery to you'—and his smile became more amiable and at the

The Haunted Hotel

same time more malicious—'that is absolutely impossible at the present. And you must believe how much I regret it.'"

Babin's curiosity was only further inflamed when Thiberville projected this latest film, *Le Travail rendu facile* (*Work Made Easy*) (figure 4): "Marvel of marvels! A carpenter's shop, a bench with a vise, a hammer and a saw, all at work without my being able to perceive any human hand. There's the real miracle. And the question we have asked so many times returns: 'How do they do it?' Me, I've thrown in the towel. But perhaps among the readers of *L'Illustration* someone devoted to riddles will be ingenious enough to give us the solution. Maybe it's very simple."

Thiberville's story of the discovery of the secret of animation was later retold more dramatically by another eyewitness—his Gaumont colleague, cameraman Etienne Arnaud:

There were three of us *metteurs en scène* who had received from the big boss, Léon Gaumont, the mission of going to find out by what really diabolical means objects could appear to be moving on the screen without any human intervention. We went through three consecutive screenings. Louis Feuillade left more myopic because he had popped his eyes searching for the wires that he thought made the objects move. Jacques Roullet concluded it was an "affaire mystérieuse" and decided to submit it to the Pinkertons. As for me, I was particularly vexed because I was supposed to be the specialist in trick scenes and frankly this new film from overseas dropped in completely out of the blue.[8]

Finally, according to Arnaud, it was a newcomer at the studio, Emile Cohl, who unlocked the secret. The camera was fixed so that each turn of the crank permitted the exposure of only one image. After each turn, the director would move the objects on the table a few millimeters, step out of the way for another take, then repeat the process.

Figure 4.
Work Made Easy (Vitagraph, 1907). From Babin, "Les
Coulisses du cinématographe."

The Haunted Hotel

Thus was the fundamental technical procedure, frame-by-frame exposure, introduced into France.

By these firsthand accounts, it was the absolute novelty of *The Haunted Hotel* and the frantic rush by European producers to decipher the technique that fomented an animation explosion in 1908. But the available facts raise questions.

The alleged ignorance of these experienced cameramen is very baffling, because *The Haunted Hotel* was by no means the first animated film. The technique was almost as old as cinematography. Mechanically, even the earliest cameras were capable of single-frame takes. Their shutters usually consisted of a disk with a single hole rotating in such a way as to expose one frame per quarter, half, or whole revolution, depending on the particular gear system in use. It was theoretically a simple matter for an intelligent cameraman to determine the positions during cranking when the shutter was closed, to pause and move the object being photographed, and to continue. Later cameras were geared to make one exposure per turn and automatically stop with the shutter closed, but these were alterations of convenience, not of necessity. Of course it took a skillful operator to manually achieve consistent exposures for each frame, and failure to do so produced the flickering that marked most early animated scenes.

The earliest date suggested for the discovery of this technique is 1898. It was around then that Blackton and Smith, the producers of *The Haunted Hotel,* noticed some curious defects in one of their films. Many years after it happened, Smith recalled that they had been shooting a Méliès-style trickfilm on the roof of the Morse Building, their new "studio" in New York. During the intervals between takes, while the trick substitutions were being made, clouds of steam from the building's electrical generator would drift across the background. When the film was projected these

puffs appeared, disappeared, and jumped about the screen
most unexpectedly:

> These unplanned adventures with puffs of steam led us to some
> weird effects. In *A Visit to the Spiritualist* wall pictures, chairs
> and tables flew in and out, and characters disappeared willy-
> nilly—done by stopping the camera, making the changes, and
> starting again. . . . Vitagraph made the first stop-motion picture
> in America, *The Humpty Dumpty Circus*. I used my little daugh-
> ter's set of wooden circus performers and animals, whose movable
> joints enabled us to place them in balanced positions. It was a
> tedious process inasmuch as the movement could be achieved
> only by photographing separately each change of position. I sug-
> gested we obtain a patent on the process; Blackton felt it wasn't
> important enough. However, others quickly borrowed the tech-
> nique, improving upon it greatly.[9]

Among the borrowers were technicians at the Edison
studio who knew the two young entrepreneurs. Recently
rediscovered Edison films from the 1905 period, such as
How Jones Lost His Roll, reveal animated title cards.[10]
Blackton seems not to have reused the idea until early
1906, when he made *Humorous Phases of Funny Faces*. It
occurred to him that if objects could be animated by the
single-framing technique, why not drawings?

Audiences in 1906 were first intrigued by the letters of
the curious title *Humorous Phases of Funny Faces* forming
themselves out of moving bits of paper (figure 5). Then a
hand (Blackton's) sketches caricatural faces of a man and
a woman on a blackboard. When Blackton takes his hand
away the faces roll their eyes, but there is little other actual
movement. Instead, details are added on top of each other
between exposures. When the man's cigar billows a cloud
of smoke that obliterates the woman, Blackton erases the
board and begins anew. This time the outline of a gentle-
man with a bowler and umbrella draws itself, and the man

The Haunted Hotel

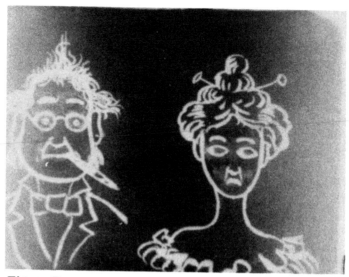

Figure 5.
Blackton, *Humorous Phases of Funny Faces* (Vitagraph), © 1906.

Figure 6.
Gaston Velle and Segundo de Chomón, *Le Théâtre de Petit Bob* (Pathé, circa 1906). From 1907 Pathé Frères Catalogue.

Before Mickey

doffs his hat. (This was done by using a black cardboard cutout in the shape of the man's arm, outlined in white to simulate chalk drawing. The device relieved Blackton of having to redraw the arm for each exposure.) Next, two profile caricatures of a man and a woman emerge from a swirl of eraser marks. Details are subtracted until the drawings disappear completely, accomplished by running the film through the camera backward. In the final sequence a clown's hat, arms, and legs—all of cardboard—float slowly around the screen. A cutout poodle joins him and jumps through a hoop.

As a film, *Humorous Phases* was really little more than an assembly of unrelated experimental effects. The sequences containing animated drawings were confined to the first few feet. Nevertheless, true animation was demonstrated, and we now know that it was being scrutinized by many attentive filmmakers in those first international audiences.

One of those who would have examined Blackton's film with keen interest was the Spaniard Segundo de Chomón (Segundo Victor Aurelio Chomón y Ruiz) (1871–1929). Nothing is known of the early life of this pioneer except that he was in Paris in 1897 and there became excited about the omnipresent Lumière Cinématographes. In 1901, Chomón opened a lab in his Barcelona home for hand-coloring and tinting films and translating foreign title cards. Ferdinand Zecca, a director and the managerial assistant for the Pathé company, hired him for similar duties in 1902.[11]

The happy accident that led Chomón to the discovery of animation supposedly happened in that year. One day he was shooting some title cards and concentrating on cranking the camera slowly to obtain high contrast. He was so absorbed that he did not notice a fly crawling on the card until the film was developed and projected. Because of the

The Haunted Hotel

slow and irregular exposure rate, the fly appeared to jump about the screen much as Smith and Blackton's steam puffs had done. From his observations, Chomón deduced the theory of animation.

He put his discovery into practice in a film of the "haunted hotel" genre: *El Hotel electrico,* in which a couple were shown registering at an ultramodern hotel whose unusual attractions included mysterious invisible forces that moved their luggage into the elevator and hung their clothes in the closet—tricks partially accomplished through frame-by-frame cinematography. The guests' sojourn was ruined by a drunk downstairs who interfered with the electrical system and caused them to be electromechanically evicted. Picking their luggage up from the street, they vowed never to return.

El Hotel electrico, although attributed to 1905, was not released in Paris until after Blackton's *Haunted Hotel,* and not in the United States until December 1908.[12] These late dates make it seem possible that Blackton had influenced Chomón.

Chomón began working for Pathé in Paris in 1906 under the gallicized name of Chomont. There he anonymously contributed special effects to films directed by Ferdinand Zecca and Gaston Velle, including *Le Théâtre de Petit Bob* (*Bob's Electric Theater* in the United States), which, as recently discovered prints reveal, contained object-animation sequences (figure 6). The success of Blackton's film in Paris stimulated Chomón's Pathé activity, as in *Le Déménagement* (*Magnetic Removal*), "which has stupefied all spectators as the furniture leaves its house all by itself and returns to its indicated places." It was the story of a couple who avail themselves of a new electrical moving invention. When the switch was thrown, "everything in the place starts to move, and soon the house is entirely dismantled, and we see all the furniture filing out of the house and

along the street like living objects."[13] Chomón's *Cuisine magnétique (Unusual Cooking)* used pixillated motion to move actors dressed as kitchen utensils around the screen "mysteriously." *Sculpteur moderne* (1906) has been restored by the French Archives du Film. The new prints reveal the marvelous visual richness of early cinema. In luminous jewellike tints, a woman demonstrates a magic picture frame to the audience. Inside, miniature *tableaux vivants* are created by trick photography. Then clay sculptures are metamorphosed by her magic spell. A lion's head "roars" and rolls it eyes. Shoelaces come alive. These may be the earliest examples of "claymation." Chomón reportedly made animated drawings as well, but no evidence exists on film. In all, he may have collaborated on as many as 150 Pathé trickfilms before signing with Carlo Rossi and moving to Turin to work for Itala Film in 1908.

There is little question that Blackton influenced the English discoverer of animation, Walter R. Booth, a professional magician who, like Méliès, recognized the potential of the cinema and began directing films produced by R. W. Paul around 1898. Booth's specialty was a type of transformation in which a drawing of a person was changed into a living figure by the use of dissolves or stop-action substitution, a trick he probably used in *The Hand of the Artist*. Although this has been called the first British animated cartoon, the 1906 catalog description almost certainly indicates the stop-action technique instead.[14]

Booth's 1907 *Comedy Cartoons* was clearly inspired by *Humorous Phases*. Like Blackton's film, it began with male and female portraits and a smoking gag. Booth also borrowed the moving clown cutout from Blackton. For the finale, "the hand of the artist wipes the whole from the blackboard, section by section, though muscular action remains even in the last portion left—one eye—which winks at the audience in an impudent manner before being finally

The Haunted Hotel

wiped out."[15] Again, this was an idea lifted from his American counterpart.

Booth also shot a *Haunted Bedroom* (July 1907) to profit from *The Haunted Hotel,* but it is unknown whether this or any of these films utilized Blackton's animation technique because no copies have been found. *Hanky Panky Cards* (also from 1907) may be viewed at the Museum of Modern Art, and surprisingly does not contain any animation despite the obvious appropriateness of the technique for the subject, closeup views of sleight-of-hand tricks. The earliest existing film by Booth that does contain animated sequences is *The Sorcerer's Scissors* (October 1907).[16] In a beautifully tinted British Film Institute print, magic scissors cut through the main title (figure 7). An animated teddy bear uses them to cut out paper shapes that change into live actors by ordinary stop-action techniques. An animated moving brush paints figures, which dissolve into real persons. But there are no animated drawings in this film or in any other by Booth.

It was perhaps inevitable that Edwin S. Porter, with his penchant for technical innovation, should also dabble in animation. His first exploration was in a 1904 film, *The Whole Dam Family and the Dam Dog.* The 1907 Edison film *The "Teddy" Bears* was an up-to-date version of the fairy tale narrated by means of a rather sophisticated montage sequence. The highlight was when Goldilocks peeped through an upstairs keyhole to espy six animated bears of diminishing size dancing. The animation is very smooth as they perform acrobatic feats. The trick is all the more impressive because it was superimposed into the keyhole by a matte process. However, the sequence is very short (118 feet, about a minute) and rather gratuitous, since elsewhere in the film the bears were portrayed by costumed actors.

In July 1907, Blackton released *Lightning Sketches* and was congratulated by the press "for the admirable render-

Figure 7.
Walter R. Booth, *The Sorcerer's Scissors* (Urban, 1907). Courtesy of National Film Archive.

The Haunted Hotel

ing of his skill as the cartoonist"; it was said that "the photographs of this enterprising partner of the firm and his sketches are superb. . . ."[17] Again, there was considerable international influence. In France the film was distributed as *Croquis au grand galop* and double-billed with *L'Hôtel hanté*.

It is clear that by 1908, when Paris became so excited about animation, *The Haunted Hotel* was not at all the unique sensation that Vitagraph's press releases made it out to be. On the contrary, as Babin suggested, it had become almost routine to see animated films on the weekly programs. Blackton's Vitagraph films, Edison's films, Chomón's Pathé films, and Booth's Urban films (distributed in France by Eclipse) had been shown for years. And of course Babin was right to guess that the technique was simple. The very crudity of some of the films would have revealed the secret to any attentive cinematographer. In *Humorous Phases,* for example, Blackton's arm was repeatedly caught by the camera because he did not get it out of the scene before Smith turned the crank. It is unthinkable that the major producers did not know how the process was done. Then why does there seem to have been a deliberate attempt to create a public aura of mystery and insolubility?

A partial answer presents itself when economic factors are considered. To begin with, many producers must have felt the same chagrin expressed by Etienne Arnaud at the stupendous success of *The Haunted Hotel*—not because they did not know the secret, but because they had missed the chance to exploit it with Vitagraph's bravura. Animated films were much more expensive to produce than live action because of the extra work the frame-by-frame photography demanded. Yet because films were sold on the open market by the meter, their price was the same as an ordinary film. Why should producers undertake greater financial risk on an unproven idea? The commercial triumph of

Vitagraph proved that the others had grossly underestimated the public's interest.

Also, the trickfilm was definitely on the way out in 1908. Since 1896, Georges Méliès had been turning out his *féeries* by the hundreds. These were distributed internationally and were shamelessly pirated and plagiarized, and as a result of this saturation their appeal was declining rapidly. Perhaps more significant, the editor of *Comoedia* advanced the opinion that the modern spirit of scientific objectivity was contributing to the downfall of fairytale subjects on stage and screen.[18] In 1914, Blackton noted that, once the novelty had worn off, trick pictures "became deadly monotonous for the mature mind."[19] That this attitude prevailed was demonstrated by the review of a 1908 Méliès imitation called *The Cave of the Spooks*: "This film has illustrated once more that the American public does not care much for spooks, coffins and skeletons."[20] But at the same time Walter Booth's animated film *The Hand of a Wizard* garnered the following comment: "Such films are not only interesting but are extremely entertaining. More like this should be produced. The opportunity for variety in this direction is unlimited."[21]

The message to producers was clear: Here was a novelty that fascinated the public but ran the risk of disappearing like the *féerie* once the secret of the technique was known. They assumed that it would be necessary to stimulate public interest by intentionally creating an atmosphere of mystery and by attempting to keep the technology out of the public domain for as long as possible. But even some producers were quick to point out the naiveté of this position.

Antagonism erupted during the controversial reaction to Babin's *L'Illustration* articles. The first to respond indignantly to these revelations was, not surprisingly, Méliès. He wrote a vehement letter to the editors of *Phono-Cinéma Revue,* who prefaced it with their own statement of adher-

The Haunted Hotel

ence to his views. The editors also charged (probably correctly) that the Babin article was a publicity "plant" by Léon Gaumont. In Méliès's letter his background as a stage magician came to the fore as he proposed a formal code of secrecy based on the one sworn to by the members of the Syndicate of French Illusionists. He rather plaintively appealed that his own personal survival was at stake: "The truth is that when one devotes himself to this genre, one espouses an awesome profession which forces one to work without a break and to always be personally at the breach." [22]

Most trade papers sympathized with Méliès's position. *Phono-Ciné-Gazette,* for example, announced editorially its pleasure that Babin had failed to learn the secret and proudly stated that the paper would not reveal it. [23] But one of the *Gazette*'s staffers responded to Méliès. François Valleiry argued that the favorable publicity gained, especially at a time when the cinema was under attack by moralists, more than offset the risk of the public's loss of innocence: "In our opinion, the cinematograph has everything to gain from the greatest number of revelations and we hope that many articles analogous to Gustave Babin's will appear in magazines as important as *L'Illustration.*" [24] Valleiry also noted considerable jealousy among the producers because Gaumont had beat them to the draw. His article must have caused some consternation at the front office, because his pro-Pathé editor, Edmond Benoit-Lévy, added a dry disclaimer: "Personally, we are of a different opinion."

The efforts of the producers allied with Méliès to maintain secrecy were futile, since the method was already being revealed to the public. Gaumont obviously agreed that publicity was good, because he sponsored a second revelatory article in the June issue of another mass publication, *Lectures Pour Tous.* This time Etienne Arnaud explained the various tricks, including the animated portion

of a film called *La Statue*: "Take a statue modeled in clay.
With successive touches of the thumb, deform it until it is
only a mass and with each change, expose one frame."[25]
At the same time, trade journals were passing the word on
to their readers:

> Un-natural scenes, such as tumbling cans, self-acting tools, etc.,
> are made thus: take the marching battalion of toy soldiers. Put
> them in ranks and files, make one exposure and then move all of
> them little by little forward, between each movement making an
> exposure. . . .
>
> Pictures of figures, etc., drawn on a blackboard without hands
> to guide the white chalk, are produced by the piecemeal process,
> i.e., a camera is used which is provided with the means for making
> one or more exposures at a given movement of the handle, and
> each time the handle is stopped some additional stroke is added
> to the drawing before the camera is started again. To keep the
> chalk in place the drawing is generally made on a board lying
> horizontally or nearly so, and the image is received by the lens of
> the camera after being once reflected. Hence the board being in
> a horizontal position, the chalk will rest on the board quite well.[26]

Thus animation moved once and for all out of the ar-
canum. What is finally most mysterious about the "secret"
of *The Haunted Hotel* is not that its technique was so
unfathomable—this myth had obviously been manufac-
tured—but that producers had delayed so long in exploiting
it. Perhaps it was a question of waiting until economic
conditions were right, until the trickfilm desperately
needed revitalization, and until the filmmakers came along
who were willing to take the time to experiment, despite
the possible unprofitability of the venture.

In terms of their content, these first films were as inex-
tricably bound up with the cultural expectations of their
time as with the economies of a nascent industry. The
language used to describe them was a curious blend of

The Haunted Hotel

supernatural allusions and pseudoscientific jargon typical of trickfilm titles. "Haunted," "spooky," "electric," "magnetic," "hypnotic," and similar words appearing in titles and in reviews must be interpreted as looking both backward and forward. On the one hand the linkage with late-nineteenth-century romanticism and symbolism, at least in a vulgarized form, is evident. The trickfilm, more than the rest of cinema, became the focus of the gothic taste favored by lower and middle classes. But, as in the works of Verne, Villiers d'Isle-Adam, Wells, and others, the romantic sensibility also reflected an imaginative attempt to assimilate the staggering developments of late-nineteenth-century science and technology. Are these curious filmmakers playing with bringing their puppets and household objects to life far from Shelley's *Frankenstein* and similar homunculus themes in romantic literature? These ancestors of science fiction were writing metaphorically of the scientific revolution and its positivist implications for civilization.

Perhaps the gothic and scientific subjects of early animation, blended together in what now strikes us as a quaint and amusing melange, are comprehensible as images of the turn-of-the-century fascination with self-propulsion. The automobile and the airplane were wonderful inventions because they represented totally liberating freedom of movement. These objects moving with what seemed their own internal life were reflected when the normally inanimate objects of everyday life—furniture, tools, toys, even pictures—lurched into sputtering motion on the screen. Unexpectedly, through the marvelous "electrical" invention of the cinematograph, the whole world appeared to be in flux, as though electricity and internal combustion were secrets of the universe. For the most part the animation sequences in these first films serve no narrative function; they exist only as movement for its own sake. Although some may view this as "primitive," it demonstrates that

even at the beginning the makers of animated films were,
like earlier romantics, fascinated with the material of artistic creation. These subjects, then, however "haunted," were also representations of animators' enduring concern with autokinesis, movement in itself, the stuff of animation.

The Haunted Hotel

From Comic Strip and Blackboard to Screen

The early cinema in all its forms had a craving for narrative, dramatic situations, visual motifs, and inconography (the use of recurrent imagery to establish consistent meaning) that could only be satisfied by foraging in other media. The early development of the western (to use a well-known example) was an amalgam of structures and aesthetic codes borrowed from dime novels, gaslight melodramas, wild west shows, Currier and Ives Americana prints, popular journalism, and illustration. Eventually these sources all melted into recognizable western movies. The situation was similar with early animation. Having no models upon which to base their films (except the *féerie,* which was rapidly approaching obsolescence), filmmakers looked to related media for inspiration. We can sense this "trying on" in the curious title of Blackton's *Humorous Phases of Funny Faces.* Perhaps 1906 audiences were supposed to associate it with the popular lantern-slide projections known as "humorous transformations," such as the movable ones sold by the T. H. McAllister Co. of New York. These were operated by a lever and illustrated visual one-liners. Many of their titles seemed to anticipate the images in Blackton's film: "Magic Portrait," "Clown's Transformation," "Clown with Moving Eyes," "Woman Smoking," "Circus Dog Jumping through Hoop."[1] Even the simple two-dimensional movements of the figures in Blackton's

film were similar to the effects produced by these crude movable slides. The creative possibilities that lantern projections offered to the first animators were limited indeed. It was necessary to look elsewhere for fresh material.

There is a widespread misconception that comic strips were somehow intimately related to the inception of animation. I will begin by examining that possibility in detail, then will suggest that another popular amusement—the vaudeville stage—was an important early influence.

Comics and the Animated Cartoon

By 1895, when the cinema was launched, the comic strip was already an old, established art form.[2] In the first half of the nineteenth century the Swiss Rodolphe Töpffer, the German Wilhelm Busch, and the Frenchman Nadar gave pictorial narrative its fundamental form. In the 1880s, recognizably modern strips were appearing in weekly humor magazines around the world, including *Puck, Punch, Life, Judge, Fliegende Blätter, Le Rire, La Caricature,* and *Le Chat Noir.* Most of these were simple gags, but some already had casts of regularly recurring characters. During the Hearst-Pulitzer circulation wars in New York in the 1890s, comic strips were annexed by first the weekly and then the daily newspaper and began attracting mass readership.

The popularity of the comics certainly could not be ignored by early filmmakers. Although comic strips had developed their own formal conventions for telling stories in pictures, their impact on the earliest films was minimal, except perhaps for some crude attempts to simulate speech balloons in a couple of 1906 experiments.[3] Throughout the first decade of cinema, filmmakers preferred to tell stories

by showing them in one long shot, rather than in a "découpage" of several shots.[4] Even for the period after cross-cutting was introduced, one strains to attribute any influence to comic-strip narrative codes.

The comic strip did, however, make a primary contribution to the cinema by providing a virtually unlimited supply of gags and story material perfectly suited to the two- to five-minute running times of the films. This relationship was already established in one of the first film narratives, Lumière's famous *Arroseur et arrosé* (*Tables Turned on the Gardener*).[5] By 1895, when the film was shot, the "scenario" was already a comic-strip antiquity. Two versions had appeared in 1887, but the definitive source was drawn by France's leading comic-strip pioneer Christophe (Georges Colomb) in 1889 (see reference 6 and figure 8). The filmmaker transposed the cartoonist's urban setting to the more convenient location of the family garden in Lyon, but the high background wall that limits the space of the composition was retained (figure 9). In the strip the mischievous boy stops the flow of water by shutting off the hydrant, but in the film he stands on the hose with the same result: The dim-witted gardener gets squirted. It was indicative of Louis Lumière's bourgeois standards that the boy, instead of escaping as he had in Christophe's strip, gets a sound thrashing in the film version.

In the American cinema, too, comics were an early narrative mainstay. The transposition to screen was simple; an actor impersonated a popular comic-strip character in a quick roustabout performance. Blackton and Smith, for example, had produced for their Vitagraph company a series of "Happy Hooligan" films in 1899, with Blackton playing the title role.[7] Edison copyrighted a *Hooligan Assists the Magician* in 1900 and four other adaptations in 1903. The American Mutoscope and Biograph studio issued ten of

From Comic Strip and Blackboard to Screen

Figure 8.
Christophe, "Histoire sans paroles—Un Arroseur public," *Le Petit Français Illustré,* August 3, 1889.

Before Mickey

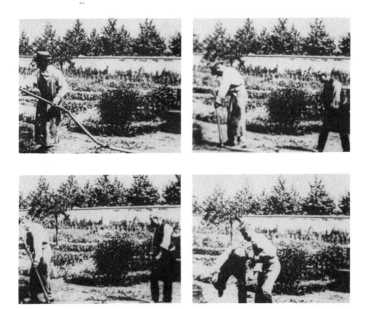

Figure 9.
Lumière and assistants, *Arroseur et arrosé* (1895).

their own "Happy Hooligans," also in 1903.[8] Happy Hooligan was a creation of Frederick Burr Opper, who never received any royalties from these adaptations or from films exploiting two of his other characters, the stereotyped Frenchmen Alphonse and Gaston.

In 1902, Biograph also launched their ambitious series of ten films based on Carl Schultze's "Foxy Grandpa." Actually, this time the comics arrived via William A. Brady's Broadway adaptation, which, like the films, starred Joseph Hart in the title role. More dependent on comic-strip material than the other early studios, Biograph also shot in 1903 two "Katzenjammer Kids" films and *Trouble in Hogan's Alley,* based on Outcault's strip.

No comic-strip artist was excited about the prospects of cinema as much as Richard Felton Outcault. Thomas Edison himself had sponsored Outcault's art study in Paris, and the artist partially returned the favor with sketches he drew for the *Electrical World,* including one of the "Black Maria," Edison's strange tarpaper shed which rotated to follow the sun in order to film the first Kinetoscope subjects.[9] In 1902, Outcault—now working for the New York *Herald*—launched "Buster Brown," the strip that would assure him fame and earn his fortune. A canny businessman, he was the originator of tie-in merchandising; he licensed Buster and his dog Tige to advertise everything from cigars to shoes. It was natural for Outcault to look toward the movies as another publicity outlet, and in 1903 he signed a contract with Edison for eight films based on his strip. In the one copyrighted in March 1904, the artist was pictured drawing Buster at his easel. In 1913, Outcault's friend Theodore W. Wharton of Essanay produced *Buster Brown and Tige with their Creator R. F. Outcault,* and still another series began in 1914, directed by Charles France for Edison (see reference 10 and figure 10).

The most spectacular film based on a comic strip was

Figure 10.
Richard F. Outcault, Ruth Henderson, and Tommy Shirley in publicity shot for the 1913 "Buster Brown" series.

Figure 11.
a: Detail from Winsor McCay, "Dreams of the Rarebit Fiend,"
© 1905. **b:** Edwin S. Porter, *The Dream of a Rarebit Fiend*
(Edison), © 1906.

unquestionably Edwin S. Porter's 1906 *Dream of a Rarebit Fiend*. It was adapted from Winsor McCay's strip, which had begun in the New York *Telegram* the previous year (figure 11). Porter's film, made without McCay's collaboration, was freely adapted from one of the episodes showing a dreamer floating over the skyline in a bed. Porter changed McCay's protagonist to a male and "rationalized" the nightmare by adding a prolog that showed the victim stuffing himself with rarebit and ale. Significantly, in place of McCay's remarkable "montage" of different viewpoints, Porter summoned up all the special effects the cinema had to offer—save animation—to recreate the dream as a series of fantastic tableaux.

The Nestor Company signed an agreement with cartoonist Bud Fisher in 1911 to use his Mutt and Jeff characters. Even the novelty of "Talking Pictures," which actually were just superimposed captions, was not enough to save the first release, a flop called *On the Job*. The producers hoped that ". . . with succeeding numbers of the series, the other characters in the pictures will be along the line of the grotesque, and thus conserve the general idea of cartoon comedy."[11]

In May 1912 the Katzenjammer Kids of Rudolf Dirks's strip made another devilish appearance on the screen, this time for the Selig company.[12] The essential fact to note is that all of these adaptations were live-action films. There was no attempt to adapt comic strips in animated drawing form until the surprisingly late date of 1911, when McCay finished some tentative experiments with his "Little Nemo in Slumberland" characters. By then the technical knowledge had existed for at least half a decade. Why were there no earlier efforts? Why had Blackton, for example, not included any comic-strip characters in his animated drawing films? The answer must go beyond the simple formidability of the task of rendering the hundreds of detailed

From Comic Strip and Blackboard to Screen

drawings that such a project would require; Blackton and others knew how to use cutouts to save time. The early producers were just not all that interested in comic-strip graphics. They viewed the strips only as a mine of story material and ready-made characters with appeal for the same huge middle-class audience for which film producers were competing. There was a strong demand for comic subjects in the period before the classic Sennett and Chaplin films, and these adaptations provided a quick and cheap source.[13]

The situation was the same in Europe. Alice Guy, for example, had freely borrowed from Guillaume's picture stories when she was a Gaumont director, and Jasset, writing in 1911, acknowledged the cinema's debt to Steinlen, Willet, Doës, Guillaume, and Caran d'Ache, whose picture stories appeared in *Le Chat Noir* and *Le Gil Blas illustré*.[14] Judging from the few identifiable samples of these adaptations that survive, all except Porter's were static and stagebound, profiting little from the lively visual arsenal available in their comic-strip prototypes.

In addition to providing stories, the comic strip made another real contribution to the cinema in the form of its personnel. All the pioneers of the animated film had previous experience in the popular graphic arts, beginning with James Stuart Blackton himself.

Born in Sheffield, England, in 1875, Blackton immigrated to America with his family when he was still a child (figure 12). In 1896 he was working as a cub reporter and cartoonist for the New York *Evening World* when his editor assigned him to do a feature story on Edison's new projecting machine, the Vitascope, which had just been demonstrated in public for the first time. During an interview with Edison, the inventor asked the artist if he would sketch him. As Blackton later reported,

Figure 12.
James Stuart Blackton, portrait by Mrs. Blackton, 1907.

I told him that I could and he said, "You come on out to the Black Maria," and we did and he had them get boards and wide white paper and some charcoal, and right then and there he had the camera recording your humble servant drawing a picture of Thomas A. Edison. He said, "Put your name on that board," and "This will be a good ad for you, it will go all over the country in the show houses." I did and that was my entrance into the motion picture industry. I finished that picture with two others with the name of Blackton, Cartoonist of the New York *Evening World* written over the top of that board.[15]

Realizing instantly the potential of Edison's projector for profit as well as entertainment, Blackton ordered one and formed a partnership (which eventually became Vitagraph, one of the most important pre–World War I producers), turning out a variety of films including Blackton's animation subjects. As the business grew, his administrative responsibilities usurped the time he had for indulging in experiments like *Humorous Phases*. He abandoned animation completely after 1909. His later directorial efforts were influenced by Griffith's successes. He resigned from Vitagraph in 1917 to go into independent production in England, then resumed an executive position with the company in 1923, remaining there two years until it was purchased by Warner Brothers. He died in Los Angeles in 1941.[16]

Blackton's role in the history of animation is curious. Although he had originated so many animated techniques, and although his work was so influential, he grew to disdain cartoons and all other trick effects. He neglected to write one word about his contribution to the field in his unpublished autobiography,[17] but in 1917 he wrote: "In that year of 1905, I had not yet outgrown my fondness for all kinds of 'trick' photography, generally of my own devising. What pride I took in carrying out all the weird happenings in *The*

Haunted Hotel! . . . Nowadays, a vastly different order of problem engrosses my attention. The enthusiasm is the same, but I fear I have outgrown my joy in lens magic as a thing by itself. Camera tricks are still all right, but they have reached a point where they must interpret, not divert."[18]

Although Blackton regarded his work as juvenile "wild oats," his case illustrates the typical ease with which graphic artists made the transition into the film business. Harry Furniss, an uninspired but articulate English caricaturist who had started working for Edison in 1912, left a 1914 account that spoke for several of his colleagues:

Ever since I was a schoolboy I have been making a practice of drawing and caricaturing, of writing stories and novels, and of lecturing and giving popular entertainments. It has only just dawned upon me, however, that these exploits of mine were merely the preliminary steps towards the writing and producing of cinematograph pictures. By this I mean to imply that this class of work, which to me was a complete novelty, has come to me more naturally and more easily than any other work I have ever attempted in the course of a long and varied career, which, no doubt, is in a great measure due to my wide experience in other spheres of art.[19]

Once these artists learned the film trade, the lasting value of their early training varied greatly with each individual. With Blackton, perhaps because he was so young, the influence of his journalistic background dissipated immediately; with others it would prove vitally important. In any case it is clear that, though the comic strips were an important narrative source for the early live-action cinema, their influence on film form and on the animated cartoon was slow to develop, was often indirect, and, as far as these early years is concerned, has probably been overrated.

From Comic Strip and Blackboard to Screen

Lightning Sketches

When the early cartoonists came to the cinema it was often by way of what Furniss had called "popular entertainments," or performing lecture tours. Looking at the old animated films, one realizes again how closely they were related to the popular stage.[20] More important than the influence of comic strips is a link between the first animated cartoons and a hybrid of graphic and performing art known as "lightning sketches." This was essentially a Victorian parlor entertainment that took to the vaudeville stage near the end of the nineteenth century. Here, in a sense, was the birthplace of the animated cartoon, because as lightning sketches made their entry into early films their iconography provided the mechanism by which self-figuration first occurred.

The artist Edwin G. Lutz has left us a record of how lightning sketches were typically presented in 1897 (figure 13). (Twenty years later, Lutz would write a manual on animation.) The artist would stand by his blank easel and deliver an illustrated monolog. Here, he first draws a marine landscape, then adds details to transform it successively into a winter sunset, a bicycle, and finally a "scorcher" (cyclist). The novelty arose both from the unexpected alterations produced by only a few lines and from the speed of the drawing, indicated by the sketcher's dynamic poses. (If Lutz's figure is a portrait of a specific artist, he has not been identified.)

Inherent in the lightning sketch act is an archetypal formula for a multitude of films, out of which the first animated cartoons evolved. There were three irreducible components: an artist, ostensibly the protagonist of the film and invariably played by the filmmaker himself; a drawing surface (sketch pad, blackboard, or canvas), always initially

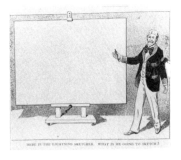
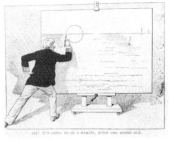

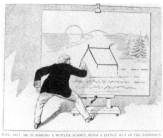
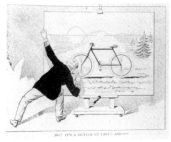

Figure 13.
Edwin G. Lutz, "The lightning sketcher," *Life,* April 15, 1897;
© 1897.

From Comic Strip and Blackboard to Screen

blank; and the drawings, shown being executed by the artist with the appropriate implements, such as pens, brushes, and chalks. There was also a basic narrative structure. The artist makes his drawings and they become endowed with the magic ability to move, spontaneously change their shape, or become "real" (three-dimensional). They may attempt to assert their independence from the artist by teasing him or by refusing to be eradicated.

The transposition of lightning sketches from stage to screen came first in England, where one of the earliest films made was an 1895 recording of a caricaturist named Tom Merry standing by his easel sketching a lightning portrait of Kaiser Wilhelm. This 40-foot film by Birt Acres was the first in a series by Merry, who, as proved by one of his extant performances, could draw not only at lightning speed but upside-down as well (figure 14). He was so popular that a juvenile rival, Little Stanley the Lightning Cartoonist, challenged him in 1898.[21]

During the first year of cinematography Georges Méliès became the lightning cartoonist of the French cinema. Billing himself as the "dessinateur express," Méliès sketched caricatures of Adolphe Thiers, Chamberlain, Queen Victoria, and von Bismark in front of his camera.[22] In these 1896 films the drawing speed was accelerated by intentionally slow cranking of the camera. Soon Méliès introduced the element of magic to the subject in *Le Livre magique,* a 1900 film that showed the artist transforming his full-size drawings into living people through stop-action substitution. This film was also released in England, where Walter Booth made an imitation called *Artistic Creation.*

Either Méliès's or Booth's film might have been viewed by James Stuart Blackton, who brought lightning sketches to the American screen (figure 15). While still an adolescent, Blackton had toured the suburbs of New York as

Figure 14.
(Attributed to a British Lumière cameraman), *Peinture à l'envers*
(Lumière), with Tom Merry (circa 1898). Courtesy of National
Film Archive.

Figure 15.
Advertisement for Blackton's lightning-sketch act, 1895. Courtesy
of Anthony Slide.

"Mademoiselle Stuart" and performed what were called chalk talks or lightning landscape paintings. His partner Albert Smith described the routine:

Blackton, a man of chesty physique, was neither decorative nor poised. He was encased in white tights and wore a morbid black wig fringed with a row of delicate rosebuds. More unfortunate still, little clusters of flesh-colored sequins formed at the points where Blackton's knotty arm and leg muscles bulged most, giving the effect of something conceived by a diabolical impressionist with a weakness for misplaced bosoms. The dowagers of White Plains viewed Blackton with cold contemptuous silence, found him particularly lacking in virility and charm, despite his emotional gyrations at the easel.[23]

Blackton no longer appeared in drag—but his gyrations are still evident—in his frenetic performance in *The Enchanted Drawing* (figure 16), copyrighted by Edison in 1900 but probably filmed earlier in the Black Maria. We see the young artist sketching a caricatural face on his pad. As he adds cigars and a bottle of wine, the face smiles. As Blackton touches these objects, they become real in his hands, prompting the face to frown as they are taken away. Like the earlier European models, this film does not use frame-by-frame cinematography but instead borrows Méliès's stop-action tricks.

In *Animated Painting,* made by an anonymous Edison director in 1904, we once again find the artist at his easel, this time drawing the sun (figure 17). Suddenly it begins to spin and levitates completely off the canvas, making the room unbearably hot. The desperate painter throws open the windows, grabs the sun (now fuming like a pinwheel), and throws it into a bucket of water. Like *The Enchanted Drawing,* this film is not animated; the effects are done with wires. By the time Blackton made his truly animated *Humorous Phases* he was able to avail himself of this stage

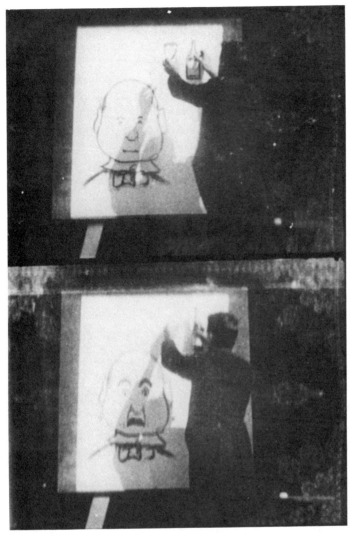

Figure 16.
Blackton, *The Enchanted Drawing* (Edison), © 1900.

From Comic Strip and Blackboard to Screen

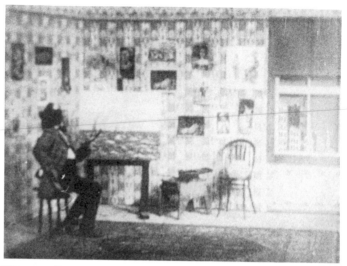

Figure 17.
Anonymous, *Animated Painting* (Edison), © 1904.

Figure 18.
Brink, "Windsor McCay," Toledo *Blade,* 1906.

Before Mickey

tradition, which had already been incorporated into the trickfilm. Iconography preceded the requisite technology.

These films did not displace the sketchers from the stage, but rather coexisted with them. Blackton's *Humorous Phases* and *Lightning Sketches*, issued in 1907, might be viewed as an attempt to capitalize on an evident renewal of interest in the stage act. In 1905 the comic-strip artist Outcault had taken to the traveling circuit with an act in which he sketched Buster and Tige on a large easel. It was this routine that Edison had recorded in 1904. His success inspired Winsor McCay, who put together an act called "The Seven Ages of Man," first presented in June 1906.[24] McCay, who collected a whopping $1,000 a week for his two daily 20-minute performances, used innovations like colored chalks and a specially composed musical accompaniment in place of the usual "patter." A newspaper sketch of the artist at work (figure 18) shows that he may have borrowed the conversing male and female faces from *Humorous Phases* (or vice versa).

In *Lightning Sketches*, we first see an exuberant Blackton introduce his partner Smith to the audience and seat him in a chair. He sketches Smith's profile on the large gilt-framed sketch pad and asks the spectator to admire his work. The camera moves slightly closer and the artist makes caricatures of a Jew and a black from the words "Cohen" and "Coon" (figure 19)—an embarrassment to modern audiences, but a reminder of the many "Coon, Cohen, and Kelly" jokes familiar to turn-of-the-century vaudeville audiences. Then a sequence of animated drawings follows, including such scenes as a bottle of Médoc pouring its contents into a glass in an echo of the table-top animation in *The Haunted Hotel*. The performance over, Blackton bows to the audience and takes his leave.

The important thing to note about these lightning-sketch films is that the spectator was never allowed to forget that

From Comic Strip and Blackboard to Screen

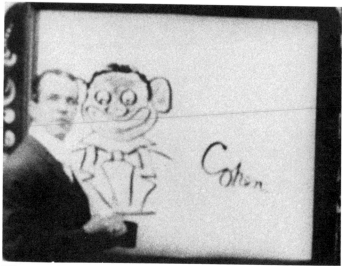

Figure 19.
Blackton, *Lightning Sketches* (Vitagraph), © 1907.

he was observing a theatrical performance. The filmmaker (often represented by his hand) was the center of attention. Yet there were no straight recordings of a performance; each was altered by camera tricks to create a magical illusion. Significantly, the costume chosen by Merry, Méliès, and Blackton was formal evening wear—also the costume of the stage conjurer. The theatrical setting and the costumes are codes with one purpose: to promote the illusion that the animator is a magician. His initial appearance beside his blank blackboard or sketch pad is the equivalent of the magician's opening his act by proving that his hat and sleeves are empty. We understand that a mundane situation is about to be transformed. When the artist's drawings spring to life, the magical nature of the event is all the more delectable because the original materials seemed so ordinary. Audiences knew that camera trickery was involved, but easily accepted the invitation to suspend disbelief and imagine a world in which an artist's drawings could become real.

For an artist to be able to bring something to life bestows upon him the status of a privileged being. Whether they realized it or not, the sketcher-animators were involved in a retelling of the story of Pygmalion, the artist whose creation was so realistic and whose desire was so strong that his statue came to life as the beautiful Galatea. In the cinema, as Bergson said, movement is life, and the ability to synthesize screen movement was quickly grasped as a magic wand by Blackton and the others. These mythic *a priori* assumptions about animation are acknowledged in the root of the word itself: By depicting themselves at work on the screen, engaged in their business of making magic moving drawings, the artists showed themselves imparting the *anima*—the breath of life.

From Comic Strip and Blackboard to Screen

Figure 20.
Emile Cohl, circa 1895. Courtesy of Mme. André Courtet.

The First Animator: Emile Cohl

In 1933 an aging misanthrope living in a Paris suburb clipped an obituary notice of the death of Pat Sullivan—the creator, it read, not only of Felix the Cat but of animated cartoons in general in the year 1918. Emile Cohl scrawled an anguished note in the margin: "Pat Sullivan 'invented' animation ten years after me!"[1] Stricken with desperate poverty, Cohl (figure 20) found himself unknown to the public and ignored by the industry of which, with good reason, he considered himself a founder. Between 1908 and 1921 he had completed more than 250 animated films. He was especially bitter because Georges Méliès, who had been "rediscovered" by journalists and cinéastes in 1929, had been achieving considerable acclaim while Cohl could not even afford the price of a movie on his 100-francs-a-month welfare income.

Cohl died just as the magnitude of his career was beginning to be recognized. Even now he is a neglected marginal figure in film history, and he would have had to live to the ripe age of 121 to see his first major retrospective festivals in Annecy, Paris, New York, and Montreal. These 1978 revivals finally brought to light again the work of a major film artist who designed, animated, and usually even photographed everything singlehandedly.

Unlike Booth, Blackton, and Chomón, for whom animation was a whimsical divertissement, Cohl instantly seized

upon the new technology as his life's calling. He became the first of many similar individuals who would eventually populate animation studios everywhere. Among the distinctive features of this personality profile are a background in journalism, a compulsion to sketch, "workaholic" tendencies, and a well-developed but idiosyncratic sense of humor. Cohl was the first to bring to the cinema the necessary qualities of intellect, imagination, patience, and the obsessive love of drawing that would mark other great animators.

Emile Cohl's achievement is especially remarkable because he was truly a man of the nineteenth century. He was the senior of Georges Méliès by 3 years, of Auguste Lumière by 5, of D. W. Griffith by 12, and of Louis Feuillade by 16. In comparison with other animation pioneers, he was 14 years older than McCay, 18 years older than Blackton, 22 years older than J. R. Bray; when Walt Disney was born, Emile Cohl was just about to celebrate his 44th birthday. He saw the inside of a movie studio for the first time when he was 51. Nevertheless he adopted his new medium with a convert's passion and proudly signed himself "cinématographiste."

The first film Cohl directed, *Fantasmagorie,* was also arguably the first true animated cartoon. Although it followed in the wake of *The Haunted Hotel*'s success, in comparison with Blackton's crude momentary flashes of animated movement this film was a spectacular feat. Except for two brief moments when Cohl's hands appeared in live action, its plot was enacted entirely by moving drawings. Despite its short length (only two minutes), it is recognizable as a modern cartoon.

At the time, 1908, Cohl was working for the Gaumont studio in Paris, where he had ample opportunity to study *L'Hôtel hanté* and *Croquis au grand galop,* since Gaumont

distributed these Vitagraph films. Evidence in *Fantasma-*
gorie indicates that Cohl also knew *Humorous Phases of Funny Faces*: like Blackton's 1906 film, Cohl's begins with the lightning-sketch motif of the artist's hand at work with chalk (figure 21). Individual drawings for the animated segment had been made in India ink on white rice paper, but Cohl had asked the laboratory to print them in negative to preserve the white-on-black chalkline effect. Cohl also borrowed two characters from Blackton, a clown and a bourgeois gentleman, but he drew them in a much more charming manner. There the influence ended.

Instead of a clumsy blackboard and rigid cutouts, Cohl made over 700 drawings, which he traced and retraced over a light box. Each one represented one discrete phase which the projector would eventually synthesize into motion. Although the film would be projected at the rate of 16 frames per second, Cohl guessed that he could cut his work in half by making only eight drawings for each second, then photographing each twice. The result was a film with extraordinary fluidity of motion, startling perspective alterations, and a convincing illusion of solid figures moving in spatial depth. The results delighted Cohl, and he began immediate work on a sequel, undeterred by the prospects of the physically demanding labor and mental strain before him. Cohl was no dilettante; on the contrary, he was on his way to becoming a monomaniac and would dedicate the rest of his life to the promotion of animation as an art and industry. He was the one most responsible for transforming the efforts of his trickfilm predecessors into a unique twentieth-century art, but, paradoxically, his own roots extended far back into the past.

He was born in a Parisian working class district on January 4, 1857, and christened Emile Eugène Jean Louis Courtet. His mother died when he was only six, and his

Emile Cohl

Figure 21.
Cohl, *Fantasmagorie* (Gaumont, 1908).

father sent him to live with relatives until he was old enough for a boarding school. During the 1870 Franco-Prussian war, with Paris in a turmoil, the youngster skipped school with his friends and wandered the streets, fascinated by the hundreds of caricatural propaganda posters plastering the walls of the city. Life after the war was a constant battle with his father, who was determined to apprentice him in some respectable profession. He bolted to join the Army, and when his three-year enlistment was up in 1878 he decided that he wanted to make drawing and caricaturing his life.

Somehow he managed to solicit a letter of introduction from the photographer Etienne Carjat. Clutching it nervously, he presented himself to André Gill, the foremost political caricaturist of the day, respected by liberals and feared by the government. Gill took an immediate liking to his 21-year-old admirer, and Emile eventually regarded Gill as his surrogate father. An inveterate practical joker and lover of word games, he changed his name from Courtet to Cohl, perhaps to pun on *colle* (paste) and to signify his intention to "stick" by his master.

The young artist's intellectual formation began at the same time as his artistic apprenticeship. He was attracted to Gill's bohemian circle, including a group of artists, poets, journalists, and critics who (apparently as a joke having to do with one of Daumier's drawings) called themselves the Hydropathes. Among their ranks were to be found many future leaders of the symbolist movement in theater and literature, whose ideas Cohl would readily absorb. In 1880 he became the editor of their newsletter, *L'Hydropathe,* to which he contributed poems, reviews, and drawings.

Inevitably, Cohl began to acquire an independent reputation, both as a notorious practical joker and as a duelist. He also began directing a weekly satirical journal called *La*

Emile Cohl

Nouvelle Lune, and from 1880 through 1885 his most pro-
lific work appeared in its pages. His frequent skirmishes
with political censors quickly made him well known.

Painting, poetry, and two comedies written for the pop-
ular stage are evidence of Cohl's wide-ranging interests.
He worked as a theatrical costume designer and even en-
joyed a brief stint as a professional portrait photographer.
This growing independence was not altogether of his own
choosing. In 1881, his friend Gill had been hospitalized
with a mental disorder, and his condition gradually wors-
ened until he had to be committed to the infamous Char-
enton asylum. Cohl sought financial relief by appealing to
Gill's once-large circle of friends, but in vain. As the artist
slipped into complete insanity, the friends continued to
dwindle away until only Cohl was left when Gill died on
May Day 1885. Gill's lonely final days left a permanent
trace on Cohl, who would later perceive a parallel between
his own neglect and the desertion of Gill by his friends and
public.

As Gill's mental health was deteriorating, Cohl became
associated with a group obsessed with insanity as an aes-
thetic issue. They were the Incoherents, who would have
a profound influence on Cohl's cinema more than three
decades later. For twelve years, beginning in 1882, Cohl
and the Incoherents organized charity balls and exhibitions
of their strange paintings and drawings. They even at-
tracted a modish following, including the artists Toulouse-
Lautrec, Steinlen, and Jules Chéret. Their philosophy was
iconoclastic, antibourgeois, antiacademic, and violently an-
tirational. Small wonder that the academic master Gérôme
decried them as the anarchists of art.

Cohl was no longer active with the Incoherents in the
1890s, preferring to spend his time pursuing a variety of
activities, including philately and the new fad of bicycling.
He also illustrated the important biographical magazine *Les*

Hommes d'Aujourd'hui, assorted books, songsheets, and anti-Dreyfus papers, and he even traveled briefly to London in 1895–96 to work for British humor magazines. By 1900, he had abandoned the outdated Gill-style facial caricatures and was working almost exclusively in the more popular comic-strip format. His contributions to one ephemeral periodical alone, *L'Illustré National,* ran into the hundreds of drawings.

Had Cohl never discovered the cinema, he would still be entitled to some degree of fame. At the turn of the century his name was far better known than that of Méliès. He had been recognized in articles in leading periodicals and encyclopedias, and in 1905 he was honored with lifetime membership card number one in the "Société des dessinateurs humoristes" (which is still active). This means that Emile Cohl was the first artist with an established reputation to become a full-time filmmaker.

That happened in 1908. During the winter, Cohl had been walking in Montmartre when he noticed a poster for a film that apparently stole an idea from one of his comic strips.[2] That this was a common practice at the time did little to assuage his temper, and he stalked over to the Gaumont studios to demand compensation. There he was met by Louis Feuillade, the "artistic director" of the company and the future director of *Fantomas.* Feuillade, no doubt secretly amused by the old man's wrath, offered him a job writing scenarios. In fact, just about anyone could walk in with a one-page story outline and be paid 25 francs for the idea, but Cohl took the offer seriously and wrote several *féeries.* Feuillade realized that Cohl's experience as a popular graphic artist would be invaluable for creating comic material, and encouraged him to adapt his own comic strips. His *Hôtel du silence,* for example—another haunted-hotel film, directed by Etienne Arnaud—revived a joke from a 1900 comic strip showing a sleeper being

Emile Cohl

ejected from an electric bed (figure 22). The film is one long static take.

While he was writing scenarios, Cohl was also working on the *Fantasmagorie* drawings. The cartoon was completed in July and released in August, and was an international success. Cohl's subsequent work pleased Léon Gaumont, and in January 1909 (probably one year exactly from his first visit) he was made a full-time salaried director. By the time he left the studio in 1910, Cohl would complete 77 films.

Cohl was one animator whose background in the popular graphic arts remained an active, vital force when he began creating films. At Gaumont he developed what might best be called his Incoherent cinema. This was a conception of film that not only borrowed images and narrative situations from his nineteenth-century work, but transposed the Incoherent philosophy to film. The result was a body of work with a unified aesthetic basis reflecting the filmmaker's worldview and his personality.

Cohl's Incoherent cinema rejected normal methods of telling a story. Rather than relate incidents in their logical order, he preferred to let images flow in stream-of-consciousness fashion. In *Fantasmagorie*,[3] for example, the action is so irrational and the events unfold so quickly that the "plot" is difficult to decipher on first viewing. There is, however, a story: As soon as Cohl's hand has completed drawing the little clown, he springs to life (figure 23). Immediately he is obscured by a large rectangular form (an elevator?) containing a bourgeois gentleman in a top hat carrying an umbrella. Freely floating in black space, the hat and umbrella change into a movie theater interior. As a film within the film begins, the clown pops out of one of the chairs like a jack-in-the-box and scares the man so much that his hair stands on end. The clown flies away,

Figure 22.
Cohl, "Nos grandes inventions: Le Lit reveil-matin," *L'Illustré National*, February 11, 1900.

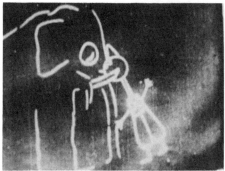

Figure 23.
Cohl, *Fantasmagorie* (Gaumont, 1908).

Before Mickey

but the man's troubles are not over. A woman wearing a giant feathered hat seats herself in front of him, obscuring his view of a scene of marching soldiers. Angrily he pulls the plumes out one by one and inserts them through a tear in the background. The woman seems oblivious, though, and alternately laughs and cries as she watches the film before her. When the man pulls the hat off completely, the clown rematerializes inside her head, which is swelling like a balloon. The clown engulfs the man and the theater set evaporates. Next come several picaresque scenes in which the little clown is tormented by figures as diverse as a giant toy soldier and the Michelin "Bib." An elephant changes into a house as the clown plummets through its upper-story window. The crash decapitates him, but Cohl comes to the rescue with a paste pot and the clown floats into the air with a valise, bidding the audience adieu as he rides away on a hobby horse. Quite a story! And one that gives the impression of having been improvised drawing to drawing. This spirit of spontaneous invention would mark nearly all of Cohl's films.

Dreams, nightmares, and hallucinations were as much a part of Incoherent cinema as they had been of the nineteenth-century exhibitions of Incoherent art. *Le Cauchemar du fantoche* (*The Puppet's Nightmare,* 1908), Cohl's lost second film, was populated with strange hybrid monsters. A waiter's "DTs" were the excuse for the strange transformations in *Le Rêve du garçon de café* (*The Hasher's Delirium,* 1910), a film replete with bizarre visions and non-sequitur imagery. Cohl's irrational juxtapositions recall the stimulating shocks delivered by many of his Incoherent friends' drawings, or by Lautréamont's savoring of the poetry to be found in the encounter of an umbrella and a sewing machine on a dissecting table. This flow of illogical imagery linked Cohl's cinema with the traditions of visionary art that extended beyond the Incoherents to Bosch,

Emile Cohl

Breugel, and Grandville, an association that adumbrated the fantasist tendencies of animation after Cohl.

Cohl developed specific codes for achieving these dislocating effects. His most characteristic, and most spectacular, was the extended metamorphic sequence in which the outlines of objects continually melt into other shapes. One of the most striking metamorphoses begins in 1911's *Le Retapeur de cervelles* (*Brains Repaired*) (figure 24) when two gentlemen meet and shake hands. Their heads swell and their hands merge together. The heads become birdlike and grow large enough to fill the screen, as though the camera were zooming in on the drawings (a technical impossibility then). Even when the outline has passed out of sight beyond the boundaries of the frame, the "zoom" continues, centered on one growing eye. But as it gets closer we see that it is no longer an eye, but a pumping bellows which in turn will become the starting point for another transformation. The precedent for these metamorphic sequences lay in Cohl's graphic work. The elephant that changed into a house in *Fantasmagorie* was the filmic descendant of one that dissolved inexplicably into a photographer in a cartoon of many years before (figure 25). Now, although it still only occurred rarely, graphic narrative devices were being tentatively adapted to the cinema.

The recycling of old ideas was typical of Cohl's work. An 1892 British drawing entitled "A Diagnosis; or, Looking for a Bacillus" (figure 26) became the basis for *Les Joyeux Microbes* (1909), his best known film. A live-action prolog showed the burlesque doctor (probably a parody of the publicity-loving Parisian surgeon and biologist Eugène Doyen) asking his skeptical patient to peer through his microscope at a blood sample. The animated microbes he sees there represent various "social ills"—politicians, taxi drivers, bureaucrats, drunks, and even mothers-in-law—all

Figure 24.
Cohl, *Le Retapeur de cervelles* (Pathé, 1911).

Emile Cohl

Figure 25.
Cohl, "Distant lens enchantment to the view," *Judy: The London Serio-Comic Journal*, February 12, 1896.

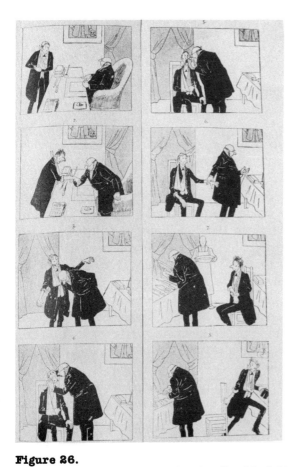

Figure 26.
Cohl, "A diagnosis; or, looking for a bacillus," *Pick-Me-Up,* March 5, 1892.

Emile Cohl

formed inside circular vignettes from moving dots and squiggles.

Playing games with matchsticks—an amusing if somewhat risky pastime Cohl had recommended often to his nineteenth-century juvenile readers—was translated into film as *Les Allumettes animées* (1908), *Les Allumettes fantaisistes* (1912), and *Bewitched Matches* (1913). This last film astounded an early reviewer when one of the matches "even walks a tight rope and stands on his head on it."

Among Cohl's extraordinary technical accomplishments was the first use of matte photography to combine animation with live action, in *Clair de Lune espagnol* (*The Man in the Moon*) (March 1909), years before others attempted this. Matador Pedro has a tiff with his girlfriend and, while sulking in his room, is visited by aliens and whisked to the moon (a small stage). In the black sky above, the laughing moon sticks his tongue out at the angry matador. Ever more infuriated, Pedro hurls rocks, fires a blunderbuss, and even heaves a hatchet at the taunting face (figure 27). The timing of the moon's reactions is perfect. We see Pedro throw a real hatchet, for example, but midway in its flight it changes into a drawing of a hatchet before sticking in the moon's nose. This extraordinary precision must have been achieved by first photographing the live action against a black velvet background. Carefully counting the frames on the negative, Cohl would have been able to arrive at a numerical guide for planning his animated sequence. The drawings of the moon would have been photographed against a black background; then this negative could be combined with the live action by double printing. Thus Pedro and the moon seem to act in unison.

Perfecting matte photography was typical of Cohl's resourcefulness. He was also the first to abandon the hand-cranked camera for one with an electrically driven shutter. This system was in use as early as May 1909 for the filming

Figure 27.
Cohl, *Clair de Lune espagnol* (Gaumont, 1909).

of *La Bataille d'Austerlitz*. It made his work easier and provided consistent exposures, thus eliminating the flickering of earlier animation. However, not all of Cohl's inventions were so fortunate. Gaumont's constant pressure for a film every two weeks forced him to resort to labor-saving shortcuts. One was to have Etienne Arnaud shoot live-action scenes to frame shorter animated sequences; sometimes animation accounts for only 15 percent of a film. Another shortcut was the substitution of cutouts for animated drawings (figure 28). As Blackton had done in 1906, Cohl designed articulated figures whose limbs could be moved without the need to retrace every frame. At its worst the results were stiff and wooden. Cohl recognized this and later regretted it: "This intrusion of rigid cardboard led to a certain lifelessness of the figures. Made from one piece, they moved as one piece, their arms attached to their shoulders by a single pivot. Without making drawings for each frame, work was greatly economized obviously, but to the detriment of suppleness."[4] On the other hand, Cohl often exploited the artificiality of the technique for its own sake, as in *Les Douze Travaux d'Hercules* (1910). Here the jointed limbs of the two-dimensional puppet representing Hercules are constantly detaching themselves from his torso and drifting out of the frame. In his later films, notably in the "Pieds Nickelés" series, Cohl showed he could use cutouts for more subtle effects. As the three heroes walk into the distance, cutouts of diminishing size accurately reproduce their perspectival foreshortening.

Cohl also relied on cutouts in *Le Peintre néo-impressionniste (The Neo-Impressionist Painter)* (1910), the film that best illustrates his debt to the Incoherents. A stereotyped bohemian artist is seated at his easel sketching his model. The doorbell sounds and an art dealer enters. As the artist displays each of his canvases, he announces their strange titles. Herein lies the dry humor of the film. They

Figure 28.
Cohl, design for the articulated puppets in *Le Peintre néo-impressionniste* (Gaumont, 1910).

Emile Cohl

are all clever plays on words and colors (for instance, "A cardinal eating lobster and tomatoes by the Red Sea"). Each "painting" then appears in a brief insert, with animated cutouts literalizing the title (figure 29). These sections were originally tinted the appropriate colors, except for "Negroes making shoe polish in a tunnel at night," which was nothing more than a few seconds of black leader. Joking titles like these were commonplace in the Incoherents' exhibitions. In 1884, someone submitted "Opaque Stained Glass Windows for a Blind Man's Bedroom." A cartoon in *Le Charivari* that year satirized the Incoherents by showing one of them holding a blank canvas before a baffled art dealer and announcing its curious title, "Police Repulsing a Nocturnal Attack" (figure 30). The idea clearly anticipates Cohl's film by 26 years. The rationale for taking such delight in verbal-visual dissonance was expressed by the Incoherents' founder Jules Lévy in 1885.[5] Pictorial language, he argued, was foundering from exhaustion. Violent means must be used to revitalize it, including attempts to find visual equivalents to neologisms in puns, rebuses, and wordplay. Certainly *Le Peintre néo-impressionniste* (which might have been more accurately titled *Le Peintre incohérent*) goes a long way in this direction. Its humor is not slapstick but dry and intellectual and, strangely enough, elicits much the same response as the punning intertitles of Marcel Duchamp's 1926 avant-garde film *Anemic Cinéma*.

Successful as Cohl's films were, the tight-fisted Léon Gaumont turned a deaf ear to his request for a raise; so in January 1910 Gaumont's archrival Charles Pathé was able to lure Cohl to his Vincennes studio. Soon after his arrival, the animator began to have second thoughts. Like Chomón, his predecessor at Pathé, he was pressured into directing live-action films in addition to trick photography and animation. In March there was a quarrel, probably because

Figure 29.
Cohl, *Le Peintre néo-impressionniste* (Gaumont, 1910). "Une
Toile qui représente un cardinal mangeant du homard aux to-
mates sur les bords de la Mer Rouge."

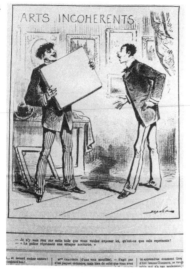

Figure 30.
a: Draner, "Arts incohérents," *Le Charivari,* October 30, 1884. **b:**
Cohl, *Le Peintre néo-impressionniste* (Gaumont, 1910).

Before Mickey

Cohl had been assigned the Jobard comedy series starring a weak Max Linder imitator named Lucien Cazalis. Cohl completed ten Jobard films before calling it quits in July. The only one of the eight animated films Cohl made for Pathé that survives is one of his best—*Le Retapeur de cervelles* is distinguished not only by its superior animation but by its fluid intercutting of live and animated action.

Fortunately, Cohl's friend and technical mentor Arnaud asked Cohl to join him at the Eclair company's new studio in Fort Lee, New Jersey, which was the "French Hollywood" in the years just prior to World War I.[6] He and his family joined the already large French film colony there in September 1912. As soon as he had settled, Cohl began work on "The Newlyweds," a lost milestone in animation history. It is unknown whether Eclair approached George McManus, the creator of the popular comic strip "The Newlyweds and their Baby," or whether McManus, possibly inspired by his friend Winsor McCay's experiments, approached Eclair. In either case, a deal was consummated for a screen adaptation of the New York *World* strip, which we recognize today as the prototype of McManus's "Bringing Up Father." Cohl had known the strip in France, where as "Le Petit Ange" it had run in *Nos Loisirs,* to which he had also contributed.

In general Cohl adhered closely to the graphic style of the "Newlyweds" comic strip. McManus did not collaborate on the drawings. The Newlyweds were a nattily attired petit-bourgeois and an elegant Gibson girl; their truculent offspring was baby Snookums (figure 31). The humor arose from the father's heroic but futile efforts to satisfy Snookums's sudden cravings for unattainable objects. The first film was *When He Wants a Dog, He Wants a Dog,* released on March 16, 1913. Eclair's publicity stressed the important difference between this new series and previous comic-strip adaptations: "The Newlyweds are not real people

Emile Cohl

Snookums Likes the Taxi

And now here comes our friend Snookums with more screamingly funny antics.

Watching the dial of a taxi-cab is like a fall on a slippery pavement. It is funny, only when the other fellow suffers. But Dada Newlywed is a game little father, and when he found that it tickled Snookums to see the numbers flash—well, he just wouldn't let his little darling howl and so he and that beautiful wife just rode around all the afternoon with the precious one.

Once or twice they thought they would quit, but Snookums set up a howl, and so back they climbed for another little ride. Finally Dada had a brilliant thought, and so he told Mr. Chauffeur to drive into the country. And what do you thing?—when they were out about five miles—Snookums, the little bunch of sweetness, went to sleep.

And was Dada going to take chances on his waking up again—not on your life! He might want to see those numbers flash some more—and so Dada planked down forty odd simoleons for their "joy ride," and he carried "Snookums" back to his little trundel bed. Here is another scream from start to finish, and it is sure to be one of the most popular of the great Newlywed series of animated cartoons, which have proved to be the laughing hit of the year. See that you get this one.

Figure 31.
Publicity for *He Loves to Watch the Flight of Time, Eclair Bulletin,* 1913.

Before Mickey

dressed up to imitate the famous McManus cartoons, but are *drawings that move*! The trick photography required to produce such wonderful effects is the work of the 'Eclair' people."[7] Needless to say, it was George McManus and not Cohl who received all the credit for the films, but this is understandable because motion-picture personnel were still generally anonymous and Eclair was anxious to profit from McManus's immense renown.

The releases proved to be irregular—the announced goal of a film every other week was impossible—but amazingly Cohl was able, alone, to complete thirteen all-animated "Newlyweds" films (and other, nonseries films) between March 1913 and January 1914.[8] Thus, "The Newlyweds" became the first cartoon series with a recurring cast of characters appearing regularly in a way analogous to the weekly comic strip. This event has somehow escaped the history books, but it was crucial because henceforth animation would be associated with comics in the mind of the public, and to dozens of journalist cartoonists the possibilities of the animated cinema were suddenly revealed. It was in an advertisement for "The Newlyweds" that the phrase "animated cartoons" was first used to describe this new genre.[9]

Cohl received specific praise, though not by name, for his hit series:

[*When He Wants a Dog, He Wants a Dog*] is a unique little comedy which has been very cleverly worked out, evidently with pasteboard designs and figures. The peculiar manner of its progression and the whimsical play of the different designs which eventually resolve themselves into the figures of two men, a woman, a baby and a dog, will no doubt prove most entertaining and laughter provoking. . . .

The baby, Snookums, is seen in all his glory, and the eccentric effects of the line drawings in motion are irresistible.[10]

Emile Cohl

Probably for family reasons, Cohl moved back to France after an eighteen-month stay in the United States. On March 19, 1914, one day after he docked at Le Havre, a disaster back in America had far-reaching effects on Cohl's future. A fire in the editing rooms of the Eclair laboratory destroyed all the highly flammable nitrate negatives and prints stored there. Virtually all traces of his American work went up in smoke, and the credit this neglected pioneer deserved went up with them. Then, in August, the World War erupted in Europe, the background for Cohl's later activity and his dénouement. His last significant film, *La Maison du fantoche,* found an independent distributor in 1921, only after much difficulty. The trade press scarcely noticed it, and it has now disappeared.

In the 1930s, Cohl lived in increasing poverty with his grown son André's family in the Paris suburb of Saint-Mandé. He vented his anger to the occasional reporters who, shocked at his living conditons, came to visit him: "I'm afraid that soon in France it will no longer be common knowledge that Mickey, Flip the Frog and Felix the Cat were only the 'industrialized' descendants of the puppets and drawings of a Parisian caricaturist who used to draw in a modest Montmartre loft."[11] To be fair, his neglect was not total. The historian Guiseppe Lo Duca and the animator Pierre Bourgeon projected some of his Gaumont films during their 1936 festival of animation. *Comoedia* ran a series of sympathetic articles on the cartoonist's career and current need. Acting on Léon Gaumont's suggestion, a society of industrialists awarded Cohl a medal and a small stipend for his contribution to the "national industry" of animation. This was in March 1937. A few weeks later Cohl was working by the light of an oil lamp and accidentally knocked it over. The fire spread quickly and he was placed in a charity hospital. He died of pneumonia on the night of January 20, 1938, shortly after his 81st birthday.

Before Mickey

Cohl's death on the eve of another world war retarded his proper recognition in France. His family and that of Georges Méliès (who died the day after Cohl) were victimized by a sculptor who absconded with the funds collected for a monument. It was not until after the war that the city of Paris designated a small park the Square Emile-Cohl.

The artist's bitterness at the time of his death was understandable. We now realize the importance of his work and its influence on American animation, which actually came in two phases.

The first was in the form of his Gaumont films, which arrived here almost as soon as they were released in France through the distributor George B. Kleine. Their unique properties were hailed by the first film reviewers. *Un Drame chez les fantoches* (*A Love Affair in Toyland*) was singled out for critical praise in November 1908 as

a unique and exceptionally attractive Gaumont film. It cannot be described, but a game common many years ago known as 'geometry at play' comes nearest to it. It is funny and in such an unexpected and unique way that it wins rounds of applause wherever it is shown.[12]

According to another reviewer,

We overheard considerable guessing among the audience at Keith's Bijou Dream as to how the clever transformations were accomplished. Gaumont's man is up to all the tricks of the camera.[13]

Indeed, Cohl's work was in some part responsible for the reputation of the Gaumont company in America. With his animated films pouring in to such praise, it was inevitable that Americans would respond. James Stuart Blackton made, in quick succession, his first animated films since 1907: *The Magic Fountain Pen* (July 1909) and *Princess Nicotine; or, a Smoke Fairy* (August 1909). The former

Emile Cohl

showed Blackton seated at a desk drawing caricatures; the latter plagiarized part of Cohl's *Les Allumettes animées,* which had been released here in December 1908. In October 1909, *La Bataille d'Austerlitz,* a schematic reenactment of Napoleon's victorious battle, became the first animated film ever to have an entire article devoted to it in an American trade magazine.[14] The frame-by-frame exposure process was described in minute detail, so anyone still naive about animation technique could easily have availed himself of Cohl's secrets. Writing in 1927, Winsor McCay recalled that his first inspiration for "modern cartoon movies" came to him in 1909. Although he did not acknowledge Cohl, that date corresponds to the height of the French filmmaker's American vogue.

The second phase of Cohl's influence came when he arrived in person. A survey of the trade press shows that before the 1913 Newlyweds series animated films were sporadic novelty items; after the commercial success of the Eclair films animated series popped up like mushrooms. The recognition Emile Cohl thought he deserved was not an old man's egotistical folly. He was the one who had been primarily responsible for disassociating animation from the trickfilm genre. Cohl demonstrated the potential affinity between animation and popular graphic art, connecting it first with the visionary arts of the nineteenth century, then later with the modern comic strip (thus giving it a broader contact with middle-class taste and renewed commercial impetus). And he had the ingenuity to develop the technology to make it all possible.

There are many common points between early trickfilm iconography and Cohl's work. The familiar motif of the artist's hand viewed in closeup was also one of Cohl's favorites, and viewers often see him put his fingers into the field of the lens, as when he pokes the drunk in *Le Rêve d'un garçon de café* (figure 32). But, in contrast with these

Before Mickey

Figure 32.
Cohl, *Le Rêve d'un garçon de café* (Gaumont, 1910).

Emile Cohl

earlier lightning sketch–derived films, there is little sense of a stage performance. The drawings are foregrounded, rather than the artist as actor. Cohl interjects his presence into the films not so much by means of his corporeal self as by his rigorously consistent style and unique aesthetic philosophy. It is as though the viewer's attention was being diverted from the magician, toward the mechanism of the trick.

Winsor McCay and his contemporary Emile Cohl are a study in contrasts. Cohl was past middle age when he discovered cinema; McCay was still in his thirties and at the apogee of his sparkling career as a comic-strip artist. We stand in awe before Cohl's enormous output over the span of a decade; McCay's reputation as an animator rests on a handful of cartoons drawn in the privacy of his atelier in Sheepshead Bay, Brooklyn. McCay never actually entered the film business full-time, and was content to hire out the photography and similar production chores. There was no Léon Gaumont breathing over him, so he was free to spend months, perhaps even years, laboring affectionately on each film.

Unlike the cerebral and introverted Cohl, McCay was a gregarious host, a flamboyant showman, and altogether a public personality. He took to the stage with glee, whereas Cohl kept his theatrical contributions behind the scenes. When the two artists entered the cinema, demure Cohl limited his own appearance to his hands, whereas McCay took the part of the protagonist and prominently displayed his name, known to most literate New Yorkers, above each title.

Emile Cohl all but abandoned his earlier graphic style to create a new streamlined one especially suited to the commercial and aesthetic demands of moving drawings, but

McCay's genius resided in his ability to translate the comic strips that had made him famous onto the screen with a minimum of modification (figure 33).

Cohl's life story was the patient but futile pursuit of his rightful fame, but McCay's life was one of those legendary turn-of-the-century success stories. Winsor Zenis McCay (figure 34) was born on September 26, 1871, in Spring Lake, Michigan, although there is some question about the precise year because the record was lost in a fire.[1] At his father's sawmill the boy did odd jobs before going to school in nearby Ypsilanti, where he discovered his talent for drawing. When the family moved to Chicago, McCay enrolled in a commercial art school, but it closed after a few days. This brief exposure to pens, brushes, and models was his only formal art education. His practical training came from working for a manufacturer of lithographed carnival posters when he moved to Cincinnati and designed ghastly signs and banners advertising the attractions of Kohl and Middleton's Vine Street Dime Museum. Thus, McCay was thoroughly acquainted with the world of popular amusement even before the movies invaded it. In 1891, he married Maude Leonore DuFour and, no doubt feeling pressure to land a more respectable job, went to work as an artist-reporter for the Cincinnati *Commercial Tribune*.

Armed with sketchpad, pen, and India ink, McCay (as Blackton had done before him) would rush off to record local newsworthy events, as well as to illustrate features for the Sunday editions. The job fostered drafting speed, accurate observation, and the ability to complete a drawing on the first try—talents that would also prove valuable when the time came to adapt the artist's drawings for animated motion pictures. McCay began his first comic strip in Cincinnati; by 1903 he felt ready for New York. McCay's capacity for work astonished the staff of the *Evening Telegram*. He produced not only daily installments of his

Before Mickey

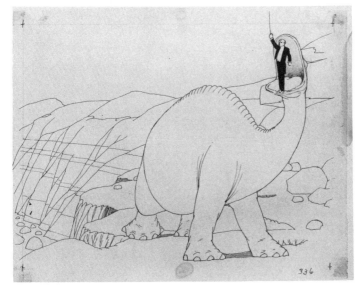

Figure 33.
Winsor McCay, original drawing for *Gertie,* 1913–14. From John
Canemaker collection.

Winsor McCay

Figure 34.
Winsor McCay, circa 1908.

Before Mickey

"Dream of the Rarebit Fiend" or "Poor Jake," but a weekly strip for the Sunday *Herald* as well. From the beginning, McCay busied himself creating a world of dreams and fantasy without precedent in comic-strip history. The protagonists were ordinary men and women with whom the readers could identify. These bewildered but calm heroes, who changed with every strip, were thrust into a world of heightened and distorted reality.

McCay's first New York weekly strips remain almost unknown, yet they were crucial in his development as a graphic artist and show early evidence of his growing interest in the cinema. "Little Sammy Sneeze" began in mid-1904 and continued for two years until supplanted by "Little Nemo in Slumberland." Every episode was a variation on a single gag: Sammy is present at some social gathering. In panels one through five he builds up to a catastrophic sneeze that destroys everything near its epicenter, embarrasses his parents, and results in his being booted out of the frame in the sixth panel. (In later strips, his punishment was less harsh.) The formal composition of the strip was as rigorously inflexible. Six squares, each bound by a thick black border with curved corners, were aligned in two rows. Sammy's position within each panel never changes. He just progresses with his sneeze, his body totally involved, while the bystanders stare helplessly in the background waiting for the final explosion. Although the word "cinematic" is often carelessly used to describe comic-strip art, here is one case in which it seems justified. The unusual black border of the strip, for instance, closely approximates the almost-square aspect ratio of early film frames. Though the repetition of a single figure or scene in consecutive panels had too many nineteenth-century graphic antecedents to be considered necessarily influenced by cinema, certainly McCay's compositions create the impression of cinematic settings. He typically employs

Winsor McCay

the knees-up framing of figures, which early film producers called the "American shot." Occasionally there seem to be reminders of specific filmic situations, as in the January 1, 1905 strip showing Sammy and his parents seated at a table in an arrangement reminiscent of Lumière's *Le Repas de Bébé* (figures 35, 36). Though McCay relied primarily on his keen observation of life for Sammy's anatomically perfect sneeze, he probably also knew the most famous sneeze of all: the one Edison's assistant Fred Ott performed for his camera in 1894, which was published in *Harper's Weekly*.[2] This "kinetoscopic record" (figure 37) revealed all the delightfully unexpected facial contortions. In his film on McCay, John Canemaker demonstrated that the artist's analysis of the sneeze was accurate enough to be synthesized into motion using modern animation techniques.[3]

While "Sammy" was still running, "The Story of Hungry Henrietta" commenced on January 8, 1905. Although similar formally and stylistically, this was essentially a very different kind of strip. It was never intended to be humorous, but rather is a work in a pathetic and highly ironic key. It was also McCay's only true serial comic, appearing in 27 consecutive weekly "chapters." Each episode was a one-line gag, but, unlike Sammy, Henrietta aged visibly from one week to the next. (McCay was evidently fascinated with the effects of accelerated growth; he explored the idea in other strips and in his films.) Henrietta was an ordinary little baby born into a thoroughly normal family. Her only distinction was that, from her earliest days, she possessed a voracious appetite. In contrast to Sammy, whose sneezing is only a comic effect unmotivated by any psychological factors, Henrietta's gluttony was clearly neurotic and induced by her well-meaning but incompetent parents. Underlying the strip is an extraordinary sensitivity to the delicate depths of the child's mind.

In the first episode Henrietta is only three months old

Figure 35.
McCay, "Little Sammy Sneeze," New York *Herald,* January 1, 1905; © 1905.

Figure 36.
Lumière and assistants, *Le Repas de Bébé* (1895).

Winsor McCay

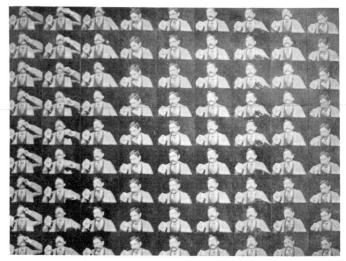

Figure 37.
W. K. L. Dickson, "Edison kinetoscopic record of a sneeze," *Harper's Weekly,* March 24, 1894; © 1894.

Figure 38.
McCay, "Hungry Henrietta," New York *Herald,* January 8, 1905; © 1905.

Before Mickey

when she is taken by her family to have a portrait made (figure 38). The baby sits naked and frightened in a basin for the cute Victorian picture. When she begins to cry, someone immediately suggests that she must be hungry. The last panel is a moving portrait of the little girl sitting with the bottle thrust in her mouth, a substitute for the warmth she needs. Throughout her life relatives continue to placate her with food instead of providing familial bonds. Soon she has become a compulsive eater—getting up in the middle of the night, for example, to devour all the pies in the pantry. The concluding strip showed Henrietta asleep under a tree after eating the family's whole picnic lunch. She is about eight years old and is already a plump, sad, alienated girl whose chances for future happiness seem rather dismal. The total effect of the strip is a subtle but damning comment on middle-class child rearing, and McCay's vision is closer to William Blake's view of childhood than it is to that of his contemporaries, such as Outcault or McManus.

Sammy and Henrietta forecast Little Nemo, McCay's heroic dreamer who was originally patterned after the artist's son Robert. The full-page "Little Nemo in Slumberland" depicted his adventures with King Morpheus of Slumberland, the Princess, and an assortment of sidekicks. Nemo's escapades in a world in which adult authority and rationality are alien elements were comparable in conception to Ravel's 1908 operetta *L'Enfant et les sortilèges,* but the scope is far grander. And the significance of the strip lies as much in its graphic execution as in its theme. The meticulous rendering of each image and the ingenious (even daring) arrangement of the newspaper page went far beyond the usual expectations of audiences and publishers. The strip continued in the *Herald* until 1911, when McCay signed with Hearst. He probably intended to continue it, but the *Herald* obtained an injunction and Little Nemo

Winsor McCay

would not reappear until 1924, during McCay's two-year return to the *Herald-Tribune*. In the meantime McCay was confined to single-panel cartoons in the Hearst papers. He remained active until July 27, 1934, when he succumbed to a massive stroke.

As the 1906 "Seven Ages" lightning-sketch vaudeville act demonstrated, Winsor McCay's interests were not confined to comics. Another theatrical venture was the Broadway production of *Little Nemo* (figure 39), a musical written by Harry B. Smith and scored by Victor Herbert. Producer Marc Klaw (of Klaw and Erlanger, also film producers) announced the project in the summer of 1907 and hoped that the operetta would "combine the qualities of fantasy and sentiment."[4] McCay was not an active collaborator, but he did sneak advertisements into his comic-strip panels. This event confirmed the characters' theatrical potential. Movies were the next logical frontier. According to McCay, "It came about in this way. Winsor Jr., as a small boy, picked up several flippers of 'Magic Pictures' and brought them home to me. From this germ I established the modern cartoon movies in 1909."[5] Knowing Blackton as a journalist and a neighbor, and perhaps seeing Cohl's films, might have been additional factors leading to his flash of insight.

Although we do not know the starting date of McCay's first film, the date of completion is certain: 1911. This corresponds to the cessation of the "Little Nemo" strip. Despite claims that he was using the completed footage in his vaudeville routine by 1909, contemporary reviews state clearly that when the act opened at Williams's Colonial Theater in New York on April 12, 1911, "the idea was being presented for the first time on any stage."[6] This same review corrects the erroneous report that a short all-animated version was used on stage: "On a screen the vitagraph shows pictures of Mr. McCay in company with

LITTLE NEMO'S DREAM!

Figure 39.
Scenes from the play *Little Nemo in Slumberland,* 1908.

Winsor McCay

several friends at a club. He is telling them of his new idea. . . . The artist . . . signs a contract, agreeing to turn out 4,000 pictures in one month's time for a moving picture concern." This accurately describes the prolog that still accompanies the film. There is also internal evidence that allows us to date the shooting of the prolog. In January 1911, *Motion Picture Story Magazine,* the first movie fan magazine, was launched "principally through the energy of J. S. Blackton."[7] To garner a bit of free publicity for the new Vitagraph publication, Blackton, who was directing the live-action sequence, placed editor Eugene V. Brewster in the group holding the latest issue aloft. Obviously the prolog (and probably the animation as well) was not photographed before 1911. Vitagraph issued this synopsis of the film:

One of the fellows asks Winsor why he has never been able to make moving pictures; he replies that he feels positive he can produce drawings that will move, and wagers that he will make four thousand pen drawings inside of one month that will move as actively and as life-like as anything ever produced by the camera, and surpass in their performance anything ever seen. His companions laugh at him and tell him he is getting foolish in his "noodle." One month later he has the four thousand drawings ready for the Vitagraph Company's camera and invites his club friends to come and see him make good. They arrive and he shows them drawings of some of the leading characters of his "Little Nemo" series. The cameraman turns the crank of the machine, and what these celebrated little cartoon characters do, would be more difficult to tell than what they do not do. The incredulous friends of McCay are surprised and puzzled.[8]

When McCay finished his drawings (probably in late 1910) and brought them to be photographed, he encountered some of the same problems that had plagued Cohl and would haunt other animators. The thin rice paper he

had used for retracing each sequential image had cockled when the ink wash was applied. The sputtering arcs necessary to provide light for the slow film emulsion caused flickering because of their inconsistent illumination. Nevertheless, when the footage was developed the drawings moved, and McCay considered it a success. Vitagraph released it on April 8 (figure 40), and a few days later McCay used it during his act at the Colonial. Today the film is generally known as *Little Nemo*.

McCay never was inclined to modesty—the title card read

Winsor McCay, the Famous Cartoonist of the New York Herald and his Moving Comics
The first artist to attempt drawing Pictures that will Move
Presented by the Vitagraph Corporation of America.

Among the congenial skeptics pictured in the prolog was Vitagraph's star John Bunny, considered an extra box-office draw.

In the film, McCay draws Nemo, Impy, and Flip on a sketchpad in lightning-sketch fashion (figure 41). His friends offer him a drink, but McCay makes a grand display of preferring water. (This was no doubt a private joke; McCay was hardly a teetotaler.) Next comes a hilarious scene in which workers roll barrels of India ink and bales of drawing paper into a studio (a stage set) where McCay is hard at work on stacks of drawings. He even demonstrates his homemade Mutoscopelike device for flipping the drawings on a large rotating drum. Bunny pays a visit and the projectionist starts the film within the film. Flip's outline draws itself by means of stopping the camera between strokes of the pen—Blackton's old trick. Then McCay's hand draws Flip and slides the drawing into a holder, the same one used to clamp the drawings upright during the actual photography. The camera tracks forward until the

Winsor McCay

Figure 40.
Advertisement for *Winsor McCay* (*"Little Nemo"*), New York *Dramatic Mirror,* March 29, 1911.

Before Mickey

edges of the holder disappear beyond the frame. The caption "Watch Me Move" is emblazoned above Flip's head, and he begins to roll his eyes and chomp his cigar—tentative movements suggesting that he is gradually awakening to his new kinetic abilities. Judith O'Sullivan has aptly characterized the remainder of the film as "abstract animism," and it is true that the four-minute sequence exploits movement for its own sake in a highly exploratory way.

Little Nemo materializes from a swirl of moving dots and, like a magician, stretches and compresses the bodies of Impy and Flip. Then he seems to become the artist's alter ego, and picks up a crayon to make a lightning sketch of a princess (his own Galatea), who comes to life. A flower grows from the lower edge of the frame, its complete growth accelerated so that it buds and matures just in time for Nemo to pick a blossom for the princess. Together they ride away in the mouth of a crawling dragon whose body diminishes in perfect mathematical foreshortening as it recedes from the picture plane toward the horizon. Impy and Flip ride up in an exploding car. The animated sequence ends with the camera tracking away from the final drawing, again revealing the holder containing the last image and providing narrative closure.

Among the early viewers of *Little Nemo* was Emile Cohl. He was still working at Pathé in France when Vitagraph released the film as *Le Dernier Cri des dessins animés* in June 1911,[9] and he wrote the following in *Ciné-Tribune*: "I recall perfectly that Zecca, Pathé's director of production, called me specially to Vincennes to show me McCay's first film when it had just arrived."[10]

Cohl must have been aware of the probable debt to his Gaumont films, as when McCay borrowed his metamorphic sequence code. But Cohl must also have realized that, although McCay used essentially the same retracing technique, his graphic conception was totally original. The

Winsor McCay

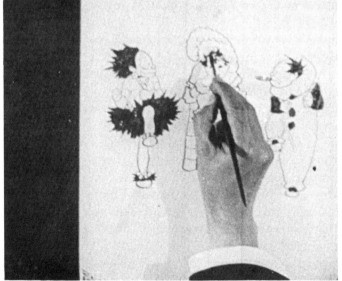

Figure 41.
McCay, *Little Nemo* (Vitagraph, 1911).

Before Mickey

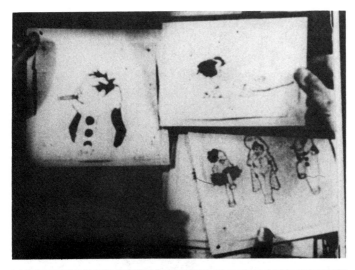

Figure 41, continued.
See also following page.

Winsor McCay

Figure 41, continued.

Before Mickey

American had audaciously transposed his comic-strip characters without sacrificing linear detail. The short sequence had obviously required months of fine drawing, but the reward was that the characters moved as lifelike solids in three-dimensional space. Although there are no backgrounds, McCay's intuitive knowledge of perspective projection had enabled him to foreshorten the moving figures with photographic accuracy as they moved in and out of illusionistic depth. Present-day audiences still gasp when the dragon-chariot grows progressively smaller as it recedes, swishing its serpentine tail. Early viewers were similarly astonished. One wrote ". . . indeed, after watching these pictures for a while one is almost ready to believe that he has been transported to Dreamland along with Nemo and is sharing his remarkable adventures. . . ."[11] The same reviewer was quick to point out the opportunity to exploit the film as a tie-in with the strip: "It should be popular everywhere. It is one of those films which have a natural advertising heritage in the great and wide popularity of its subject. Little Nemo is known everywhere."

McCay was so pleased that he began a second cartoon, to be called *The Story of a Mosquito*. Again the animated footage was introduced by a live prolog (which has been lost). In it,

Windsor McKay [*sic*] is in his summer home in Jersey with his daughter and they are pestered to death by mosquitoes. It is by accident that the artist happens to meet a professor, who says that he is studying the language of the mosquito and knows all about them. He suggests that the artist make a series of drawings to illustrate just how the insect does its deadly work. So McKay sets to work and several months later the two of them go to a moving picture studio to see the finished work on the screen.[12]

In the surviving footage the mosquito startles us with his vampirish appearance (figure 42). His spiny wings, sharp

Figure 42.
McCay, *The Story of a Mosquito* (Vitagraph, 1912).

Before Mickey

proboscis, and stiff legs are quintessentially "insectlike," suggesting a combination of a mosquito, a cockroach, and a spider. However, he is more comical than menacing because he is also wearing a top hat and carrying a carpet bag. *The Story of a Mosquito* simulated the montage of a live-action film, with changes in scenes and points of view. After the introduction of the mosquito, whom McCay called Steve, there is a shot of a fat man in a nightgown approaching a bedroom door. The animator has him pause and pivot several times, an economy planned to obtain the maximum footage from the drawings. The naturalism of the scene is remarkable not only for the anatomical accuracy of the drawing, but also for the realism of the man's movements, down to his moving shadow as he enters the room and closes the door. The stalking mosquito is too large to pass through the keyhole, so the "camera angle" is shifted to show him entering through the transom.

Steve makes repeated forays into the skin of the sleeping man, shown in an unnerving extreme closeup. The viewer's response is one of approach and avoidance: We are attracted to the cleverness of the drawing and the suppleness of the animation, but repulsed by the visceral nature of the humor. The microscopic views of the man's stubbly fat neck and his grotesque eyeball create a sense of excessive closeness. When the mosquito draws blood, we see it flow into his transparent abdomen. Our reaction to the penetration of the man's porcine flesh by the sharp beak is not unlike our discomfort during the famous eyeball-slicing scene of *Un Chien andalou*. McCay also successfully gives us a subjective representation of how the sleeper might picture his buzzing tormentor by greatly distorting the scale; Steve seems to be about three inches long. There is certainly a disconcerting Freudian aspect to this image of compulsive vampirism. The mosquito is only satisfied when his beak is inserted all the way to the hilt, enabling him to

Winsor McCay

engage in such an orgasmic frenzy of blood lust that he becomes dangerously engorged and explodes. Parts of his body and his feast of blood bathe the screen.

This grimly humorous film was again drawn by the re-tracing method. Backgrounds were not used, but the illu-sion of stability was created by including static props (the bedroom door and the pillow).

The Story of a Mosquito was produced and photographed by Vitagraph, but McCay did not allow the studio to dis-tribute the film in the United States, where it would com-pete with his vaudeville act. He toured with it in the spring and summer of 1912, and when he played New York's Hammerstein Theater "the moving pictures of his drawings . . . caused even film magnates to marvel at their cleverness and humor." [13]

McCay's anecdote that audiences thought the drawings were moved by wires hardly seems credible, but it provided him with a good introduction for *Gertie,* his next project. Bringing an extinct dinosaur to life should allay all suspi-cions about wires. This third and most memorable film became the enduring masterpiece of pre-Disney animation.

This time a static background was added to the compo-sition. McCay's young neighbor John A. Fitzsimmons was assigned the nerve-wracking chore of tracing the unchang-ing landscape background onto each and every six-by-eight-inch sheet of paper. [14] Initial plans were announced in 1912, and the drawings were in progress during the run of Cohl's "Newlyweds"—a competitive incentive. The draw-ings were photographed in the Vitagraph studio in early 1914. McCay presented the film on the stage of the Palace Theater in Chicago on February 8, 1914. Reviewer Ashton Stevens was moved to write: "Thus the camera, that George Washington of mechanism, at last is proved a liar." [15] The film was copyrighted on September 15, 1914. *Gertie* was intended to become part of the vaudeville act, like the

previous two films. McCay performed with it in New York,
where Emile Cohl watched it avidly just before departing
for Europe. As Cohl later recalled,

Winsor McCay's films were admirably drawn, but one of the
principal causes of their success was the manner in which they
were presented to the public. I remember one of the first public
presentations at the Hammerstein Theater in New York. The
principal, in fact, the only performer in the film was an antedi-
luvian beast, a kind of monstrously large diplodocus. In the be-
ginning the picture showed a tree and some rocks. On the stage,
before the screen, stood the elegant Winsor McCay, armed with
a whip and pronouncing a speech as though he were the ring-
master of the circus. He called the animal who loomed up from
behind the rocks. Then it was like exercises in horsemanship,
with the artist always in control. The animal danced, turned, and
finished by swallowing the trees and rocks then curtsying to the
audience which applauded the work of art and the artist at the
same time. It was lucrative for McCay who never left the theater
without stopping by the cashier to be laden with a few banknotes
on the way out.[16]

Richard Huemer and Robert Winsor McCay recreated the
act for an episode of the "Disneyland" television program.
It correctly showed McCay's impersonator standing at the
lower right of the screen to coordinate his gestures and
monolog with Gertie's motions. When McCay rewarded
Gertie by tossing her an apple, for instance, she appeared
to catch it in her enormous mouth just as the real prop
went behind the screen.[17] In the triumphant finale, McCay
would disappear behind the screen just as Gertie seemed
to scoop him up on her head. Then the beast would exit
screen right with a little animated Winsor McCay cracking
his whip upon her back.

For some reason McCay's success on stage raised the ire
of his employer, William Randolph Hearst, who invoked

the exclusivity clause of his contract. McCay agreed to restrict his performances to New York City. Effectively, though, the artist's vaudeville career was finished. This must have hurt him deeply; since he had been enjoined from continuing "Little Nemo" in 1911, work on his animated films provided a release for this compulsive draftsman's enormous energies, as well as consolation (and considerable compensation) for the loss of his favorite strip. He probably viewed his stage career as a means of keeping his reputation alive. Fortunately, William Fox (of the future Twentieth Century–Fox) was just emerging as a major producer-distributor and had formed Box Office Attractions in January. In November, McCay accepted Fox's offer of "spot cash and highest prices," and this announcement was made:

Box Office Attractions has arranged to market "Gertie the Dinosaurus." The subject has been in constant demand by vaudeville managers. The film got $350 for one week at the Palace Theater New York, the best house on the United Circuit. It is the biggest figure ever paid for a single reel attraction. . . . McCay has set a new pace with his hand-drawn film of a trained "Dinosaurus" which he prosaically calls "Gertie." This film achievement is a new departure in the industry as well as in art.[18]

For this moving-picture theater version, McCay filmed another prolog and replaced the stage patter with intertitles. Present in the film are several of McCay's cartoonist friends, including Tad (Thomas A. Dorgan), Tom Powers, Roy McCardell, and George McManus. This array of Hearst artists is itself intriguing. If the prolog was filmed before McCay's feud with Hearst, then their appearance was probably just for extra publicity. But if the prolog was shot later, then their presence might indicate a show of solidarity among the Hearst cartoonists. The shooting date is not known.

Before Mickey

The animation is once again introduced by the fictive device of a bet. While viewing the brontosaurus skeleton at the Museum of Natural History, McCay wagers that he can bring the beast to life in moving drawings. As in his first film, there are shots of him hard at work. McManus drops in and provides the opportunity to explain the system. We see some of the sheets being photographed, still positioned vertically as in *Little Nemo*. When the "10,000 drawings, each a little different from the one preceding it" (as a title identifies them) are done, the friends reconvene in a restaurant to watch the results (figure 43). McCay lightning-sketches the prehistoric landscape on a large pad and calls the dinosaur out of her cave by name; then the animation begins.

The brontosaurus emerges, shy at first and aware of the audience, but she quickly warms up to the performance. Her personality is a cross between a trained circus elephant and a frisky puppy. Gertie is tame, but not domesticated. She even snaps at McCay when he tries to get her to salute the audience. Perhaps in his conception of this lovable but cantankerous creature McCay was influenced by Maud, Opper's comic-strip mule with an equally prosaic name and stubborn disposition.

McCay's ability to simulate natural movement was uncanny. Gertie's ponderous weight is suggested as she shifts rhythmically back and forth on her feet. When she kneels to drink, the ground sags beneath her enormous mass. We see her abdominal muscles work to suck in the water, as her stomach slowly expands. The up-and-down rhythm of her breathing can be seen when she lies on her side. Anthropomorphic qualities contribute to her personality, as when she daintily scratches an itch with the tip of her agile tail. In minutes McCay convinces the audience that he has resurrected a tangible and lovable animal—a triumphant moment for the animator as life giver.

Winsor McCay

Figure 43.
McCay, *Gertie* (Box Office Attractions), © 1914. **a:** McCay and
George McManus. **b:** McCay at sketchboard, **c:** Gertie meets
Jumbo.

Before Mickey

Winsor McCay

Hearst problems were probably the cause of the hiatus between the completion of *Gertie* in 1914 and the announcement of the next film in mid-1916. Like many people, McCay was shocked by the sinking of the passenger ship *Lusitania* in 1915, and he decided to depict the event in animation since there was no photographic record. The impulse was remarkably similar to Griffith's historicism in *Intolerance*. Working with patriotic fervor, McCay and Fitzsimmons flew into the thousands of drawings required for the task. *The Sinking of the Lusitania; An Amazing Moving Pen Picture by Winsor McCay* was released in July 1918, and differed from the films of the earlier period in several respects. Its documentary character called for a more realistic graphic style, so the detailed crosshatching, the washes, and the spatter techniques of the Hearst editorial illustrations were used. Technically, it was McCay's first attempt to use cels. The animated sequences were conceived as alternating shots to simulate the editing style of the newsreel subjects typical of the Universal Weekly, in which the film was included.

After identifying McCay as the "originator and inventor of Animated Cartoons," a Mr. Beach brings him a large painting of the ship. McCay says it will take 25,000 drawings. In the next shot we see him in his famous working hat supervising a crew of six assistants, one of whom is flipping through a bound volume of sheets to check the motion. "From here on you are looking at the first record of the sinking of the *Lusitania*," a title announces as the vessel steams past the Statue of Liberty, rendered in hazy atmospheric perspective. A stage curtain closes on the scene, indicating the passage of time. The next shot shows a German U-boat surging through the waves directly toward the audience. In the upper half of the picture, a cel provided the background of painted clouds.

The alternating long shots of the smoke billowing from

the ship and water-level closeups of the victims leaping from the deck and forming human chains before falling to their death make this film truly horrific. The smoke (figure 44) forms art nouveau arabesques and a fleeting skull-like outline. The tiny bodies twist and turn frantically as they plummet into the water. A block and tackle from the sinking ship swings directly in front of the "camera" to establish the illusionistic distance and the huge scale of the drawing, as well as adding a touch of verism. At the end there are pathetic shots of children bobbing in the waves, the Union Jack going under, and—most awful—a mother and her baby sinking into the depths with the camera following their helpless descent. After these scenes comes the bitter final title: "The man who fired the shot was decorated by the Kaiser and yet they tell us not to hate the Hun."

There are few details about McCay's film career in the late teens. Undated fragments of three films (*The Centaurs, Flip's Circus,* and *Gertie on Tour*) remain, but they do not appear to have been released. In 1921, Robert McCay assisted on a "Dreams of the Rarebit Fiend" series. All three films suffer from clumsy use of cels, but the fantastic scenarios and the drawings themselves are still brilliant.

The best of these late works is *The Pet*. Colonel and Mrs. B. have retired for the night, and the gentleman expresses the hope that the rarebits he ate will not keep him awake. The dream begins with an adorable Pooh-like creature meowing outside a door. Mrs. B. takes it in, bathes it, ties a ribbon on it, and lets it play in the yard. In every shot the animal is a little larger, but its growth is barely perceptible. Soon the mother has adopted the pet as a surrogate baby, even tucking it into a crib for the night (figure 45). By morning it has grown as large as a calf, and it swallows the family cat. When the beast devours everything on the table, the colonel goes to the pharmacy to buy a barrel of "Rough

Winsor McCay

Figure 44.
McCay, *The Sinking of the Lusitania . . .* (Universal-Jewel), ©
1918.

Before Mickey

Figure 45.
McCay and Robert McCay, *Dream of a Rarebit Fiend: The Pet*
(1921).

Winsor McCay

on Rats." Meanwhile the monster is gobbling up the furniture and a bin full of coal. The "Rough on Rats" only brings out a rash of disgusting boils on the hide of the rhinocerous-sized thing. As big as King Kong, the pet marches through the streets of the city, and McCay follows its progress with a remarkable "panning" shot. Finally planes fire upon it. Like the mosquito of a decade earlier, it explodes, and its parts rain upon the city.

Bug Vaudeville animates a menagerie of insects who invade the dream of a sleeping hobo. Perhaps McCay was influenced by some of the Russian animator Starevich's insect films. *The Flying House* (figure 46) has husband Bertie protesting the foreclosure on his home by building a giant gasoline engine in the attic. By adding a propeller and using the porches as wings, he and his wife fly up and away, over Grand Central Terminal, knocking a water tower down on a temperance rally. When the house departs the Earth for the remoter regions of the galaxy (presumably free from debt collectors), McCay inserts a surprising announcement: "To Teachers and Students—Special attention is called to the remarkable piece of animation which follows.—The Earth and Moon revolving on their orbits in the firmament drawn true to astronomical calculations with the beautiful constellation of "Orion" in the foreground. —The Management." As promised, the Earth recedes in scale as the moon grows larger. The Man in the Moon tries to slap the house with a giant swatter.

McCay's post-1915 work is full of flashes of richness, but one senses a schism in his career as a whole. The cel animation made after *Gertie* simply does not have the graphic fascination of the earlier retracing work, which, despite its reputation in the twenties and thirties as primitive and unstable, now seems energetic and vital and not at all immature or out of keeping with its subjects. McCay's restless moving lines are part of the excitement of the films.

Before Mickey

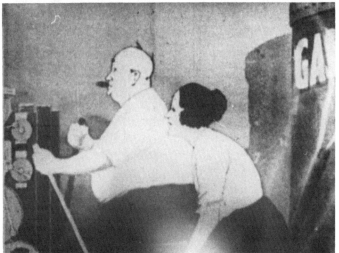

Figure 46.
McCay and Robert McCay, *Dream of a Rarebit Fiend: The Flying House* (1921).

Winsor McCay

But perhaps the explanation for the schism goes beyond technical considerations. In his pre-1915 cartoons the spectator still experiences an awareness of the lightning sketcher. The films were conceived as, and worked best as, stage presentations. The filmed prologs were essential for reconstructing the presentational context of the films. This personal quality is lacking in the films made after the end of McCay's vaudeville career.

But even if Hearst had not been successful in limiting McCay's live appearances, history would have had the same effect. "By the mid-teens," according to historian Robert C. Allen, "big-time vaudeville had lost its position as premiere American popular entertainment form—that place taken by the motion picture." [19] The very popularity of McCay's film *cum* live performance might actually be read as a symptom of the decline of pure stage vaudeville. It was apparently the spark of excitement caused by physical contact with an audience and the opportunity to inject his own charismatic personality into his films that originally attracted McCay to animation. This physical involvement is precisely what is missing from the later works.

This is not to undermine the greatness of McCay's achievements, not the least of which was to strengthen the bond between popular graphic art and animation. His films were initially promoted on the strength of his widely recognized name, and by including shots of his cartoonist friends he affirmed the appropriateness of animation as an activity for comic-strip artists.

McCay never strayed far from his own graphic work when he made films. In making *Little Nemo* he relied so much on his earlier strips for inspiration that it is possible to trace the images in the film back to specific sources. The costume in which Nemo was dressed was the one he wore "resplendent in gold lace, plumes, velvet and spangles" in an adventure that began in the *Herald* on April 1,

1906.[20] The film's Impy character was introduced to the strip in May 1907, but evolved from the earlier Cincinnati work. Dr. Pill's exploding car was taken from a May 3, 1908 episode. When Nemo causes the bodies of Impy and Flip to stretch as though reflected in distorting mirrors (figure 47) McCay is borrowing an idea from a February 2, 1908 installment, which itself came from a "Dream of the Rarebit Fiend." (However, elastic bodies were part of a much older tradition, extending back to Tenniel and Grandville; see figure 48.) The spectacular dragon-chariot is the same one that crawled through three consecutive installments of "Little Nemo" during the summer of 1906 (figure 49).

"Jersey skeeters" were frequent visitors to the monologs of vaudeville comedians and to the comic strips. A 1907 *Judge* cartoon (figure 50) showed their basic characteristics: huge, lean and hungry, toughened by life outside the tourist hotels of Atlantic City and in the Catskills. Just such a mosquito made two appearances in McCay's comics (figure 51) before *The Story of a Mosquito* was shot. One of these strips anticipates the plot of the film when the mosquito creeps through a keyhole to indulge in a drunk's blood. The composition of each frame, with the man's face filling the foreground and the background suppressed, looks forward to the movie. In another, a mosquito who resembles Steve bores into a sleeping man's neck to an impossible depth and sucks his insides out. Although compositionally unrelated to *The Story of a Mosquito,* it shares the film's vision.

Even Gertie had ancestors in the comic strips (figure 52). McCay announced in 1912 that the American Historical Society had asked him to draw pictures of prehistoric animals, but the idea had actually occurred to him years before. In a 1905 "Dream of the Rarebit Fiend," a galloping brontosaurus skeleton entered a horse race. By the time work on the film began, the dinosaur's next of kin was

Winsor McCay

Figure 47.
a: McCay, *Little Nemo* (Vitagraph, 1911), **b:** Detail from "Little Nemo in Slumberland," New York *Herald*, February 2, 1908; © 1908. **c:** detail from "Dream of the Rarebit Fiend," New York *Evening Telegram,* © 1905.

Winsor McCay

 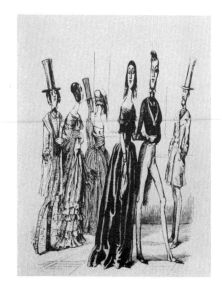

Figure 48.
a: Sir John Tenniel, *Alice's Adventures in Wonderland,* 1865. **b:** J.-J. Grandville, *Un Autre Monde,* 1844.

Figure 49.
Detail from McCay, "Little Nemo in Slumberland," New York *Herald,* July 22, 1906; © 1906.

Before Mickey

Figure 50.
Detail from Zim, "Jersey Skeeter," *Judge,* August 24, 1907; © 1907.

Winsor McCay

Figure 51.

a: McCay, "Dream of the Rarebit Fiend," circa 1910, from *Dream Days*. **b:** "Midsummer Day Dreams," circa 1910, from *Dream Days*. Courtesy of Bill Blackbeard.

already fleshed out in a May 25, 1913 *Herald* page. The late works too depended on comic-strip prototypes for inspiration. The scenario for *The Pet,* for instance, was adapted from a 15-year-old "Dream" in which a puppy grew into a fearsome indestructible monster.

In addition to specific iconography, McCay's films were invested with their comic-strip precursors' remarkable reflexiveness. The almost obsessive desire to reveal the mechanics of animated photography to the audience recalled McCay's frequent playful undermining of the conventions of comic-strip art. The border outlining the panels had been exploded by sneezes, ignited by "hot" clothing, and used for a tightwire (figure 53) by McCay's characters. When Nemo, Flip, and Impy were locked out of Slumberland in December 1907, and were very hungry, they ripped up the border lines and used them to knock down the letters of the masthead (figure 54). Flip says "that will teach the fellow who draws us a lesson," and Nemo responds that he is "hungry enough to eat the whole [comic] supplement." McCay conceived these jokes in the spirit of fun, but in addition to inadvertently showing his egotism by reminding the readers of his presence, the reflexive qualities also strike us as very modern distancing effects analogous to contemporaneous cubist strategies.

When this sensibility was applied to filmmaking, the result was an extraordinary materialist conception of animation. Repeatedly we are told, in the advertising and in the films themselves, about the thousand of drawings and the hours of labor required for each cartoon. It is this affinity for revealing the means of production that distinguishes McCay from the first generation of trickfilm artists. Méliès, Merry, Booth, and Blackton were adamant in refusing to divulge the secrets of animation—an attitude completely alien to McCay. Rather than figuring himself as a nineteenth-century stage magician, McCay represents

Winsor McCay

a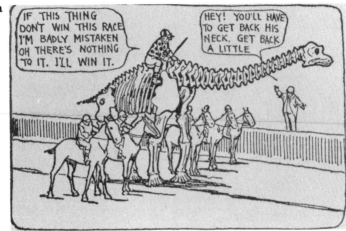

Figure 52.
a: Detail from McCay, "Dreams of the Rarebit Fiend," New York *Evening Telegram,* 1905; © 1905. **b:** "Dream of the Rarebit Fiend," New York *Herald,* May 25, 1913; © 1913.

b

Winsor McCay

Figure 53.
McCay, "Midsummer Day Dreams," circa 1910, from *Dream Days.* Courtesy of Bill Blackbeard.

Before Mickey

Figure 54.
Detail from McCay, "Little Nemo in Slumberland," New York
Herald, December 1, 1907; © 1907.

Winsor McCay

himself as a modern technician. He is the twentieth-century man ingenious enough to put the complex apparatus of animation cinematography at his service. His self-aggrandizing plots attempt to ally him with scientists: paleontologists, entomologists, and astronomers. The convention of the wager, which he used several times, was the perfect device for McCay's self-figuration, showing him first accepting the challenge and then performing the superhuman task of picturing something impossible.

After McCay's death in 1934, his reputation skidded into obscurity until the revival of his work and the rediscovery of his films in the late 1960s. However, other early filmmakers remembered his pioneering role in animation. For many animators in the silent period, *Gertie* had revealed the possibilities of the medium. It must have seemed like an almost unattainable paradise. Even Buster Keaton paid homage to McCay, in his 1923 film *The Three Ages*. He asked his writer, Clyde Bruckman, "Remember *Gertie the Dinosaur?* . . . The first cartoon comedy ever made. I saw it in a nickelodeon when I was fourteen [*sic*; he was at least nineteen]. I'll ride in on an animated cartoon." [21] So in a sequence of *The Three Ages* made using clay models, an animated Buster makes his entrance on the back of an animated Gertie-like brontosaurus.

McCay's graphic art set a standard for later animators. Even after the cel system had abolished the retracing method, with its kinetic subtleties and suppleness, McCay's influence was still visible throughout the first years of studio animation in the predilection of artists for clear black lines on white backgrounds. The "New York style" superficially reflects the direct transposition of domestic comic-strip graphics onto film, but it is at the same time a vestige of *Gertie*'s clean, crisp, high-contrast outlines.

McCay's propensity for closed forms and trompe l'oeil illusionism—a final contrast to Cohl's tendency toward

openness and linear abstraction—virtually defined the aes-
thetic ground rules for all later American animation, setting
it apart from work done in Europe. This is profoundly con-
sistent with the traditional concerns of American artists in
general for solidity, pragmatism, and pictorial realism.

Winsor McCay

The Henry Ford of Animation: John Randolph Bray

For the first animators, making drawings and objects move on the screen was an act of curiosity and a labor of love. Neither Cohl nor McCay hesitated to plunge wholeheartedly into the onerous task of making thousands of drawings, cutouts, and assorted props. Both used mechanical shortcuts and photography assistants, but fundamentally they conceived of animation as an artisanal enterprise.

With the resourcefulness that film distributors have always displayed, they at first attempted to turn an economic liability into an advertising asset by exploiting the number of individual drawings cartoons required and by exaggerating the time it took to make them. Privately, though, these distributors must have had little faith in their marketing approach; the novelty could not last long or compete with the single-reel comedies the studios were releasing weekly or biweekly. Until cartoons could match this regularity, it was difficult to see how large-scale production could be feasible or even desirable.

But in the optimistic atmosphere of pre–World War I America—in which there seemed to be a technological solution to practically every problem—such a situation fairly cried out for an innovative and efficient organizer, a Henry Ford of animation. The role was filled by John Randolph Bray (figure 55).

Bray's reputation as the man who stripped animation of

Figure 55.
John Randolph Bray, 1917.

Before Mickey

all its individuality and artistic interest, putting the Cohls and McCays out of business, was undeserved. But, like Ford, he did revolutionize a fledgling industry, and he inexorably changed the lives of those associated with it. Bray liked to picture himself as a hard-headed, conservative businessman. Teddy Roosevelt was his idol. Although he has been alternately neglected and disparaged by historians, his detractors have not taken into account the times in which he lived, when progressivism and big business, philanthropists and robber barons, went hand in hand. Bray's technical and organizational innovations must be understood in the light of the industrial ideology of the day.

Born in 1879 to a minister's family in Addison, a small Michigan farming town, he led a quiet, almost reclusive life and remained aloof from his closest associates. Decidedly not extroverted like McCay, he was by no means a romantic solipsist like Cohl either. But like them both he was a journalist by training, a gifted and proficient draftsman by talent, and an ambitious achiever by inclination. Around the age of 20, after an unsuccessful attempt at college, Bray began a pedestrian job at the Detroit *Evening News*.[1] One of his assignments, reconstructing sensational accidents by studying the cadavers in the morgue, convinced him that he would never be a reporter. He gladly yielded to the allure of New York's great papers. In 1903, the Brooklyn *Daily Eagle* offered him a staff position. Soon afterward he married a young well-educated German immigrant named Margaret Till who was working as a translator at Columbia. Bray struck an interesting "deal" with his aggressive, independent-minded spouse: "I decided to go in for myself [to freelance], so I asked my wife if she objected. She said no. I said, well, I won't know if I'll make any money or not for a year or so, and she said 'that's all right; I'll get a job and we'll work together.' So she got a job for one year, and I started on my free-lance work. . . .

John Randolph Bray

I didn't get along very well for the first year, but after that I was all right."[2]

Margaret Bray exemplified the platitude that "behind every great man there's a woman." She would become an important but unacknowledged force in Bray's career after he turned to the movies. This early boost gave her husband the independence he needed to establish himself as a leading New York illustrator and graphic humorist. His break came in 1906 when *Judge* began publishing his one-panel animal jokes, frankly drawn in imitation of *Life*'s T. S. Sullivant.

On February 9, 1907, Bray's full-page comic strip "The Teddy Bears" made its debut (figure 56). The format recalled the design of European *imagerie populaire,* with six symmetrical panels and captions in rhymed quatrains. The rendering was as precise as McCay's contemporaneous work, but radically opposed to McCay's conscious avant-gardism. Bray's bears were drawn in the tradition of the best Victorian children's illustration, and were anthropomorphized by placing them in veristic surroundings where they acted out their uncomplicated stories. Johnny, the boy, was similar to any number of comic-strip heroes. The bears were spinoffs from the teddy-bear craze, which Roosevelt had inspired around 1903. The editors were openly pleased by their readers' response:

Bray's Teddy Bears have made a real hit with *Judge*'s younger readers—and what the young folks like the older folks generally like too. We appreciate the many friendly letters we have received, some offering suggestions, and all testifying to the amusement Johnny and his animated pets have created. More than one little girl, one a little invalid, has written to inquire where the "wonderful compound" can be had, so that they can bring their Teddy Bears to life. Mothers write telling of the pleasure their children find in the pictures.[3]

Before Mickey

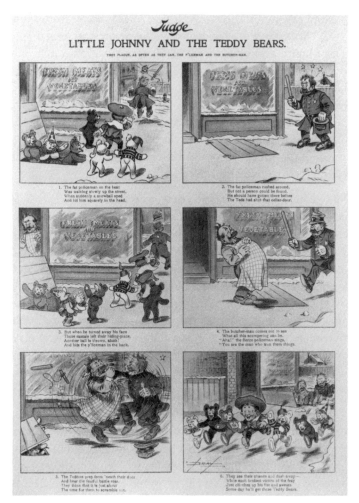

Figure 56.
Bray, "Little Johnny and the Teddy Bears," *Judge,* © 1907. Courtesy of the Bray Studio.

John Randolph Bray

Now prosperous, Bray was able to live away from New York City on a farm he had purchased in Highland Falls. The quality and style of his work seemed immutable, but the number of Bray's contributions declined steadily—perhaps an indication that his endeavors were being engaged elsewhere, possibly in a new project in which the teddy bears really were animated. As part of his preparation, he observed the movements of real bears at the Bronx Zoo.

An early source reveals that Bray's new interest was sparked by a specific film:

John Randolph Bray, whose name now [1917] is a household word wherever the motion picture has reached—and that means everywhere—conceived the idea of animating drawings through a chance visit to one of the great department stores of New York. At that time Teddy Bears were the popular toys for children, and in this store a motion picture film was being exhibited showing these cute little fellows doing funny stunts. Now Mr. Bray had attained a reputation for his drawings of Teddy Bears and while watching this film it suddenly struck him that if the toys could be animated then why not drawings. That very night he started experiments in the little studio he had fitted out in his farmhouse near Poughkeepsie.[4]

This film was, of course, Porter's The "Teddy" Bears. It circulated long after it was released in 1907, so the date of Bray's chance viewing cannot be determined, and the above article is ambiguous as to whether his comic strip was still running at the time. Later Bray would usually give 1910 as the date of his first experiments. However, evidence suggests that 1912 was a more likely starting time. This trade-journal source also indicates that Bray's first attempts failed and that many fruitless experiments followed:

Success did not attend his efforts quickly, for he had no knowledge of motion picture photography, but he set to work to over-

Before Mickey

come that obstacle. After several weeks of tireless effort the artist
began to realize that he was up against a problem, which if he
were to continue along the line on which he had started, would
require the lifetime efforts of a Methusalah. For he had learned
that each foot of motion picture negative contained sixteen sep-
arate pictures and that to make a film 1,000 feet long would
apparently require 16,000 separate pictures to be drawn. As the
Teddy Bear series contained from seven to ten characters, Mr.
Bray figured out that in order to animate his series it would
require 7 × 16,000 or 112,000 different figures—each drawn with
the most expert and painstaking care—to complete this film. He
also found that after all this had been accomplished he would
have to set each drawing in its proper place under the camera
and photograph it into the film, one exposure at a time, until the
entire 16,000 exposures had been made.

Bray never again mentioned this abortive project. The ar-
ticle goes on to recount his eventual enlightenment in a
wonderfully matter-of-fact tone: "Mr. Bray set about to
evolve processes for eliminating this prohibitive mass of
detail effort and to make the animated cartoon a commer-
cially practical proposition. After many months of patient
effort, he finally evolved a film that, while far from perfect,
yet was sufficiently well done to indicate that he was on
the right track." This film, *The Artist's Dream,* is usually
dated 1910 or 1911, but it was uncharacteristic for Bray or
his distributor Pathé to withhold a potentially lucrative
item. It was not released until June 12, 1913, and there is
no reason to believe that it was completed much in advance
of that date. In his interview with Canemaker (ref. 1) Bray
recalled: "Winsor McCay had made two cartoons, I think,
before I did, and he had good animation. But he only used
them on the vaudeville stage. . . ." This memory, probably
accurate, confirms that Bray had seen McCay's methods
demonstrated in *Little Nemo* in 1911 and/or in the stage

version of *The Story of a Mosquito* in 1912. Furthermore, in an autobiographical letter (now in the Museum of Modern Art collection) written in 1967, Bray mentions having seen *Gertie* around 1910. That was impossible, but he may well have seen McCay's other cartoons.

The Artists' Dream is no longer distributed, but prints exist in several archives. Bray himself appeared as the sketch artist, Charles Heckler. We see him at his easel in the conventional pose, drawing a chest of drawers with a dachshund sleeping next to it. A plate of sausages rests on the chest. A woman, played by Margaret Bray, lures the artist to a wild party. The dog comes to life and reaches the sausages by pulling out the drawers to form steps. After gorging on the sausages, the dog finally meets Steve the mosquito's demise by exploding.

Bray took the completed negative to the Erbograph Laboratory in the Bronx. The proprietor, Ludwig Erb, suggested that the animator take his novelty to Charles Pathé, who happened to be visiting the United States. As Bray recalled, ". . . my wife and I took it over to show it to him, and he was to leave for Paris the next day. But he saw it. And he got so excited about it that he wanted to get a lot more of them right away quick. He signed a contract with me right away and stayed over another week to do it. He signed a contract with me for everything I could produce which was one a month." Pathé's contract was characteristically demanding: six films to be delivered in six months. Since it had probably taken that long to produce *The Artist's Dream,* Bray's processes would have to be quickly perfected and streamlined. He was forced to make decisions affecting four crucial areas. First, conventional means of producing the animation units must be discarded or modified. He would implement a technique he had experimented with in *The Artist's Dream.* Second, he would have to abandon individual control over production and mete out

the work to assistants—in other words, establish division of labor. Third, the process should be protected by a patent. The idea occurred to Bray (or to Mrs. Bray) that animation could be monopolized by their improved technique, so formal claims were filed. Fourth, improved means of distributing and marketing the product were devised. Each of these decisions had its own consequences.

The animation in *The Artist's Dream* was a hesitant mixture of techniques. One in particular seemed to alleviate the chore of retracing, and it was an outgrowth of Bray's experience in journalism (specifically, photoreproduction): Instead of retracing the background of the composition, Bray had the idea of printing it. Contrary to the prevailing notion (fostered by the artist), this original process did not involve celluloid. Bray's first patent (1,107,193; figure 57) provides a highly detailed description of how the original layout was copied "by ordinary zinc etching." Hundreds of identical sheets were printed on tracing paper, with the center of the picture left blank. Then the moving elements were added by conventional retracing. These figures could be made to obscure the printed background lines either by opaque inking-in or by erasing the overlapping areas on each sheet. Crossmarks, such as those used by printers to align color plates, were added to the margins to facilitate registration.

Bray and his attorneys were clearly intent upon filing an all-inclusive claim, so they incorporated into this extraordinary document every known animation method, thus defining for us the state of the art in 1913–1914. Bray described, for example, how tracers could be used effectively: "The artist may only sketch in pencil the portions which actually change position or expression in successive pictures while the portions which do not move through a series of several pictures may be traced by assistants or

John Randolph Bray

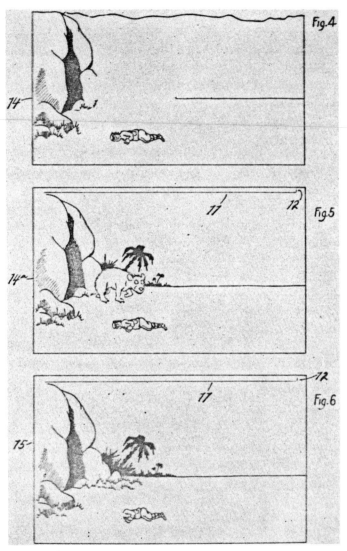

Figure 57.
Bray, U.S. patent 1,107,193 (detail).

Before Mickey

copyists." He claimed the process of previewing the drawings by flipping the sheets: "The use of thin tracing paper has the further advantage in that it is very flexible and the artist by holding the sheets representing an object in successive positions, firmly together along one edge and rapidly turning or moving the sheets may again have an idea as to how the picture will appear on the screen and can therefore determine whether or not the movement of the object will appear smooth and natural or whether it will be awkward or jerky." These statements referred to processes demonstrated by McCay in his first films, including his tabletop mutoscope viewer.

The problem of cockled paper encountered by earlier artists was solved by substituting turpentine for water as the carrier in the India ink. The patent also described sequential photography of the sheets, and the technique of doubling and trebling the exposures to manipulate the speed of movement and to stretch screen time while using fewer drawings.

These practices resulted in a definite improvement in the stability of the image. Like most of his contemporaries, Bray viewed McCay's weaving retraced lines as a primitive defect: "[McCay] tried to trace [each drawing] you know. They were only this big, the drawings, and when it was thirty feet big on the screen there was a tremendous increase in size, so when he tried to trace every little wiggle in the background one after the other, it would wobble all over."

Confident in his new technique, Bray quickly assembled his first staff of artists. The apartment at 112th Street and Riverside was the first base of operations, but soon the more spacious quarters of the upstate farm were required. According to grandson Paul Bray, Jr., the crew was boarded at the farm for five days a week so they could work without distraction. The men would often fail to return on Monday

John Randolph Bray

mornings, or else be too hung-over to animate, so the policy of Monday paydays—still in effect at the studio—was inaugurated. Even with the employees cloistered, it was a full six months before the Pathéplay *Colonel Heeza Liar's African Hunt* was released on January 14, 1914.[5] The contract with Pathé was not fulfilled. Far behind schedule, three more films were released in March, April, and May, then no more until August, when, during Pathé's European-war crisis, the cartoons were distributed with the "Eclectic" label. Only the seven films of 1914 were animated by Bray himself.[6]

In December 1914, Bray Studios, Incorporated was formed with $10,000 in capital and a floor of a 26th Street building was leased. Bray's immediate concern was to recruit and train artists. Earl Hurd was formally hired, and in 1915 he began his own series of "Bobby Bumps" cartoons. The first camera operator was Harry D. Bailey.

One of the 1915 newcomers was Paul Terry (1887–1971), who had been unsuccessfully trying to break into the film business as an independent animator. This illustrator and photographer was working for the New York *Press* when he had the good fortune to see McCay perform with *Gertie*. He labored on a short cartoon called *Little Herman,* which combined live and animated action through a split-screen effect. When he showed this satire on the Great Herrmann's magic act to Lewis Selznick, the magnate responded with a bid that was less than the cost of the raw stock. When Terry protested, Selznick is said to have informed him that the film had been worth more before he had drawn on it.

Terry tried to interest Bud Fisher in a series of "Mutt and Jeff" cartoons, and approached William Randolph Hearst (who was forming a studio), but with no luck. Margaret Bray learned of his work, but was less than appreciative; as John Randolph Bray recalled, "My wife found him.

. . . She happened to see Paul Terry's first [animated] drawing. She saw it in the newspaper; it was advertised. So she went in to see him. He was up on Broadway. She thought that his work was pretty good, so she told him he had to have a license. He didn't like that very well, but he [later] took one out anyhow. Then we gave him a job. That started him off." Terry's career at Bray was obviously begun under unhappy circumstances, if not actual duress. The young animator left at the end of 1916, after only a year.[7]

Like Terry, the others on the Bray staff were cartoonists or illustrators: C. Allan Gilbert, a fashion artist; Louis M. Glackens, brother of the famous "Ashcan" artist; and free-lance cartoonists Leighton Budd and Carl T. Anderson.[8] Leslie Elton, a newspaper sports cartoonist, joined in September 1916 and took over the "Heeza Liar" series.

During this period Bray must have spent nearly as much time with his attorneys as with his staff. The idea of obtaining an animation patent was not Bray's alone. Smith, Blackton, and Cohl had all reportedly considered patents, but rejected the idea as impractical. Léon Gaumont told historian Lo Duca that he not only had invented animation, but held the rights. Indeed, French patent 296.016 (1900) is for a system schematically reproducing the movements of objects.[9] Close reading reveals that Gaumont's method used wires and therefore had no legal or practical relevance to true animation, which probably explains why no enforcement attempt was ever made.

Bray's initial application was filed on January 9, 1914, and illustrated with drawings from the first "Heeza Liar" release. Two weeks before a patent was granted, a second application was filed on July 29. This one was an amendment covering improvements made in the appearance of the film in response to complaints that the practically all-white backgrounds produced screen flicker. Briefly, patent

John Randolph Bray

1,159,740 (figure 58) specified painting black on the reverse side of the sheets to produce a shaded effect when they were photographed. Bray noted that "in practice, I preferably employ tracing paper, but it is evident that other material having a different degree of translucency, might be employed under other conditions to secure the same results. . . . The sheet may be even more nearly transparent than tracing paper, as for instance, celluloid." It is important to notice that Bray had stumbled upon the possibility of celluloid as an aid in mid-1914, but used the material for tonal effects, as Cohl had done in 1910. Throughout the text, the "picture bearing sheet" is clearly understood as being paper.

This damaging technical loophole had allowed Earl Hurd (1880–1940), a young cartoonist from Kansas City, Missouri, to obtain the rights for the use of celluloid (figure 59). Hurd's December 1914 patent application contains a wealth of information, but the key concept was that the illusion of movement was to be produced "by drawing upon a series of transparent sheets."[10] Hurd went on to define the technique of modern cel animation:

In my process a single background is used for the entire series of pictures necessary to portray one scene. The background shows all of those portions of the scene that remain stationary and may conveniently be drawn, printed or painted on cardboard or other suitable sheet. I prefer to paint the figures of the background in strong blacks and whites upon a medium dark gray paper and when the transparent sheet carrying the movable objects is placed over this gray tone of the background, the objects on the transparent sheet appear to stand out in relief, giving what may be termed a "poster effect."

Cels, as they were soon nicknamed, disclosed a new visual world. Although celluloid had been in use as a photographic base for years, Hurd was apparently correct in

Figure 58.
Bray, U.S. patent 1,159,740 (detail).

John Randolph Bray

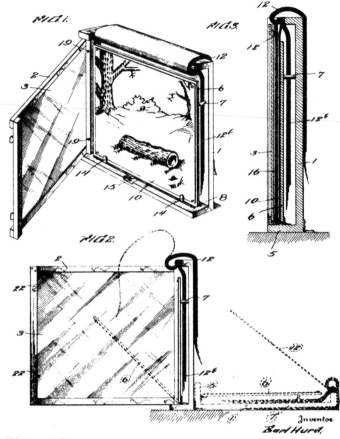

Figure 59.
Earl Hurd, U.S. patent 1,143,542 (detail).

Before Mickey

contending that he was the first to use it in this manner. Drawn figures could obscure the background, move in and out of pictorial space, and repeat motions with relative ease. The transparency of the sheets meant that only the actual moving parts of a drawing needed be redrawn. The capability to stack cels also made multiple layers of animation possible, although in actual practice the cels were limited to a very small number. Not only were they thick by today's standards, they also had a pronounced yellow cast that appeared as a dark tint when photographed on orthochromatic film. The first technical manuals suggested stacking no more than three cels.[11] Hurd's registration differed from Bray's in specifying a large glass and metal frame to clamp the drawings in place. This seems to have been based on McCay's *Little Nemo* device and assumed that the camera would be aimed at the drawings horizontally. Hurd's non-infringing patent would have, in effect, allowed him to begin production in competition with Bray. That did not happen.

How Bray and Hurd met is unknown. Hurd had been cartooning in the Chicago *Journal* since 1904, and his work was reproduced occasionally in the New York *Herald*, where Bray might have seen it. The Brays might have seen some of his independently made films. All we know is that together they formed the Bray-Hurd Process Company in 1914, a mutually advantageous alternative to a lengthy battle over rights. Although Hurd's patent eventually turned out to be more important than Bray's, the cartoonist was regarded strictly as an employee of the studio and Bray never publicly acknowledged his partner's fundamental role. For example, Bray once stated: "I got two patents on [animation]. Then I took in another patent from Earl Hurd, made him a partner in my patent company. He was from San Francisco or Los Angeles, I forget which, and I made an arrangement for him to make a series of pictures." (Bray

John Randolph Bray

here was apparently confusing Hurd with Terry, who was from San Mateo.) A 1915 article listed "Earl Herd" only as a staffer,[12] and a 1917 studio release portrayed him as an untalented technician:

> Earl Hurd's early attempts at animating his work, according to him, when projected on the screen, could only be looked at through smoked glasses. Characters that he thought would walk sedately into the picture did a St. Vitus dance, while other objects that had been drawn to move with speed and dispatch, such as brickbats, skillets and such like articles used in screen combats, moved sedately through the air. Perseverance, however, soon brought results and for the past two years "Bobby Bumps" has kept his place as one of the best liked and best drawn cartoons in the entire profession.[13]

The relationship of Bray and Hurd is one of the mysteries of early animation. Former employees remember both men as loners who never conversed with each other in the studio or saw each other socially. Whether this was the result of their natural coolness, of Bray's autocratic personality, or of some business dispute we will probably never know.

Bray's third and final animation patent was number 1,179,068, granted in April 1916. It consolidated Hurd's cel patents and attempted to incorporate certain aspects of the rival system developed (but not patented) by Raoul Barré. The widespread practice of using a cel as a background overlay was also listed as an improvement.

Now that Bray had established a patent monopoly, the next task was to enforce it. Here it was Margaret Bray, in charge of all the business affairs, who relentlessly pursued would-be infringers—a role camouflaged in this 1917 description: "And closely associated with [JRB's] success and a staunch supporter of his every effort is a little lady whose smile and encouraging words were in no little degree responsible for his being able to stand up against his early

trials. Margaret Bray, wife and companion, is the lady's name, and the pride she holds in her husband's work is one of the really worthwhile things that cannot fail to be seen by anyone who has had the good fortune to meet this sterling woman."[14] Relatives report that the "little lady" was actually an imposing Brunhilde—in stature and demeanor—who, besides managing the studio, operated a successful real estate business of her own on the side. J. R. Bray was very attentive to her suggestions.

The second animator, after Terry, to experience the litigious side of Mrs. Bray's personality was Harry S. Palmer. In 1915 he was doing a series for Mutual (working out of Gaumont's Flushing studios) entitled "Keeping Up with the Joneses," but it was suddenly terminated as the result of an infringement settlement. Bray's suit had, by chance, come to the docket on November 7, 1915, two days before the second patent was to take effect. Because several licenses had already been issued, the magnitude of the decision was fully appreciated: "Mr. Bray stated that he was very anxious to have the validity of his patents passed upon by the court and judicially determined 'particularly in view of the insinuations and direct statements which have been made' to the effect that the process covered by this patent was not his own invention."[15] Bray lawyers successfully stalled until the patent was in force, then won handily. (The "insinuations" mentioned in the quotation reflected a strategy used by lawyers for the defense to discredit Bray's patent on the grounds that it was not an original idea as required by law. Though the courts did not allow this defense, it is now obvious that Bray was profoundly indebted to McCay. There are even persistent stories that Bray personally asked McCay for a demonstration of his techniques, then attempted to sue him for plagiarism.)

Bray's Rooseveltian sentiments compelled him to defend himself against charges of unfair restraint of trade:

John Randolph Bray

Referring to suits brought for the protection of the process used in the making and photographing of the pictures, Mr. Bray said that there was danger of his motive in instituting the litigation being misconstrued. He said that he never had any wish to exert a monopoly by driving other artists out of the business. Quite the reverse; he has done all that he could in fighting the battle of the artist by insisting that he receive a just payment for his work. Mr. Bray feels that two dollars a foot for negative is not too much in consideration of the time, expert knowledge and labor expended.

"From the first," he continued, "I have tried to uphold the dignity of the animated cartoon and in doing this have naturally opposed the circulation of poor work that would give the public and exhibitors a wrong impression of the type of picture in which I was interested. Some of the film released was so entirely without merit that it harmed the business prospects of all artists engaged in making cartoon drawings." [16]

If the latter statement was aimed at Palmer it was unfair, because, although the animation and the graphics in a Library of Congress print of *Keeping Up with the Joneses* are mediocre, the film is comparable to contemporaneous Bray Studio products. The validity of Bray's patents was upheld again in January 1918, when Carl F. Lederer, an innovative animator working for (and perhaps filing suit on behalf of) Raoul Barré, lost another effort to set the monopoly aside. [17] Bray's stance became even more aggressive, and he issued a warning: "Since the patents held by this company cover completely the means of making animated cartoons, producers who have not been granted a license to use the processes are infringing, and in order to maintain its just rights, this company is about to take action against all such infringers who are consciously using the processes." [18]

The longest and bitterest skirmish over the cel process, though, was with Paul Terry and his Fables Pictures, In-

corporated (the studio he had formed in 1921 with Amedee Van Beuren). After nearly five years of legal maneuvering, the case was settled out of court in September 1926 when Bray agreed to drop the suit if Terry would just buy a license.[19]

As inventors know, patents offer little protection if one lacks the means to take action against unlicensed users, and their mandatory publication reveals secrets to those who might not otherwise learn the techniques. From the beginning, the essentials of the Bray-Hurd Process were well known. Hurd's illustrated patent was even reprinted in *Motography*.[20] Articles in the popular press and in the earliest "how to" manuals explained cel animation. Bray's effectiveness at enforcement is difficult to determine. There was a noticeable dwindling of the number of small distributors' release listings in the trade journals (with the lowest point in 1917, when only Bray, Powers, Barré, and the short-lived Hearst studio were listed). But although it might seem that the market was being limited, it may also be that independent producers were distributing their films through state's rights[21] and therefore were not listing in the trades. (Also, 1917 was the peak of American involvement in the war.) Furthermore, cels were not universally adopted, although most animators used them at least occasionally. As Sullivan's studio demonstrated, it was possible to operate legally without a license.

Bray's success probably came as much from his marketing and distribution practices as from his technical advantage. In 1915, he signed a contract with Paramount "calling for a thousand feet of comedy every week beginning in January [1916], also a cartoon to be issued in the news weekly." He professed to be attracted by Paramount's high-class reputation: "I have always aimed to produce humorous subjects that would be appreciated by intelligent audiences, just the type of audiences being reached by the

John Randolph Bray

program with which I am allied."[22] Within a year this contract provided sufficient capital for Bray to purchase a controlling interest in the renamed "Paramount-Bray Pictograph" (figure 60). P. D. Hugon, former director of Pathé-News, was appointed general director. Each Pictograph was a one-reel compilation of travelogs and educational features with a cartoon at the end.

Paramount was an effective outlet, but an even more promising arrangement was offered by Uncle Sam. In the dour words of a 1919 commentator, "the war started big things."[23] America's entry into the world war in 1917 brought Army requests for training films: "Early in the war Bray went to West Point and produced six reels on the training of a soldier. The War College accepted Bray's idea, appropriated money for the training camps and the Bray company was commissioned to make the films. These pictures show the operation of the mechanism of the Lewis and Browning machine guns, rifle grenades, trench mortars and all the various ordnance pieces, as well as how to read military maps, harness cavalry horses, etc."[24]

The effectivenss of Bray's Army training films depended largely on a new process patented by Max Fleischer called rotoscoping. Motion pictures of the various mechanisms were made; then, by projecting the developed footage one frame at a time and tracing it on cels, a film of schematic clarity could be made. No sooner had the Army agreed on a contract for films made by this process than Max Fleischer was conscripted. When Bray protested "How can I make films when you draft all my men?" an arrangement was made whereby technical director J. F. Leventhal and Fleischer would be relieved of regular service but would go to Fort Sill, Oklahoma, to supervise the films for the Army.[25] By 1919 the studio was swamped with orders from the government, from industry, and from educational institutions. Bray realized that there was a vast untapped

Figure 60.
Paramount-Bray Pictograph advertisement, 1917.

John Randolph Bray

potential for these didactic productions, and decided to re-orient his studio's direction. The burgeoning auto industry became the largest private client, and a Chicago-Detroit branch was established with Jamison "Jam" Handy, formerly of the Keeley-Handy Syndicate and the Chicago *Tribune,* as vice president in charge of sales. The rise of J. F. Leventhal was also a direct result of this new policy. He had been an architectural draftsman in Chattanooga, Tennessee, before joining Bray in 1916. It was Leventhal's skilled technical drawing that gave the Bray instructional films their clarity. He and E. Dean Parmelee set up a technical department at the studio. Dr. Rowland Rogers was named educational director and designed "film courses" on various subjects for distribution to schools.

In June 1919, Bray broke with Paramount to form the Bray Pictures Corporation with a $1.5 million capitalization. Rotoscoping and other military spinoff technology would be put to entertainment use: "The Bray organization, always the pioneer and leader in animated work, has developed and patented new processes for cartoon comedies and also a means of presenting spectacular effects in popular science. . . . These and other processes which the Bray Studios developed in secret for national service and placed at the disposal of our country, will now be devoted to entertaining and surprising theatre audiences."[26] And for the first time, nonfiction films were said to be the studio's first priority. Again Bray sought the services of the most prominent film mogul available—this time Samuel Goldwyn, who in August took over distribution of the "Goldwyn-Bray Pictograph" and announced an accelerated release schedule of three reels a week.[27] In fact, even this optimistic forecast would be exceeded.

Among the novelties announced by Goldwyn was "Brewster Color," a process similar to early two-emulsion Technicolor. A color cartoon entitled *The Debut of Thomas Cat*

Before Mickey

was released on February 8, 1920. Despite the good reviews, this first-ever color cartoon proved to be Bray's only one; Brewster Color was judged too expensive.[28] In January 1920, Goldwyn bought a controlling interest in Bray Pictures and precipitated a major reorganization. Fleischer and Leventhal emerged in strong positions on the board of directors, with exclusive contracts for their services. The "Goldwyn-Bray Comics" brought the number of cartoon releases up to two a week.[29]

Bray's own interest in animation had long since dissipated. Distribution schemes and other affairs of the front office occupied all of his time, except for a few pet projects. Among these was the 1923 Brayco Projector, an amateur-educational apparatus designed to accept only films sold by the Bray Library. There was also an elaborate plan to produce H. G. Wells's *Outline of History*. Wells had offered Bray the rights in the fall of 1921. Meanwhile, D. W. Griffith was going ahead with his own plans for a fictionalized adaptation and, when he approached Wells in England, was astonished to learn that the rights had already been sold to the animation studio. Bray had a series in mind analogous to Yale University Press's 1923–24 dramatized history "Chronicles of America." Bray went to England especially to consult with the author on the elaborate project in 1924, but (probably because it was too ambitious) no films were ever completed.[30]

Instead, Bray became interested in producing live-action comedies along the lines of Hal Roach's two-reelers. The years 1926 and 1927 found him in Hollywood making arrangements with Joseph P. Kennedy for distribution through the banker's Film Booking Office of America (FBO). In 1927, during a filming expedition down the Colorado River in which his party was lost and feared drowned, Bray seems to have profoundly reassessed his life and career. A lawsuit with FBO over the delayed release of the

John Randolph Bray

feature-length documentary *Bride of the Colorado* further depressed him, and he decided to disband the theatrical units. The last Bray cartoons were released in mid-1928, and he eased into gradual retirement. Clearly an era was ending: The Bray Studio's hold on the theatrical animation market was relinquished, the original patents were nearing the end of their seventeen-year term, and the sound film was an irreversible reality.

· ·
Taylorized Cartoons

In a very short time span, from 1913 through 1915, an entire technology developed, flourished, and became standard. The speed of this evolution looks forward to the great leaps in technology after World War II, and this is not altogether a coincidence. The industrialization of the cartoon was to a slight extent a military by-product, but that accounts for the motivation of the development and not the actual course that it took. The hardware of animation (represented by the Bray-Hurd patents) was the physical means for this growth, but Bray's organization and management concepts left equally lasting marks on the studios.

It is not labor, not capital, not land, that has created modern wealth or is creating it today. It is *ideas* that create wealth, and what is wanted is more ideas—more uncovering of natural reservoirs, and less labor and capital and land per unit of production. . . . It was Howe, Morse, Edison, Westinghouse, Bell and Gray; it was Lincoln, it was Rockefeller, Carnegie, J. J. Hill and Harriman with their ideas, it was Roosevelt with the Panama Canal, that have made the United States what it is.[31]

Whether John or Margaret Bray read the above preface to

Harrington Emerson's industrial primer *The Twelve Principles of Efficiency* is anyone's guess, but his paean to American ingenuity would certainly have struck a responsive chord with them. By the same token, the animation industry, as established by Bray, his trainees and emulators, could have served as an admirable model for the enthusiasts of "scientific management," the controversial movement that excited industrial leaders and theoreticians and promised to revolutionize industry by taking full advantage of technology and eliciting the native desire of the American worker to better his life. It was in this charged environment that the cartoon industry was nurtured.

Although the first pioneering works on management theory were done in the 1880s by Frederick W. Taylor, it was not until a 1910 hearing on freight rates, when famed lawyer Louis Brandeis awed the nation by producing figures showing that a "taylorized" railroad could save a million dollars a day, that "scientific management" became a craze.[32] The timing of the Eastern Rates Case and its fallout in the popular press is crucial, for it coincides with the initial struggles by animators to cope with the burdensome manual labor of image generation. Taylorism, consciously or not, presented itself as the solution, preaching that new ideas rather than more labor was called for. Taylor's 1911 *Principles of Scientific Management* epitomized the concept of assembly-line studio animation: "In the past the man has been first; in the future the system must be first."[33] Bray's first patent echoed this thought by stressing that the efficiency of his proposed technique was as important as the particulars of its functional operation: "The main portion of my invention resides in the steps which I have invented to facilitate the rapid and inexpensive production of a large number of pictures of a series. . . ."[34] Hurd's patent also stressed efficiency: "One of the objects of my invention is to enable such animated cartoons to be

John Randolph Bray

made with the minimum of effort and expense and to facilitate the rapid execution of any series of poses relating to or constituting a single scene."[35]

The models put forward by Taylor and his associates Carl Barth, Henry Gantt, and Frank Gilbreth (whose time-and-motion studies were fictionalized in *Cheaper by the Dozen*), as well as Emerson's formulas, were intended for large-scale factory application. But even the informally operated animation studios reflected these principles in microcosm.

Most basic was the division between management and labor. From the beginning, Bray made it clear that he was the boss and the others were subordinates, as opposed to a communal craft arrangement. Paul Bray tells of his grandfather playing "bellringer" as he sat in the loft with the camera, barking instructions to the animators below. Later, Bray adopted the more traditional invisibility of upper-level management, as Sullivan, Bowers, Max Fleischer, and Disney did to varying extents. Taylor defined good management as "knowing exactly what you want men to do, and then seeing that they do it the best and cheapest way."[36]

Another observation was that increased production "lies in systematic management, rather than in searching for some unusual or extraordinary man." The practical result of this belief was reflected in studio staffs packed with untrained women and adolescents, among whom low salaries and high turnover were the rule. According to Taylor, these "cheap men" were the backbone of industry. In *Shop Management* (published in 1912) Taylor advised employers to establish "a large daily task," clearly defined and possible to complete. Employees were to receive high pay for success and a loss in case of failure. At the Bray studio such a "differential rate piece work" system was in effect; workers were paid a small salary plus an amount determined by the amount of work completed, with bonuses for films finished ahead of schedule.[37] At most of the other studios

weekly salaries were also supplemented by bonus systems.

Instead of the old-fashioned, military-style shop organization, Taylor espoused "functional foremanship." This division of labor specified gang bosses, speed bosses, repair bosses, and "inspectors" (teachers who demonstrated techniques to the workers). The individual departments of the Bray studio corresponded to these functions. A telling 1917 photomontage of the studio reflects the pecking order (figure 61). Management—Bray—is invisible (by himself on another page, actually). At the top are the artist-animators Follett, Hurd, Carlson, Budd, and Leventhal. Below them is a view of the camera room and a unique glimpse into the art department showing the "cheap men" (and women) working on their daily tasks under the watchful eye of a female "inspector." Henry D. Bailey appears in the inset, physically separated from his workers as though to symbolize his quasimanagerial status. The walls of the art department are decorated with posters to inspire the employees with past good work; Bailey's walls, in contrast, are hung with calendars and release timetables on clip boards—icons of his concern with more practical affairs, like making deadlines. The structure of the Bray studio (and most of the others) was pyramidal, with the founder at the top.

In his 1920 manual, Lutz was still promulgating the taylorist philosophy—for example, when he described the tracers' function in language echoing Bray: "It can be seen from this way of working in the division of labor between the animator and his helper that the actual toil of repeating monotonous details falls upon the tracer. The animator does the first planning and that part of the subsequent work requiring artistic ability."[38]

For such a system to work, the unit of production must be refined to a high degree of uniformity. In film production, this meant that genre codes evolved spontaneously.

John Randolph Bray

Figure 61.
"Artists of the Bray animated cartoon staff," *Moving Picture World,* 1917.

Before Mickey

We see the same effects in the studios of Thomas Ince, who, at about the same time, ordered his production according to meticulously predetermined schedules and formulas. The suppression of individuality was an absolutely necessary mandate of taylorism, and one of the chief complaints of opponents and trade unions. For animation this extended to the drawing styles of artists, which had to be interchangeable. Uniformity was a virtue rather than a fault for Bray and the other studio founders. The final word on individual expression was pronounced by Max Fleischer in some revealing thoughts on the rotoscope:

An artist, for example, will simply sit down and, with a certain character in mind, draw the figures that are to make it animated. If he wants an arm to move, he will draw the figure several times with the arm in the positions necessary to give it motion on the screen. The probability is that the resulting movement will be mechanical, unnatural, because the whole position of his figure's body would not correspond to that which a human body would take in the same motion. With only the aid of his imagaination an artist cannot, as a rule, get the perspective and related motions of reality.[39]

In the machine age, empirical experience and observation were no longer trustworthy unless corroborated, tutored, and reproduced mechanically.

Despite its zealous advocates during 1910–1915, Taylor's movement barely survived the war and its disillusionment. "Scientific management" disappeared, except as an object of derisive satire in films like *A Nous la Liberté, Modern Times, Cheaper By the Dozen,* and *Desk Set.* Nevertheless, the multitude of animation studios (large and small) that flourished during the teens and twenties all bore the emblematic stamp of their first models, the taylorized system of Bray and his offspring. This concept, allied with cel technology, provided the praxis of studio animation.

John Randolph Bray

Figure 62.
Max Fleischer, in *Perpetual Motion* (Bray, 1920), breathing "life"
into the inkblot clown.

The relegation of most production responsibility to Bray's "foremen" had the unforeseen consequence of encouraging them to become competitors. Thus, the structure of the studio system resembles a wheel with the Bray Studio at the hub. Bray's withdrawal from the business did not end his influence.

Max Fleischer

Max Fleischer (1883–1972) (shown in figure 62) ably took charge when Paul Terry left the Studio. By coincidence, it had been *Eagle* copy boy Fleischer who had located an apartment in Brooklyn for the young cartoonist Bray when he had first arrived in New York. Both men had gone their separate ways; while Bray was establishing himself as a cartoonist, Fleischer was becoming art editor of *Popular Science*. Max's brother Dave (1894–1979) worked at a succession of part-time jobs and settled on one as an editor at Pathé Frères beginning in 1913. It was probably here that he saw Bray's first cartoons. Always a tinkerer, Dave devised the means of reconstituting motion by tracing motion-picture footage utilized in the rotoscope.[1] The first rotoscope experiments were performed in 1915, and a pat-

ent was filed on December 6 illustrated, not with cartoon drawings, but with a representation of a semaphore signaler (figure 63). Apparently, military applications were envisioned from the start. The original tests were conducted with Dave wearing a clown suit, chosen because the high contrast between the black cloth and the white buttons would later be easy to trace.[2] The costume already belonged to Dave, who had always wanted to be a clown. The original film was photographed on the roof of Max's apartment, with Dave silhouetted against a white sheet. For the first rotoscoping attempt, an arrangement similar to McCay's horizontal setup was devised; the projector, on one chair, was aimed at sheets of paper propped up on another. Needless to say, the results were not perfect. But Max took his film to Pathé, where he was allowed to work in a cubicle "studio." According to Dave, Max insisted on making a political satire on Teddy Roosevelt's African trips. The film was inferior to one of Hy Mayer's, and the Fleischers were fired.

Dave and brother Joe Fleischer had to argue with Max to convince him to bring the rotoscope invention to the attention of his old acquaintance at the *Eagle*, J. R. Bray. But Bray perceived their meeting as a chance encounter—as it was no doubt engineered to appear. Bray recalled:

I was doing work then . . . for Paramount . . . ; it was Famous Players in that day. I was in charge of their short subjects. I found [Max] one day when I happened to go up to see Zukor, the president of the company. Max was sitting out in the lobby, and I recognized him right away, went over and asked him what he was doing there. He said he'd been around to all the motion picture companies except Famous Players. . . . I said, "Well, I have all the short subjects here; you'll have to deal with me." He was very much pleased because he didn't know I was working there.

Before Mickey

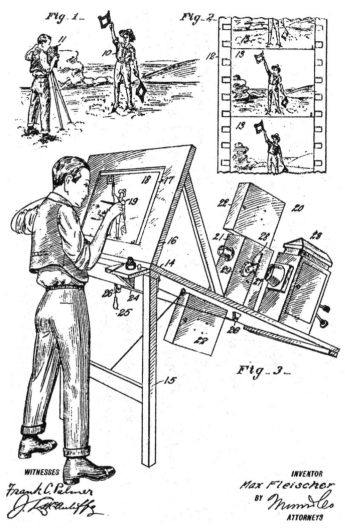

Figure 63.
Max Fleischer, U.S. patent 1,242,674 (detail).

The Animation Shops

This meeting must have occurred during 1916, when Bray's films were being released as part of the Paramount Screen Magazine. The Fleischers were hired, but the exigencies of the war interrupted their plans. While Max was in Oklahoma, Dave was putting his experience as a Pathé editor to use for the War Department in Washington. Bray, aware of Max Fleischer's role in his wartime gains, rewarded him by putting him in charge of his own unit, with the opportunity to develop a series based on the prewar film with the rotoscoped clown.

Koko the Clown, as he was named around 1923, made his public appearance much later than has generally been thought. It was well after the end of the war, on September 30, 1919, that the first "Out of the Inkwell" was actually released on the Goldwyn-Bray Pictograph program. The first film had been previewed at the Strand Theatre in New York; prior to then Koko had existed only on the original 175 feet of rotoscoped footage of Dave, running less than two minutes. A trade article indicates that this Strand preview took place in spring of 1919:

There is no surer proof of the fact that genius does not grow on trees than a close examination of cause and effect in technical art. Max Fleischer, inventor of the mystery process of lifelike action in the animated cartoon [rotoscoping], is a living example of what can be accomplished by hard work and concentration. Most of us marveled when Max's clown of the inkwell made his appearance on the screen at the Strand Theatre a couple of months ago. We laughed at the grotesque star of the "Out of the Inkwell" as he confided to the public his likes and dislikes or yowled with rage when his creator's pen point showed too strong an affection for his trouser leg. We saw him display athletic propensities such as might shame the star performers of the city's "gyms," and many attributes not the least of which is the personal directing of the coloring and fashioning of his clothes. . . . A visit

to the Bray studios brings one easily face to face with the creator of "Out of the Inkwell," but not with his dark secret, the shaping of which covered one and a half years.[3]

At the time of this notice, regular "Out of the Inkwell" releases were not contemplated, and most of Fleischer's work was still assigned to "the technical field." Nearly a year later Koko was still appearing only irregularly in New York previews. Nevertheless, the films caught the eye of a *New York Times* reporter, who wrote: "Many persons have been delighted by the little black and white clown who, one of the merriest genii, occasionally comes out of Max Fleischer's inkwell. He has been seen more frequently on the screen of the Strand Theatre, where after a long period of anonymity, among the other numbers of The Topical Review [*sic*], he has at last won his own place on the program."[4] Despite the apparent groundswell of popularity, Bray told the reporter that the clown "or some creditable successor" would appear only "from time to time," for the reason that it required four or five men five weeks to produce 200 feet of film. "Out of the Inkwell" did not begin appearing in Bray release lists until April 1920, but in July Bray announced the continuation of the series.[5]

The idea of a hand producing a figure "out of the inkwell" was already a Bray Studio tradition, since every "Bobby Bumps" was introduced by Hurd's hand. Wallace Carlson concentrated on combining live and animated characters in a string of 1916 films. One of these in particular, *Dreamy Dud Has a Laugh on the Boss,* foreshadows the role of Max Fleischer as the artist-protagonist:

The cartoons, by Carlson, are novel in that living figures are combined with pen and ink figures, and that the figures act out a humorous dream of the cartoonist. The living figures that take part are Cartoonist Carlson and Harry Dunkinson.[6]

The Animation Shops

[In *Dreamy Dud in the African War Zone,*] Cartoonist Carlson has worked out his humorous incidents by combining, through double exposure, his human figures with his well known pen and ink characters.[7]

Otto Messmer's *Trials of a Movie Cartoonist,* released by Powers in December 1916, is another forerunner of the Fleischers' mischievous creations: "The first half of this film shows the trials and tribulations of a movie cartoonist at work. The figures that he draws become rebellious and refuse to act as he wants them to, so he has a terrible time to make them do his bidding. They answer back and say that he has no right to make slaves of them even if he is their creator."[8]

The earliest reviews indicate that it was not so much the elaboration of the "out of the inkwell" formula as the magical sense of realistic movement made possible by the rotoscope that made "Out of the Inkwell" so attractive. J. R. Bray instinctively emphasized this mimetic quality when he promised the public "a wonderful new type of cartoon, made under completely new processes, by which such astounding perfection in animation is reached that people cannot believe they are made from drawings."[9] This same confusion, or suspension of disbelief, was evident in the *New York Times* review of one of the first in the series: "[Koko's] motions, for one thing, are smooth and graceful. He walks, dances and leaps as a human being, as a particularly easy-limbed human being might. He does not jerk himself from one position to another, nor does he move an arm or a leg while the remainder of his body remains as unnaturally still as—as if it were fixed in ink lines on paper."[10] This reviewer clearly perceived the underlying theme of "Out of the Inkwell": the mysterious transcendence of graphic (two-dimensional) form into a humanoid

presence. All the films, from 1919 through the "Inkwell Imps" of 1928, were more or less elaborate variations.

In 1921 the Fleischers set up their own studio—Out of the Inkwell, Incorporated—at 129 East 45th Street, and arranged for distribution through Margaret Winkler (figure 64). There were thirteen films in 1922.[11] Evidently the full-blown production of the series and its consequent influence did not begin until the early 1920s, and not in the teens as has been reported. Nevertheless, by 1924 the series and its star Koko were so successful that Max Fleischer was able to expand into a diversified studio patterned on Bray's organization. Red Seal was backed by Edwin Miles Fadiman and by theater magnate Hugo Reisenfeld. Besides producing "Out of the Inkwell," Red Seal distributed live-action serials, comedy shorts, scientific documentaries, and various oddities, including "Animated Hair." More important were the "Song Car-Tunes" that premiered at Reisenfeld's Rialto on February 24, 1924.[12] Some of these bouncing-ball singalongs were synchronized by the De Forest Phonofilm system, but unwired theaters were supplied with "eighteen piece orchestrations with every reel."[13]

Dick Huemer began working at the Red Seal studio around 1923.[14] He recalled that by that time Max was never seen outside of the front office, but Dave was friendly and accessible. Doc Crandall and Burt Gillett were the animators, and the staff fluctuated between six and ten men. After Huemer began to animate, Art Davis became his regular in-betweener. Dave Fleischer insisted that everyone use Gillot 290 pens—Gibson's (and McCay's) favorite—in order to produce a clear, bold, nonbleeding line. Indeed, the "Out of the Inkwells" from this period are distinguished by the heavy black outlines of the characters. Combinations of cels, slash, and retracing were regularly employed, although the studio was fully licensed.

The Animation Shops

OUT OF THE INKWELL
COMEDIES

THE GREATEST NOVELTY CREATION OF THE SCREEN

ONE EVERY MONTH

BOOKED

For a solid year in SID GRAUMAN'S million dollar theater, Los Angeles.

BOOKED

By DR. HUGO REISENFELD for the Rialto, Rivoli and Criterion Theaters, New York City.

TERRITORIAL RIGHTS

NOW SELLING *Act Quickly For Your Territory*

OUT OF THE INKWELL COMEDIES

Room 606, 220 West 42d Street, New York City

For Booking in New York and New Jersey *Write* **WARNER'S EXCHANGE, Inc.**
1600 Broadway

Figure 64.
Advertisement for "Out of the Inkwell," 1921.

Before Mickey

Max Fleischer renewed his contract with Red Seal for three years in October 1925. By next February, though, Fadiman was ousted under mysterious circumstances and replaced by Fleischer as president. Again for unexplained reasons, but probably because of mismanagement, Red Seal went out of business in September 1926. "Out of the Inkwell" was at its height of popularity. Fleischer's appearances in the films as the "artist" had made him a celebrity in his own right, as a talk on Chicago's station KYW demonstrated when it elicited 3,300 fan letters. Koko dolls were a national craze.[15]

Ko-Ko (his name now hyphenated for copyright reasons) reappeared in 1928 in a new Paramount series, "The Inkwell Imps," produced by Alfred Weiss and Out of the Inkwell Films, Incorporated. Weiss departed after the first season after some fiscal shenanigans. The company was declared bankrupt and replaced by the Fleischer Studios, Incorporated. The series remained at Paramount throughout these legal perturbations. In 1929, after the general conversion to sound, the "Inkwell Imps" became "Talkartoons," and Ko-Ko was eased into retirement by sexy newcomer Betty Boop.

The vacuum left by the departure of Max Fleischer from the Bray Studio in late 1921 was filled by an unlikely candidate, Walter Lantz. Until then, animation at the studio had been strictly an in-house affair, with the tools and methods laid down by Bray and Hurd and developed by Fleischer still in use. Lantz brought new ideas and techniques that he had learned while working with the veteran animators of Bray's newest rival, Hearst.

The Animation Shops

The International Film Service

If we digress to 1915, we can imagine William Randolph Hearst sourly contemplating the animated ventures of three of his major artists, Winsor McCay, George McManus, and Bud Fisher, and deciding to join the fray in his characteristic grand style. Hearst enjoyed comic strips and movies immensely, so it is not surprising that he would be interested in combining the two—especially since the films would publicize the comics, and vice versa, and that was good business.

The International Film Service was an offshoot of Hearst's International News (wire) Service (INS). Animated subjects were planned for the newsreel from its inception in mid-December 1915, and a studio was installed at 729 Seventh Avenue, joining the dozens of film offices already in the same building. By February, the Hearst-Vitagraph News Pictorial was running animated cartoons based on Tom Powers and George Herriman characters. By April 1916 the lineup of comic-strip artists was supposed to include Tom Powers, Tad, George McManus, Hal Coffman, Fred Opper (figure 65), Harry Herschfield, Herriman, Cliff Sterrett, Tom McNamara, and Winsor McCay. Later the names of Walt Hoban and Jimmy Swinnerton were added to the list of star cartoonists who, it was promised, would contribute regularly.[16] A cel license was properly acquired from Bray-Hurd. To man his studio, Hearst applied the same tactics that he had used to build his newspaper empire: luring animators from existing studios by doubling their current salaries. The studio was supervised by Gregory La Cava (1892–1952) (figure 66), who had studied at the Chicago Art Institute and the Art Students League. Like several of his classmates, La Cava earned extra cash as a caricaturist and illustrator. Presumably for the same motive, he began taking on odd jobs at the Barré

Figure 65.
Advertisement for "Happy Hooligan" (International Film Service/Pathé, 1917).

180

Figure 66.
Gregory La Cava, 1924.

Before Mickey

studio around 1913. Thus, he was judged to have acquired sufficient experience to organize a major studio of his own at the ripe age of 24.

La Cava proved to be the efficient worker that Hearst had suspected, and the studio was soon churning out weekly releases. Not all the promised luminaries participated in the cartoon production (McCay's absence was most prominent), and those who did participate did so in name only. There was never any attempt to present the films as the personal work of the artist whose name appeared in the credits. La Cava began the practice of making each character series a semiautonomous production, and encouraged the crew of "Krazy Kat" to compete with that of "Bringing Up Father." He also engaged his former boss Raoul Barré to produce a "Phables" series based on a strip by T. E. Powers, but Barré quit after only seven films.

Isadore (Izzy) Klein came to work at Hearst's studio in early 1918, and has described its operation.[17] He was studying at art school and, observing the mast "see us in the movies" atop the Hearst comics, applied for a job at La Cava's studio armed with a portfolio of drawings in the styles of Charles Dana Gibson and James Montgomery Flagg. First he earned $4–$5 a week as a tracer, and in only a few months was asked to be an animator at $15. (Klein estimates that La Cava himself probably made about $400 a month.) The atmosphere at the studio could best be described as "ad lib." Everyone played it by ear and, although there seemed to be a lack of organization, the films always came out on time.

In spite of the array of talent, the course did not run smoothly for IFS. The studio's most popular property, "The Katzenjammer Kids," was being threatened with competition. The year 1916 found animator-entrepreneur Charles Bowers in a race with Hearst for the first "Katzenjammer" cartoons. The original strip had begun as a loose adaptation

The Animation Shops

of Wilhelm Busch's *Max und Moritz* drawn by the young German-American Rudolph Dirks. However, Dirks was also a "serious" artist (associated for a time with the New York "Ashcan" group), and when he demanded more time to pursue his painting and study he ran afoul of the boss. Dirks left the *Journal* for Pulitzer's *World* in 1912. But Hearst sued, and after two years a precedent-setting decision was handed down giving the title of the strip to the copyright owner (Hearst) and giving the right to use the characters to the artist (Dirks). "The Katzenjammer Kids" resumed in the *Journal,* drawn by Harold Knerr until his death in 1949. Meanwhile, Dirks continued his original strip as "Hans und Fritz" in the *World* until his retirement in 1958. Each strip continued to attract enthusiastic readers who chuckled over the two mean "Katzies" and their pigdin-English-speaking family.

Bowers and Dirks met to plan a screen series based on the strip. As it began, on September 4, 1916, Dirks affirmed in a public letter to Harry Grossman of Celebrated Film Corporation, that ". . . the only cartoons that I am interested in are those being produced by your company under the name 'Hans and Fritz.' As you know, I am the originator of the Katzenjammer Kids. But everything emanating from my pen in this line bears the title of 'Hans and Fritz.'"[18] The very same week, as Dirks and Bowers had undoubtedly known, Hearst was prepared to announce that the International News Pictoral would soon add "The Original Katzenjammer Kids" to its weekly cartoon releases. The Hearst Studio was much slower than Bowers's, though. There was a reminder in November that "Gregory La Cava and other animators of the first rank are putting their best work into this new feature," but by the time the first film was completed anti-German sentiment had prompted Knerr to change the title of the strip to "The Shenanigan Kids." So the first IFS appearance of the Katzies, which was not until

January 28, 1917, was *The Captain is Examined for Insurance*. The decision to release the films as a "Captain" series invited confusion with Dirks's competing strip, which he had renamed "The Captain and the Kids" during the war. In June 1917, Dirks's "Hans and Fritz" cartoons were taken over by Paul Terry's distributor, the Short Feature Exchange.

The growing controversy over Hearst's anti-British and possibly pro-German position on the war affected the distribution of the films. A Canadian ban on the newsreel, along with other Hearst publications, was instituted in November 1916 and was lifted only after assurances that the Hearst films (cartoons included) would be excised. In San Francisco and elsewhere, audiences hissed when the "Hearst-Pathé News" logo appeared on the screen.[19] The film branch also suffered from association with the bad reputation of its parent organization. After the INS was denied use of foreign cables, its reliability plummeted scandalously. The nadir came in June 1917 when the wire service was enjoined against stealing news stories from the Associated Press.[20]

As an economy move, the animation branch of INS was closed on what the animators came to call "black Monday," July 6, 1918. Henceforth, Hearst's cinematic intentions were focused on establishing the career of his friend Marion Davies. La Cava embarked on his career as a director of comedy features; the animators dispersed to the other studios.

In August 1919, Goldwyn-Bray took over distribution of Hearst cartoons produced under a license to Frank Moser. In April 1920 Goldwyn announced: "The motion picture public will renew old friendships. Happy Hooligan, the Shenanigan Kids with the Captain and the Inspector, Old Judge Rumhauser and his pal Silk Hat Harry will again make their appearance on the screen . . . produced by the

The Animation Shops

International Film Service for Bray Pictures Corporation through the efforts of Gregory La Cava, John Foster, Vernon Stallings and of Max Fleischer."[21] The Hearst cartoons alternated weekly with Bray's own films, but did not realize the expected profits. According to Bray Studio records, the contract was canceled in June 1920, with the Studio indebted $41,000 to IFS.[22]

Although the legal relationship between Bray and the ex-Hearst group was dissolved, there was considerable intermingling of the staff—ultimately supplying the new manager Lantz.

Walter Lantz at Bray

Walter Lantz was born on April 27, 1900, in New Rochelle, N.Y., and assumed most of the responsibility for raising his brother. He also helped operate his father's grocery store after they moved to Middletown, Connecticut. With his cartoon training learned from a correspondence school, Lantz journeyed to New York and landed a job as copy boy on Hearst's *American* (where one of his duties, he claimed, was to deliver love letters from the boss to Miss Davies).[23] Lantz's editor Morrell Goddard recommended him to La Cava, who made him a cel washer and all-around helper at IFS in 1916. He assisted on the Katzenjammers, Happy Hooligan, and Krazy Kat, then directed "Jerry on the Job" himself. When the studio closed in 1918, Lantz went to Barré and then joined the art department at Bray's when they annexed the IFS films. His posters prove that he was adept at drawing all the Hearst comic heroes in their creators' styles (figure 67). At the studio, Lantz rose quickly to such prominence that Bray made him "director general of Bray Productions" to replace Fleischer.

Figure 67.
Walter Lantz, advertisement for the "Goldwyn-Bray Comic," 1920.

Lantz's arrival seems to have coincided with a period of unrest among the Bray staff. Hurd, Harry Bailey, and others had left in September 1920. (Hurd set up a small independent studio in Kew Gardens.) In April 1921, Jam Handy sued the Bray studio for breach of contract after having been fired. When Max Fleischer left in June, his longtime collaborator Leventhal resigned with him.[24] One suspects that Lantz's first assignment, reviving the "Colonel Heeza Liar" series, was Bray's idea. Vernon Stallings directed the short-lived series which, by combining live and animated action and having the Colonel pop out of an inkwell, was clearly intended to compete with the Fleischers' products. Contemporary reviews suggest that the special effects were the main attraction, as in the review of *Colonel Heeza Liar and the Ghost* (January 1923): "A living actor, a negro standing 5' 10", shrinks until he is only half an inch in height. He is then transformed into a pair of dice which roll out of sight. Another living actor, six feet and heavy for his height, dives headlong into an ordinary waste basket."[25]

Colonel Heeza Liar's Forbidden Fruit (December 1923) incorporates the inkwell motif into a live-action introductory segment in which it is established that a banana famine is gripping New York City. Two artists (one played by Lantz) are discussing the situation when the animated Colonel enters, disguised as a banana. In a slight variation on the conventional method, the Colonel empties an inkwell onto a sketchpad and his story appears in animated images. At the end of the story, the artists restopper him.

Lantz became a director when Stallings became ill in 1924, and released his first "Dinky Doodles" in December 1924. By then Bray films were distributed by FBO. The first in the series were "burlesques on well known fairy tales," apparently in the manner of Terry's "Aesop's Fables." For the 1925–26 season 26 films were announced, with original scripts by Lantz (who also acted in them in

Before Mickey

a style belying his admiration of Harold Lloyd.) "Ving" Fuller, former sports cartoonist of Hearst's *Daily Graphic,* was hired to animate.[26] The boy character and his dog Weakheart then developed more consistent personalities.

A second series, "Unnatural Histories," overlapped the first beginning in 1925. The titles were even more blatantly aesopian: *How the Elephant Got His Trunk, How the Bear Got His Short Tail, The Camel's Hump,* and so on. (*The Camel's Hump* was animated by Earl Hurd, who returned to Bray after his Kew Gardens studio failed.) These alternated with the "Dinky Doodles" and were distributed by FBO until September 1926, when Bray resumed distribution and a new series of "Hot Dog" cartoons was announced. Although they only ran six months (until Bray closed the entertainment studio in spring of 1927), these films represented Lantz's best technical work. However, they were still totally dependent on "out of the inkwell" structures. The live-action sequences, directed by Clyde Geronomi, starred Walt as a dapper artist. Pete the Pup, his mascot, was modeled on Ko-Ko's newly introduced sidekick, Fitz.

The Lunch Hound, released April 23, 1927, begins with artist Lantz drawing a roast turkey in order to entice his pup out of hiding (figure 68). The situation is remarkably similar to that of *The Artist's Dream,* except that after 14 years it is no longer necessary to cloak the story as a dream. After the pup emerges from a grove of trees, he and the artist are able to communicate through perfectly timed shot–reverse shot editing. The "story" is their quest for food, narrated by parallel montage, cutting back and forth effortlessly between animation and live action. Lantz combined moving drawings and live action in the same picture by means of a tedious process recalled by James "Shamus" Culhane, who had begun working summers at the studio when he was 14.[27] An errand boy, plot man, opaquer, and

The Animation Shops

a

Figure 68.
Lantz, *The Lunch Hound* (Bray Studio), © 1927.

The Animation Shops

darkroom assistant, Culhane was also responsible for producing the combined shots used in many of the cartoons produced by the studio during the 1920s. Using the original camera negative from the live shooting, Culhane's job was to make eight-by-ten-inch blowups of each frame. These prints were used by the animators as backgrounds. They drew the mobile elements on onionskin paper, then turned them over to Culhane or another assistant for tracing, opaquing, in-betweening, and exposure in the usual way. *Lunch Hound* proves how spectacular the results could be. In one superb sequence Lantz's hand grabs for Pete, who gingerly hops out of the way. The projected shot lasts less than two seconds, but required 34 frame enlargements and 21 individual drawings.

In 1927, anticipating the closing of the studio, Lantz resolved to quit animation and moved to Hollywood to write for Mack Sennett. He signed with Universal in 1928, but was there only a short time before he was asked to return to the business and take over Disney's "Oswald the Lucky Rabbit."

When judged only by the originality of their stories and characters, Lantz's films are not very innovative. The decade of the 1920s for him was bracketed by his work on others' creations: Bray's "Heeza Liar," and Disney's "Oswald." Nevertheless, during this formative period his technical skill and his organizational capacity were evident and maturing. The films had a youthful verve and devil-may-care quality that would not always be found at the Lantz Studio when it became one of the important ones of the 1930s and 1940s.

Paul Terry

What became of the Bray prodigal Paul Terry? After leaving
the studio, he released an unknown number of films
through the Edison studio during its final year of operation.
Farmer Al Falfa's Wayward Pup, the only one of these
1917 films available, shows that the filmmaker's style had
matured and that he was already using cels exclusively.
The characters are mostly white, are lightly modeled, and
stand out against fully detailed dark backgrounds—an un-
usual effect for the period. Terry was called up to serve in
the Surgeon General's office in Washington during 1917–
18 and worked with a team of medical cinematographers.
Al Falfa's return was announced after the war in the Par-
amount Screen Magazine, but did not materalize. Instead,
on June 19, 1921, Amedee Van Beuren, president of Fables
Pictures Incorporated, announced that Terry's "Aesop's Fa-
bles" would appear every week and would be distributed by
Pathé. Van Beuren, who had made a fortune distributing
Mutoscopes, found a backer in the giant Keith-Albee thea-
ter chain. They would underwrite the studio's expenses
and guarantee bookings.[28] The company went on to be-
come the most proficient and profitable one of the decade.
"Aesop's Fables," thanks to production shortcuts and little
concern for quality or originality, never once missed its
weekly release schedule. Many of the films were obvious
potboilers, but since distribution was ensured so was the
studio's income.

The 200th "Fable" provided Terry with the occasion to
discuss his techniques in 1925.[29] The staff consisted of
eighteen artists. Terry would write a "script" and "cast" the
film using one of his repertoire of characters. Next back-
grounds were prepared—with great detail, since the aim
was to reuse them in other films whenever possible. Terry
recognized a division of labor among his animators: "Each

The Animation Shops

animator is assigned scenes requiring the type of characters which lend themselves best to his talents." In-betweening at Fables was done on tissue paper so that the movement could be checked by stacking the drawings. Then tracers transferred the drawings to cels. Black, white, and gray tempera were used for shading, then washed off after photography. Registration was obtained by the standard peg system. The "supervisor" would inspect the cels, number them, and enter instructions on an exposure sheet. The cameraman would mechanically follow the exposure sheet's indications. Then the film would be ready for developing, titling, and editing.

Among the important animators working for Terry were John Foster, Mannie Davis, Bill Tytla, Hugh "Jerry" Shields, and Harry Bailey. In 1928, Van Beuren bought out Keith-Albee's share and formed the basis of his own studio. Terry departed but remained active until he sold his Terrytoons company to CBS in 1955.

Raoul Barré and Charles Bowers

In the technical realm, Bray's only real competitor was Raoul Barré. This pioneer was as colorful as Bray was plain, as unlucky in business as Bray was fortunate. Born in Montreal on January 29, 1874, he was sent to Paris to study art at the Ecole des Beaux-Arts. During the 1890s he contributed to the popular illustrated press. An early drawing (figure 69) shows that his strong linear style was developing, but some problems with anatomical proportions remained.

When he returned to Canada, Barré was the first to introduce the French-style album of the type drawn by Caran d'Ache. He penned the first Québécois comic strip.[30]

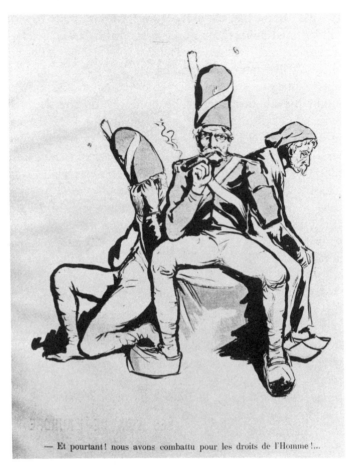

— Et pourtant! nous avons combattu pour les droits de l'Homme!...

Figure 69.
Raoul Barré, "Quatre-Vingt-Treize," *Le Sifflet,* March 3, 1898.

The Animation Shops

In 1912, Barré had moved to New York and there saw an unidentified animated film. He visited the Edison studios, where he met William C. Nolan (1894–1954), who was shooting live-action advertisements. The two of them set out to make a cartoon. Now there is an intriguing but totally hypothetical connection here with an anecdote told by Emile Cohl in his later years. During his 1912–13 stay in Fort Lee, N.J., Cohl was visited by two mysterious strangers, and, against his wishes, was asked to reveal his methods to them. One was talkative; one was silent, wore glasses, and studied Cohl's work intently. Is it possible these two men were Nolan (the talkative one) and Barré (the one with glasses)? The Eclair studio was only a short walk from Edison's, so it would have been natural to pay a visit if one wished to learn animation directly from the source.

Barré developed a streamlined animation technique that was essentially the inverse of Cohl's decoupage system. Instead of moving cutouts over a background, he cut a hole in the background and laid it over the moving elements, which were simply retraced drawings on paper. This was refined into what became known as the "slash" (or sometimes "slash and tear") technique (figure 70). This was also used for figures: a character was drawn and photographed; then the moving limb was torn away and a new one, in its new position, was drawn on the next underlying sheet. The resulting new picture was photographed, and the procedure continued. In the hands of an expert, the slash system worked almost as well as cels, and it was not an infringement. Barré cleverly designed backgrounds that disguised the fact that they rested on top of the moving elements. Success depended on accurate registration, and to ensure it Barré used a punch to perforate the sheets so they could be stacked vertically in perfect alignment on fixed pins. This was the original "perf and peg" system, still in use.

Before Mickey

(a)

(b)

(c)

Figure 70.

Bill Nolan, drawings illustrating operation of the "slash system." The lower part of the sheet (a) is torn away and placed over the background (b), resulting in composition (c). The tearing is repeated for each exposure.

At the same time that Bray was assembling his first studio (or just before; the dating is uncertain), Barré was bringing together a group of men for a similar function. Nolan was the first "foreman," and among the young cartoonists were Gregory La Cava, Frank Moser, and Pat Sullivan. George "Vernon" Stallings joined around 1916.

In May 1915 the "Animated Grouch Chaser" series was begun by Edison. These were essentially live comedies with two- or three-minute cartoons inserted. *Cartoons on the Beach,* for example, shows a young man enlivening a bored beach party with a comic album. He opens to various pages and the animated sequences "Mr. Hicks in Nightmareland," "Silas Bunkum's Boarding House," "The Kelly Kid's Bathing Adventure," and "A Sand Microbe Flirtation" are inserted. Meanwhile, a live-action romantic comedy is progressing between the cartoon inserts.[31]

Barré stopped supplying the "Phables" to IFS in 1916 and eagerly accepted an offer to adapt the successful "Mutt and Jeff" strip.

In 1915, Harry Conway ("Bud") Fisher (1885–1954) had turned to Charles Bowers (who was making "Hans and Fritz" in his Mount Vernon studio) with his idea for a screen version of his strip. At that time, Fisher was emerging from a crucial turning point in his career; he had just resigned from Hearst's papers after eight years of service and gone to the rival Wheeler Syndicate for more money and creative freedom. Hearst, whose pride and circulation figures were wounded by the popular artist's departure, hired Billy Liverpool to continue the strip. Fisher sued for and won the rights to his own characters after proving he had copyrighted them in 1907.[32] No sooner was he free of Hearst than he contacted Bowers; their Celebrated Players began offering state's rights in January 1916. The films were short at first (four minutes), but they would appear

every week. *Jeff's Toothache* and *Mutt and Jeff in the* *Submarine* premiered in Chicago in March, and by August seventeen films had been completed.

In late 1916, Bowers approached Barré and offered to go into partnership. It looked like a good deal for both: Bowers was interested in Barré's facilities in the Fordham section of the Bronx; Barré desperately needed a salable cartoon commodity (as well as a crew, since his had been snatched by Hearst). The new combined staff included George Stallings, Ted Sears, Mannie Davis, Burton Gillett, Dick Friel, Dick Huemer, Ben Sharpsteen, Bill Tytla, and even guest "celebrities" like Milt Gross. An extraordinary number of animators spent time "passing through" Barré-Bowers.

Dick Huemer, who had just quit high school, was employed as a tracer. He recalled that cels were already in use by around 1916, but as background overlays:

The staff consisted of about five animators and about five or six tracers. Actually, there weren't more than 15 people at the studio. Barré made one film a week, and that never ran over 450 feet. . . . The Barré studio was in an enormous bare loft, about 100 feet by 75 . . . without any breaks . . . well, yes, a wall for an office. The studio part had these long benches, with room for three or four light boards on each side, facing each other. . . . No refinements, no, indeed. No curtains or carpets. We had bare flooring.[33]

The Barré-Bowers product was marketed on a state's-rights basis through the "Mutt and Jeff Film Exchange." All this had been arranged by Bowers while Fisher was in Europe serving in the Canadian Army. When Fisher returned in early 1917, he took over control of the entire operation by forming the Bud Fisher Films Corporation (figure 71). The first of this new series of fifteen cartoons was released June 9, 1917.[34]

Fisher and Bowers set up a studio at 2555 Webster Av-

The Animation Shops

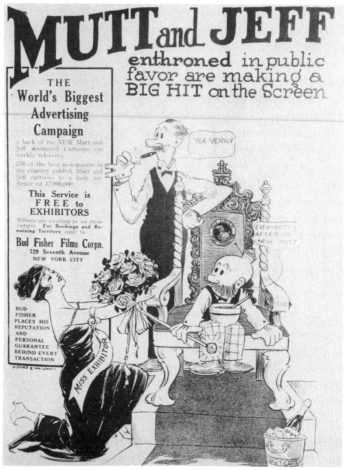

Figure 71.
Advertisement for "Mutt and Jeff," *Moving Picture World,* August 4, 1917 (Bud Fisher Films Corporation, 1917).

enue in the Bronx, with Joseph Pincus as the general manager, and a lucrative contract was signed with Fox to distribute the films.[35]

Gradually it occurred to Raoul Barré that he was being squeezed out of the operation. In 1919, exhausted and depressed after realizing that his partner had been cheating him, Barré retired from the animation business in disgust. But the films continued without interruption, even after Bowers was fired by Fisher. After a reconciliation, around 1920, the cels were being drawn in Mount Vernon and photographed in Fordham.[36]

By this time the exploits of the lanky Mutt and the short, muttonchopped Jeff were the favorites of millions of fans—not one of whom knew that Fisher had hired Billy Liverpool to ghost the strip (again), leaving him free to luxuriate. Nevertheless, Fisher continued to claim authorship of the cartoons. For instance, he commented about the many unsolicited scenarios received from viewers that "There are always a number of scenarios offered to us, but I find it best to confine myself to my own plots. . . . We don't produce anything that can be acted by live actors." This was nothing more than ballyhoo; Dick Huemer confirmed that Fisher was seldom seen around the studio.[37] Fox released 52 Mutt and Jeff films every year until 1922, when a biweekly schedule was substituted. During the apparent height of the series' popularity, in 1921, the Bud Fisher Film Corporation and Bud Fisher's Mutt and Jeff Cartoon Corporation were both dissolved, apparent victims of the cartoonist's extravagant spending.[38] When Fisher's lawyers were going over the books, they discovered that Bowers had been padding the payroll and reassigned his rights to the "Jefferson Film Corporation," which was headed by Dick Friel.

There was a Mutt and Jeff revival in 1925 when Burt Gillett formed "Associated Animators" with Dick Huemer,

The Animation Shops

Ben Harrison, and Manny Gould. They released 13 films a year in 1925 and 1926. Then the Short Films Syndicate distributed the series in 1927 and 1928, before it sputtered out. In all, there were probably over 500 Mutt and Jeff cartoons released.[39]

Raoul Barré, meanwhile, was painting and becoming tired of his retirement at Glen Cove, Long Island. In 1926, he joined the Sullivan studio and helped animate some of the finest Felix the Cats for a year before returning to Canada and becoming involved in politics and art education. He died in Montreal in 1932. Among Barré's long-lasting contributions were the refinement of animation processes used by many as supplements to cels, the organization of the studio system into an efficient chain of command, and the apprenticeship of a dozen or so young animators who went on to work in the studios of Hearst, Bray, Bowers, Lantz, Disney, Columbia, and Warners.

···
Diffusion

After the war, there was a boom in animation production. No longer was it confined to New York City; it had spread to the "provinces." Among the many factors contributing to this diffusion, the vulgarization of the processes in books and periodicals was of paramount importance. In *How Motion Pictures are Made,* published in 1918, Homer Croy devoted a chapter to "The Making of the Animated Cartoon." Among his revelations was that the authors of comic strips had nothing at all to do with their screen adaptations. John Robert McCrory's *How to Draw for the Movies* was published in Kansas City the same year. Bert Green revealed the workings of the Moser studio in *Motion Picture Magazine* in 1919. Perhaps the most detailed technical

description was that by Carl Gregory, *Moving Picture* *World*'s cinematography editor, in his 1920 *Course in Motion Picture Photography*. Gregory reproduced charts and photographs provided by the studios (figure 72).

The first book devoted solely to the craft was *Animated Cartoons; How They are Made, their Origin and Development* by former caricaturist Edwin G. Lutz.[40] This book became the vulgate of modern industrial animation, canonizing the major studios' practices. Its guiding philosophy was embodied in the statement that "of all the talents required by anyone going into this branch of art, none is so important as that of the skill to plan the work so that the lowest possible number of drawings need be made for any particular scenario."[41] Lutz illustrated the book with his own rather quaint drawings. He described peg registration, in-betweening, speech balloons, and studio organization, but curiously his description of cels was limited to their use as static overlays.

Lutz's book was a fountain of common-sense advice, such as limiting dialog so that films could be sold in foreign countries. Among its most important contributions were the detailed instructions for drawing perspective runs (figure 73) and other kinetic effects, which would grow increasingly visible throughout the 1920s, especially when combined with mobile and cycled backgrounds. Cycling, supposedly invented by Nolan, consisted of a sequence of eight drawings planned to match at the end of a cycle by making the first and eighth drawings identical. This effect may be seen in practically any 1920s studio production, but Paul Terry seemed to especially love it. With these and all the other techniques explained in detail, almost anyone with the ambition could begin making animated cartoons. Of these neophytes, certainly the most ambitious reader of Lutz was Walt Disney of Kansas City—who, because he could not afford to buy it, checked the book out of the public library.

The Animation Shops

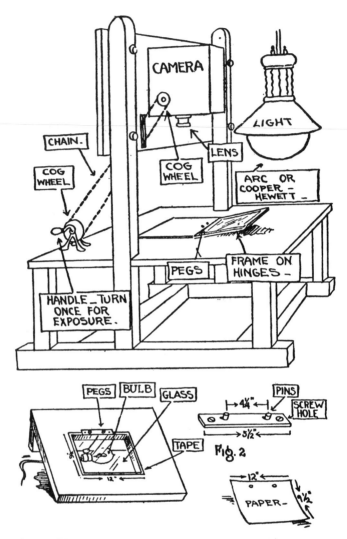

Figure 72.

"Figure showing details of the construction of a camera stand for making animated cartoons and diagrams," from Carl Gregory, *A Condensed Course in Motion Picture Photography*, © 1920.

PHASES OF MOVEMENT FOR
A PERSPECTIVE RUN.

Above: In the last of the series—on
the right—the figure has taken a
position nearly that of the first
of the series.

Below: How the figures are placed
with respect to each other when
drawn on separate sheets of paper.

FOUR POSITIONS FOR A
PERSPECTIVE RUN.

Below: How the drawings are
placed on the separate sheets
of paper.

Figure 73.

"Perspective runs," diagrams from Edwin Lutz, *Animated Cartoons,* © 1920.

The Animation Shops

Walt Disney, Winkler, and Powers

Walter Elias Disney (figure 74) was born in Chicago on December 5, 1901.[42] He escaped a trying adolescence by joining the Red Cross ambulance corps and going to France in 1918. Upon his return, he decided to set up a commercial art studio with a Kansas City friend, Ubbe Iwerks (1901–1971). This was the beginning of a lifelong association, which survived despite a falling-out in the 1930s. Yet Iwerks lived so much in Disney's shadow that only recently has his career been studied seriously.[43] It became apparent immediately, in January 1920, that the Iwerks-Disney Commercial Artists enterprise was not going to keep them solvent, and soon they were both working for a shaky lantern-slide manufacturing concern called Kansas City Film Ad, and began using Lutz's book to make semianimated promotional shorts. As Disney recalled, "We made animated advertising films, and my boss let me take home an old camera that was lying around. I rigged up a studio in a garage and started experimenting in my spare time. At the slide company we used the old cut-out method of animation, joining arms and legs together with pins and moving them under the camera. I found a new method of animation in a book from the library, tried it out and convinced my boss it was a better system, so he installed it."[44]

Kansas City was an "exchange town," and therefore a center of film distribution and commercial activity in the midwest. One of the most influential men there was Frank Newman, operator of a chain of theaters and frequently the subject of anecdotes in the national trade press. Disney approached him and agreed to supply his theaters regularly with "Newman Laugh-O-Grams". Although these short, partially animated films were popular locally, Disney's 1922 attempt to break into the big time by forming Laugh-O-Gram Films, Incorporated, failed and the company went

Figure 74.
Walt Disney, 1921. From *Newman's Laugh-o-grams.*

The Animation Shops

bankrupt. He joined his brother Roy in California in 1923, becoming the first major cartoon producer to work out of Hollywood. Before leaving Kansas City he sent letters to all the independent distributors in hopes of finding a backer for a new series to be called "Alice Comedies." To his relief, Margaret Winkler in New York agreed to look at his sample reel.

No survey of the rise of the animation industry would be complete without briefly mentioning Margaret J. Winkler (figure 75). Not herself an animator, she was the first woman to produce and distribute animated films. She described her preparation in 1924: "I have been [distributing] for three years now. . . . I had seven years of good training for it too, working for Warner Brothers. I was secretary to Harry M. Warner and as such traveled from New York to the West coast and around to film conventions meeting film people and learning much."[45] Margaret Winkler's first professional contact with animation came in 1917 when Warner Brothers—at that time only distributors—bought the rights to Barré-Bowers's "Mutt and Jeff" for the states of New York and New Jersey. In 1921, "Out of the Inkwell" became a Warners product. Winkler quit, set herself up as an independent distributor, and convinced Fleischer to sign a contract for her services. Koko the Clown's success established her reputation, and in the following year Sullivan also signed with her to distribute Felix. Thus she was the sole agent for two of the most popular series of the early 1920s. She expanded her business in 1924 by adding "Burton Holmes Travelogues" (formerly a Bray subject) and "Kid Kapers Komedies" (two-reel imitations of Hal Roach's new "Our Gang"). With this prosperity came a marriage, to Charles B. Mintz (1889–1939). Mintz had begun working as a Warner's booking agent in 1915 and had risen into the front office. Margaret gradually relinquished the reins of her business to her aggressive husband and to his

Figure 75.
Margaret J. Winkler Mintz, 1924.

The Animation Shops

brother Nat L. Mintz, who was named sales representative. Margaret's brother George also entered the successful family business, which retained the name Winkler Pictures.

Disney's letter reached Winkler at the best possible moment, for she was trying to expand her market in 1923. She contracted for six Alice pictures in October, and the first was ready for release in the spring of 1924. Disney needed competent animators in a hurry and appealed to his friends and former workers in Kansas City. Iwerks and Hugh Harman agreed to join the Disney Brothers Studio, and these draftsmen, more talented than Disney, took on the responsibility for the graphic design and animation. Others from Kansas City made the trek, including Rudolf Ising, Carman Maxwell, and—later—Friz Freleng. Later to be famed for his work in the Warner Brothers studio, Freleng came on the recommendation of Harman after some dickering with Disney through the mail. (This was in 1927, when the Oswald films were in production.)

Freleng learned a fact about the Disney studio that is often glossed over in the authorized biographies: Disney could be a harsh taskmaster, severe and not always reasonable in his criticism. The many early defections from his staff were the results of his high-strung temperament and his inability to work harmoniously with his men. Freleng was hurt by Disney's frequent stinging personal remarks, and finally he left to work on "Bosko," which Harman and Ising were starting at Warners. He still recalls the competitive atmosphere of animation in the 1920s: "Everybody was conspiring against the other one. . . . Everybody had ambition; everybody wanted to be a producer and there was no one to work with."[46] Disney, the naive boy from Kansas City, would soon learn the hard facts of 1920s cartoon life.

Margaret Winkler seems to have been a straightforward businessperson, but not so her husband, a wheeler-dealer in the grand style. He goaded Walt Disney about the quality

of the "Alice" films—to good effect, as Disney himself ac- knowledged—and was instrumental in persuading Disney to develop the "Oswald" character. Universal released the series in March 1927, mistakenly (as was characteristic of Universal) advertising it as "Oscar":

Universal Announces Release of "Oscar the Rabbit" Cartoons. One of the first releasing companies in the business to make and release animated cartoons was Universal. Windsor McKay's first pictures went through Universal's hands, many of Pat Sullivan's, Hy Mayer's and the only cartoon ever made by Milt Gross, called *In the Dumbwaiter,* was a Universal product. Ten years ago Universal ceased to make them, and from that time to this, no animated cartoons have played any part in the Universal program.

Exhaustive investigations of the market and the demand on the part of theaters for a really funny animated cartoon have convinced the Universal sales force that there is an exceptionally good field for animated cartoons made, released and backed by a reputable international releasing corporation. For three months negotiations have been going on with various cartoonists and manufacturers of animated cartoons. As a result of this, a contract was entered into between Universal and Winkler Pictures for twenty-six cartoons, the first of which is to be delivered in time for release September 1st.

The cartoons will be drawn by Walt Disney about the fortunes of a rabbit named Oswald, an exclusive creation of the artist, which the sales force is already designating as the Welsh Rabbit or the Lucky Rabbit. They will be released under the brand name of Snappy Comedies. The contract was signed on March 4 between Charles Mintz, President of Winkler Productions, and R. H. Cochrane, Vice President of Universal. Mr. [George] Winkler took the train Saturday for California where he will establish a specially constructed studio for the purpose of turning out these Oswald comedies.[47]

In July, *Trolley Troubles,* the first Oswald, premiered at

The Animation Shops

the Roxy in New York and at the Criterion in Los Angeles, and it was followed quickly by *Great Guns* and *The Mechanical Cow*. The reaction to the new character was enthusiastic.

The technical excellence of the first Oswald films reflected the extra time that had gone into their planning and production. The aerial "dogfight" in *Great Guns* is an impressive ballet of plastic forms moving in space. The anthropomorphic planes even cast accurate shadows, an effect calculated to imply mass and volume. Perspective backgrounds and 54-frame laterally moving backgrounds are among *The Mechanical Cow*'s special attractions. Carefully constructed sight gags, as when Oswald reverses the cow's head and tail to change directions, led to the immediate and justified success of the series. Assessing the Oswald films at the close of their first year, *Moving Picture World* reported that they had "accomplished the astounding feat of jumping into the first-run favor overnight."[48]

By the time the above compliment was printed, Walt Disney had lost Oswald. Charles Mintz had plotted and carried out a coup, luring away most of the staff and convincing Disney that Oswald was his property. However, he did not convince Carl Laemmle, head of Universal. Mintz's studio produced Oswalds for a year in New York; then, in 1929, Universal put Walt Lantz in charge of his own Oswald studio in Hollywood to replace Mintz. The Oswald charcter underwent many successive changes in appearance (changing shape and from black to white) and in personality. He lasted a decade, though, until he was replaced at the Lantz studio by Woody Woodpecker.

Mintz's plot to make Disney his vassal ultimately failed. The experience convinced the animator that in the future he would have to control as much of his own operation as possible. As for Mintz, in 1930 he continued as an independent producer, releasing through Columbia. Margaret

Before Mickey

Winkler Mintz, the pioneer who holds the amazing distinction of having "discovered" the Fleischers, Sullivan, and Disney, faded quietly into oblivion.

Disney fought back with Mickey Mouse. Iwerks completed *Plane Crazy* in May 1928, and then *Gallopin' Gaucho,* but no distributors were forthcoming. So Disney decided to make a bold break and join the sound revolution.

By 1928 the "talkies" had clearly arrived; it was just a question of which of several incompatible technologies would capture the largest share of the market. Still innocent of all the technical requirements, Disney and Iwerks went ahead with *Steamboat Willie* assuming that somehow synchronized music and effects could be added. This was not just an act of faith; the Fleischers had been issuing "Song Car-Tunes" with optional De Forest Phonofilm soundtracks throughout the 1920s, and (although Disney was probably not aware of it) Terry was preparing his own synchronized cartoon. It is a little-known fact that Terry "scooped" Disney with *Dinner Time,* which was announced on August 18, 1928 and premiered at the Mark Strand in New York on or before September 1: "Van Beuren Enterprises announces that *Dinner Time (Aesop's Film Fables)* has been synchronized with the RCA Photophone. All the animals of the jungle as pen-and-inked in animation in Aesop's Fables will annunciate aloud in their more or less natural 'voices,' it is said. A background of orchestral music is offered throughout the reel."[49] Disney was accorded a "sneak preview" when he attempted to interest RCA in recording his own film. In a letter to Roy Disney and Ub Iwerks, he exclaimed "MY GOSH—TERRIBLE—A lot of racket and nothing else. I was terribly disappointed. I really expected to see something half-way decent. BUT HONESTLY—it was nothing but one of the rottenest fables I believe that I ever saw, and I should know because I have seen almost all of them. It merely had an orchestra playing

The Animation Shops

and adding some noises. The talking part does not mean a thing. It doesn't even match. We sure have nothing to worry about from these quarters."[50]

That Disney was far ahead of all other animation producers in making sound cartoons is a myth. Regardless of quality, by November 1928 both Van Beuren and Mintz had announced that they had converted to all-sound production for "Aesop's Fables" and "Oswald," although these were actually postsynchronized silent films. The Fleischers' Paramount "Song Cartoons" began in December.[51] It is, however, indisputable that of all the producers Disney had the strongest desire to master sound technology for its own sake. What makes his accomplishment even more impressive is that he succeeded as an independent without corporate backing. Instead he relied on Pat Powers, a stranger to neither the business of cartoon production nor film sound.

Patrick A. Powers was an erstwhile huckster who had allied himself with Carl Laemmle in his battle against the Motion Picture Patents Company and thus gained a toehold in Imp and then in the Universal Film Manufacturing Company. In 1916 he began distributing independently made cartoons through Universal, including the early works of Sullivan and Messmer. Within two years Powers had acquired sufficient influence to give up producing and rise into the management ranks of the Universal organization.[52] But Powers's aggressive practices antagonized Laemmle, who bought out his stock and then immediately fired him. As an independent producer, Powers anticipated the rush to sound conversion and made an abortive effort to take over control of the De Forest Phonofilm Corporation in June 1927. Undaunted, he engaged two engineers, R. R. Halpenny and William Garity, to develop "Powers Cinephone," a sound-on-film system virtually identical to Phonofilm.

Before Mickey

Figure 76.
Walt Disney and Ub Iwerks, *Steamboat Willie* (Powers Cinephone), © 1928. Note hand-drawn "bouncing ball" at left of each frame to mark 4:4 time for orchestra.

The Animation Shops

　　It was on this Powers system that Disney recorded the track for *Steamboat Willie*.[53] After numerous difficulties with orchestra leaders and with synchronization systems, Disney resorted to inking "bouncing balls" onto the print to maintain the beat (figure 76). The film was premiered—without a distributor—at the Colony Theater in New York on November 18, 1928. *Moving Picture World* reported the following: "Mechanical interchangeability was further demonstrated Sunday when the Colony Theater here exhibited a one reel cartoon subject drawn by Walter Disney and recorded by Powers Cinephone. It was shown on the Western Electric device. . . . The cartoon called *Steamboat* is also said to be the first cartoon subject to be made specially for sound."[54] And animation entered a new era.

A Postscript

To avoid the risk of leaving the impression that the animation shops of the 1920s were all orderly assembly-line operations, I close this chapter with a quote from "The Animated Cartoon" that gives a glimpse into a typical 1927 studio.

A movie cartoonist has to be more than *just a little bit crazy,* he must in most cases be a raving maniac. In the beginning he must have the endless source of perfectly silly ideas and then in order to work them out so as to provoke laughs in the theater, he has to have the qualities of a butcher, a carpenter, musician, actor, soldier—and—and even though they are all *girl shy*—they must even know how to be a "Sheik or great lover."

　　God only knows what a vast number of things a movie cartoonist has to study and observe before he can do his day's work. In fact, everything from how a snake makes love, to cooking a Spanish

omelet in an Irish restaurant. It is not unusual in a cartoon studio to see several artists doing high dives off their desks, or playing leap frog, maybe doing a dry swim on the floor while several others stand by and watch to study the timing of the action.[55]

The Animation Shops

Commercial Animation in Europe

While the American animation industry was refining its production methods during the teens and the twenties, Europeans were not watching idly from their café terraces. This chapter, a kind of interlude, examines this period of comparable activity and Europe's struggle to compete against the commercial domination of the American cartoon.

The mood among animators in Europe in the twenties was a mixture of bitterness, frustration, and envy. For all their expenditure of energy and resources, their efforts were scarcely appreciated in their own countries and later were sometimes dismissed altogether. In his 1948 book *Le Dessin animé*, Lo Duca wrote the following: "In Europe the animated cartoon has never attained the slightest industrial force. Except for old German publicity films and some Russian cartoons, there has never been the continuous production necessary for future development."[1] His diagnosis was harsh: "The artists' timidity, the slackness of capital, not to mention ignorance of what cinema is, has caused the European origins of animation to be forgotten."

Lo Duca viewed the accomplishments of his countrymen through the filter of the postwar, post-Disney attitude toward animation, and his book is symptomatic of the typical ease with which silent European animation has been written off.

The effects of the 1914–1918 war devastated the film industry in general. When the hostilities began, the huge flow of exports to America slowed and then ceased. One by one the large companies divested themselves of their American branches, then began paring their domestic production as well. Inevitably, European exhibitors began relying on American movies to fill their screens. Their audiences seemed to prefer these westerns, comedies, and lavish romances to the European wartime films. After the war, European governments' resistance to imported films in the form of tariffs and quotas proved ineffective. By the mid-1920s, most of the major production companies were controlled by American studio money. When American movies came over, they were often accompanied by American shorts. Thus, the low point of the European film economy coincided precisely with the rise of the American studio cartoon; the Europeans found themselves without a market, facing stiff competition with few funds.

The situation in France reflected that in Europe as a whole, with the added twist that the first cartoon series to be imported in 1913 was that of the French inventor of the cartoon, Emile Cohl. Eclair translated the titles of the prewar "Newlyweds" and released them after a delay of eight months. Why "Snookums" was rechristened "Zozor" is slightly mysterious, since he had been known as "Petit Ange" in the French version of the comic strip. The release schedule was abandoned because of the war, but other American-made Cohl films were eventually distributed in France.

In March 1916, the flood of overseas imports began with Gaumont's announcement that it would soon launch "a series of films in which the skill of execution will complement the wittiness of the humor."[2] These were the 1915 "Animated Grouch Chasers" of Raoul Barré. In contrast with the early days when Gaumont advertised Cohl's ani-

Before Mickey

mation only as "trick shots," these new imports were given an American-style promotion, including press releases and full-page ads. One ad (figure 77) even included a portrait of Barré at his easel, though the likeness was imaginary. *Chez le coiffeur* (*Cartoons in a Barbershop*) met with success in April. And *Sur la plage* (*Cartoons on the Beach*), one reviewer said, "attests once again to the virtuosity and variety of this graphic artist's imagination."[3] The release of twenty Barré films in less than a year testifies to the depth of the inundation.

Not to be outdone by Gaumont, Pathé reacted by programming Bray cartoons under the "American Kinéma" brand. Carl Anderson's "Police Dog" series appeared under such titles as *Deux Dogues pour un os* and *Chien et chat*. Carlson's "Dreamy Dud" Essanay films were distributed by the Agence Générale Cinématographique (AGC) under the series title "Master Bob."[4]

Charles Chaplin's films had been appearing in Europe since 1915, and audiences there could not see enough of him. Gaumont was the first to announce animated facsimiles. In July, Kinéma Exchange introduced a series of cartoons featuring "Charlot" that supposedly had been "executed under the direction of Charles Chaplin" (figure 78). Both Essanay and Keystone threatened suits to protect the Charlot trademark, forcing the distributor to call his series "Charles Chaplin." Competition became vicious. Beaumont Film's *Charlie et l'éléphant blanc* (an American release animated by Otto Messmer) was soon available in a pirated print from another distributor with the unlikely name of Monopole-Fred. The sources of these and many other films are difficult to identify, but most were undoubtedly American in origin.[5]

Beginning in 1918, the major distributors had signed contracts that would make distribution more efficient. P. A. Powers's films were circulated by AGC, so Follett's "Fuller

Figure 77.
Advertisement for "Les Dessins Animés de Raoul Barré," 1916.

Figure 78.
Advertisement for "La Série Comique Charles Chaplin," 1916,
based on drawing by Otto Messmer.

Pep" and Messmer and Sullivan's "Sammy Johnsin" became visible after an even shorter delay. By far the most important deal was the one consummated between Aubert and William Fox to distribute Bud Fisher's "Mutt and Jeff," the series that would prove the futility of trying to compete with the Americans on a film-for-film basis. The Bowers studio had a backlog of these cartoons ready to go immediately. The two stars, known as "Dick et Jeff," took French audiences by storm. Continental producers must have been awestruck by the once-a-week release schedule, the length of 150 meters each, and the fact that the films consisted entirely of animated drawings. The films were consistently praised by reviewers, as in the following example: "These animated cartoons are among the best of the genre. Their extreme originality, the fantasy of the subjects, the irresistible figures of Dick and Jeff, and their general attitude reveal an incomparable talent and inimitable wit on the part of the artist. The comic spontaneity of our two heroes surpasses in buffoonery and picturesque drollery anything even the sharpest humorist can imagine."[6]

By 1920, Mutt and Jeff and all their American relatives were an accepted fact of French screen life, and would remain so well into the sound era. The pattern was much the same in other European countries. Considering the swiftness and thoroughness of this dramatic takeover, it is somewhat surprising that any European animation persisted at all, yet throughout the teens and twenties a few hardy animators managed to resist, sometimes heroically.

The Trickfilm Tradition

The Méliès-style *féerie*, moribund since about 1908, was kept alive by pioneer Walter R. Booth and a handful of his British compatriots. Booth's films must have retained some spark of commercial appeal, because they were reissued throughout the war years. The most productive period for this dean of British tricksters lasted until 1911. Then he left his full-time position with Urban to release films through Kineto (an Urban subsidiary) and Kinemacolor. These latter 1912 productions, made in collaboration with Theo Bowmeester, might have included the first animated sequences in color; this will not be certain until prints are located.[7]

Arthur Melbourne Cooper was Booth's chief competitor. This versatile filmmaker began as Birt Acres's cameraman in 1898. The primitive advertisement *Matches Appeal* (1899) shows Cooper's early grasp of the principles of stop-motion photography, but he also directed comedies and dramas as well as trickfilms. *Dolly's Toys* (1901) may have also used animation, or a variant of Booth's stop-action substitution. Cooper's animation career really commenced in 1904 with *The Enchanted Toymaker,* produced by R. W. Paul. This film also marked the beginning of Cooper's long infatuation with the theme of Noah's Ark. *The Fairy Godmother* (1906) featured a child who stared in amazement as the animals in his toy ark paraded around his sleeping nanny, and Noah's beasts were the stars of the 1909 *Tale of the Ark*. In 1908, Cooper made another animated match film and *Dreams of Toyland* (figure 79). *Wooden Athletes* and several fairy-tale adaptations released through Empire Films in 1912, the *An Old Toymaker's Dream* and *Larks in Toyland,* ended his career on the eve of the war.[8]

Figure 79.
Arthur Melbourne Cooper, *Dreams of Toyland* (R. W. Paul, 1908).
Courtesy of National Film Archive.

The Topical Sketchers

The lightning sketch act, which seems to have originated in England, took much longer to metamorphose into the animated cartoon there—perhaps owing to the more tenacious traditions of the music hall.[9] The war injected new vitality into this old cinematic chestnut. Harry Furniss (figure 80), certainly the most colorful of the sketchers, made *Peace and War: Pencillings by Harry Furniss* and *Winchelsea and its Environs* immediately upon his return from the States, where he had worked for Edison. The content of these sketches was pure propaganda. The best gag in *Peace and War* was a picture of the Kaiser receiving a pummeling from a kangaroo.[10]

The war also provided material for former illustrator Lancelot Speed. As if living up to his name, he began making lightning sketches for Percy Nash's Neptune Films in 1914. A typical episode from this series of "Bully Boy" films showed Speed at his easel, drawing the Kaiser (figure 81). As German cannons destroy a church, the eagle on Wilhelm's helmet is transformed into a devil. The British bulldog enters and devours him.[11]

Among the competition were Dudley Buxton's "War Cartoons" (produced by Tressograph), George Ernest Studdy's "War Studies" (Gaumont), and Dudley Tempest's "War Cartoons." Sidney Aldridge and Ernest H. Mills joined in with their drawings in 1915–16. Favourite Films distributed *"A Pencil"* and *Alick P. F. Ritchie,* which captures the flavor of all these split reels. We see the artist at his easel drawing a turkey, which falls into a pot of soup. Next a turkey and a man point to the Great Sphinx, then fall into a pit. Prominent captions explain this obtuse political allegory to the audience. Ritchie continued with his "Frightful Sketches" series in 1916.

Another topical sketcher was Anson Dyer (1876–1962),

Figure 80.
Harry Furniss, 1912.

Figure 81.
Lancelot Speed, *Bully Boy* (1914). Courtesy National Film Archive.

Before Mickey

who described himself as an "ecclesiastical artist with an interest in the theatre." Although unorthodox, this is nonetheless accurate, as he had worked as designer of stained glass windows for over twenty years.[12] When the war brought the loss of this job, Dyer's friend Dudley Buxton enticed him to audition for a role in a dramatic film. This was unsuccessful, but he was taken on in the animation department. In addition to one-shot propaganda shorts, Dyer combined his talents with those of Buxton in 1915 to do "John Bull's Animated Sketch Book," and managed to release a film a month for over a year. The pair moved in 1916 to the Broadwest Company, where Ernest Mills joined them in turning out Kine Komedy Kartoons, still mostly political in content. *Peter's Picture Poems* (1917), for example, showed Peter writing "a picture poem about the Kaiser, in which the Kaiser looks at the word Russia and thinks that if he could get Russia within his grasp, he need only add the letter P to form Prussia. He makes a grab for it and tries to rearrange the word but the letters USA object. A fist appears and hits him; the Kaiser, stunned, sees stars and stripes which arrange themselves into the American flag."[13] Dyer joined Hepworth Picture Plays in 1918 and remained active until 1922, producing a series of Shakespearian spoofs, animated sequences for live-action films, and occasional political shorts. His best films from this period are the fairy tales *The Three Little Pigs* (1918) and *Little Red Riding Hood* (1922). Thereafter he worked only on live films until he established an animation studio in the 1930s.[14]

Meanwhile, Dyer's partner Buxton was busy with his own films. A 1917 Broadwest Kine Komedy Kartoon had one of the strangest plots of the time: "The man in the moon visits a war-devastated scene and comes across an old man who pretends to be the sole survivor of the war. He makes topical references to war-time England and re-

counts how an electric ray was used with devastating effect. In the end the old man turns out to be a film extra." [15] After the war Buxton collaborated briefly with Dyer on Phillips's "Film Fables" before moving on to his own character series.

Cartoons for Advertising and Instruction

Animation found a special niche in Europe in the advertising trailer. Many American animators began their careers by doing ads for local products, but left them behind as soon as fiscally possible. In Europe, though, these commercials and what are now called public-service announcements remained the mainstay for most animators and studios. They thrived on the demand for these films promoting local goods, merchants, and services.

The step from advertising to film was a small one for Marius Rossillon (1875–1946). Under the name O'Galop he had been a contributor of comic strips to nineteenth-century French humor magazines, but his lasting fame came when, around 1898, he created Michelin's tire-man trademark, the "Bibendum." [16] At some time after 1912 and before the war began, O'Galop began making advertising and didactic films for Pathé. One of these, *Le Circuit de l'alcool,* is viewable in a truncated version in the United States. This fragment, "The Drunkard's Metamorphosis," demonstrates the pernicious economy of alcoholism by showing the spirits flowing into the man at the bar while his money completes the destructive cycle by flowing into the pocket of the bartender. As the drunkard attempts to return home, lampposts sway before him in triplicate. A bottle pours hundreds of little stick figures into an asylum. In a final grim tableau, "Delirium Tremens," the straight-jacketed alcoholic writhes in anticipation of death (figure

82). The composition is an homage to André Gill's nine-
teenth-century painting "Le Fou." The film's moral seems
rather anticlimactic: "True athletes drink water only."

Another French animator, Lortac, also made his debut
through didactic releases. Robert Collard had been a stu-
dent at the Ecole des Beaux-Arts before deciding to devote
his career to caricature. In 1908, his unusual three-dimen-
sional "statuette-caricatures" (figure 83) received some no-
tice. Lortac may have entered the film business as early as
1913. In June of that year, the Minister of Finances' recom-
mendation of a film tax irritated the film producers,
including Eclair, which responded with a satire. As *Ciné-
Journal* reported it, "This critique consists of an animated
cartoon showing a skinny [Minister] Dumont using his
nose, which elongates like an elephant's trunk, to seize a
certain quantity of films from the three large French com-
panies (Eclair, Pathé, Gaumont). The ingestion of this film
provokes an enormous swelling of the stomach which is
translated into the individual's anguish and eventual explo-
sion."[17] Any further experiments were cut short by the
war, but after Lortac was wounded he returned to work at
Eclair-Journal making similar films. In May 1917, *Les Ex-
ploits de Marius,* his first nonjournalistic work, was re-
leased by Pathé-Consortium.[18]

Lortac's most important accomplishment was his estab-
lishment of Publi-Ciné, Europe's first American-style ani-
mation studio, in the Paris suburb of Montrouge in 1921.
His knowledge of how a studio operated was said to have
come from direct observation in New York.[19] There were
about fifteen on the staff, including Cavé, Landelle, Maléva,
Cheval, Quesada, Antoine Payen, André Rigal, and Raoul
Guérin. Emile Cohl was also listed, but as with the other
oldtimers Poulbout and Savignac his presence was of an
honorary nature.[20] This atelier evolved into Europe's first
full-time advertising studio, and turned out hundreds of

Figure 82.
O'Galop, *Le Circuit de l'alcool* (Pathé, 1912).

Figure 83.
Lortac, "Statuette-charge," circa 1908.

Before Mickey

commercials until 1945, when it was absorbed in a merger.
It also launched the ephemeral "Le Canard en ciné" (a pun
on the paper *Le Canard enchaîné*), a "happy newsreel" that
ran until 1923. There was another project for Lortac in
1921. With Cavé, he founded Pencil-Films in Geneva in
order to produce *Monsieur Vieuxbois,* a remarkable 35-min-
ute cartoon based on Rodolphe Töpffer's drawings. In the
late 1920s Lortac retired from the film business; he re-
turned to painting and eventually wrote fiction.

*La Tuberculose menace tout le monde (TB Threatens
Everyone)* (figure 84) is a typical early-twenties product of
the Lortac studio. The cutout figures of a lecturer and an
articulated skeleton are the only moving characters. After
a didactic hygiene lecture delivered in speech balloons, the
skeleton symbolically knocks over sideshow dolls repre-
senting people from all classes and occupations—the me-
dieval "dance of death" theme updated with animation. The
film is not graceful, but like *Le Circuit de l'alcool* it was
made only to communicate a specific educational message.

In Germany the advertising-film industry was especially
strong. Julius Pinschewer (1883–1961) was the central fig-
ure. His first animated film *Die Suppe,* which has been
dated 1911,[21] was the first of many publicity films from his
Berlin studio, where such noteworthy collaborators as Lotte
Reiniger and Walther Ruttmann practiced animation. The
surviving examples are between 50 and 75 meters long and
tinted in eye-catching colors. Perhaps Pinschewer's most
important single film was *KIPHO,* about five minutes of
shots of "apparatus used in film making and film, showing
toys associated with the development of cinematography,
extracted scenes, scenes being made."[22] Animation effects
were also included. Conrad-Guido Seeber (1879–1940),
then one of the leading cinematographers, shot the film.
Two years later he and Paul Leni launched a series of
"Kreuzworträtselfilms" in which the advertising message

was presented as an animated crossword puzzle.[23] Seeber also authored a 1927 book, *Der Trickfilm*, which was an anthology of articles that had appeared in *Filmtechnik*, a magazine he edited.

The advertising film was important in Germany not only as an industry in its own right, but also as a means of subsidizing some of the early animated avant-garde experiments. The animated films of Walther Ruttmann (1887–1941) were especially important to his training as an abstract filmmaker. *Der Sieger*, a 1920 tire commercial, already shows the same fascination with wave forms and moving geometric shapes that marked the "Opus" series. A reviewer of the first of these "lightplays" in 1921 left a graphic description of the now-lost film:

Blue roundnesses appear in rhythmic succession, opening and disintegrating into elliptical patterns. Spiny forms protrude from the edge of the picture toward the middle. Red and light green bands flutter and dance over the screen. Round and angular forms soar like birds tracing a sublime outline in a belligerent Prestissimo. A red sun throbs in its orbit and emits a pulsing colored ray. Cubical forms smash toward the center. Waves ebb and flow. And the impression left by this amorphous spectacle was: Creation.[24]

This powerful and impressive *Opus I*, with a musical score by Max Butting, was followed by three related films during the next three years. Ruttman also animated the remarkable "Falcon's Dream" sequence of Fritz Lang's *Die Nibelungen* (1926) and an abstract prolog for his own *Berlin; Symphony of a Great City* in 1927 (figure 85).

Among those awed by these experiments in rhythmic motion and color was Oskar Fischinger (1900–1967). Although he may have been the most important independent abstract animator of the 1930s and 1940s, his career has only recently been studied seriously.[25] Fischinger's early formative works from the 1920s demonstrate how his

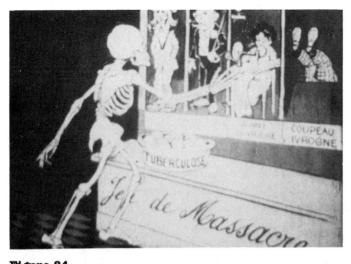

Figure 84.
Lortac, *La Tuberculose menace tout le monde* (Publi-Ciné, circa 1920). Courtesy of CNC/Archives du Film.

Figure 85.
Walther Ruttmann, *Berlin: Die Sinfonie der Grosstadt* (Fox Europa Film, 1927).

Europe

genius gradually emerged from the ooze of German commercial animation.

Bernhard Diebold, the author of the above review of Ruttmann's *Opus I,* had led the young Fischinger to the Frankfurt premier and introduced him to Ruttmann, who was very excited about Fischinger's work with a strange invention. This machine automatically sliced away extremely thin layers from a specially prepared block of wax to reveal the multicolored whorls and striations inside. When each section was photographed by an animation camera, an abstract film of moving arabesque patterns could be produced without any drawing whatsoever. Ruttmann and his studio used the machine occasionally from 1923 on, and Fischinger continued to experiment with it until 1926 as part of his ongoing investigation of techniques and styles. The *Orgelstäbe (Staffs)* films orchestrated "hard-edge" abstract shapes, while the *Stromlinien (Currents)* series seem to have been made with amorphous liquid wax. He also tried silhouette films and, around 1929, began his "Studies" with charcoal lines drawn on white paper. Over a dozen of these linear exercises, synchronized to a variety of popular songs and light classical pieces, were produced by 1932.

While this was progressing, from 1922 on Fischinger was producing advertising films in his Munich studio. In 1924 he agreed with entrepreneur and animator Louis Seel to contribute to the "Münchener Bilderbogen" ("Munich Album") newsreel, which ran from October of that year until 1926. According to his biographer Moritz, Fischinger was in charge of the series and directed animated segments featuring a character named Pierette.

Fischinger also accepted commissions for a Noah's ark sequence for Erdmannsdorffer's 1927 film *Sintflut* and for Erno Metzner's political film *Dein Schicksal* (1928). The giant UFA company brought him as a special-effects man to Berlin, where his most memorable contribution was to

Lang's *Die Frau im Mond* (1929). Assisted by his wife Elfriede, his brother Hans, and, by 1932, a staff of half a dozen, Fischinger set up a studio where he could pursue his independent work. The bread-and-butter commissions from advertising helped make the abstractions possible.[26]

Advertising and instructional films were favored with special recognition in the Soviet Union. This is not surprising, in light of the officially sanctioned status given cinema by the government. Dziga Vertov, the producer of the Kino-Pravda newsreel and later of *Man With a Movie Camera* (1929), perceived clearly the educational potential of animation. Beginning in the first 1922 installments of Kino-Pravda, animators Alexander Ivanovitch Bushkin, Alexander Vasiviliecki Ivanov, and Ivan Ivanovitch Beliakov were asked for regular contributions. Their *Soviet Toys* (figure 86), in 1923 or 1924, was the first full-reel animated film since the October revolution.[27] This twenty-fourth number in the Goskino Film Chronicle uses cutouts and transformation effects to present a tract against the "NEP" (private-enterprise partisans). The film deliberately alternates crude childish images (associated with the villain) and three-dimensional illusionism (associated with a heroic worker). In the finale, the police metamorphose into a Christmas-tree shape with representatives of NEP hanging from its branches.

Vertov zealously embraced animation in the first manifesto of his Kino-Eye group, envisioning it as an aid for scientifically concretizing abstract thought: "Film is also the art of imagining the movements of things in space, in response to scientific principles. It is the incarnation of the inventor's dream, whether he be scientist, artist, engineer or carpenter. It is possible to realize, thanks to kinokism [Vertov's program], what is unrealizable in life. Drawings in movement. Sketches in movement. Immediate future projects. Theory of relativity on the screen."[28]

Figure 86.
Bushkin, Ivanov, and Beliakov, *Soviet Toys* (Goskino, 1923 or 1924), © 1978.

There were also "advertising" films in Soviet cinemas, but they were of course for state-manufactured products. Vertov published a scenario for an animated ad in 1923: "A little boy runs down the street spreading 'magic powder' which makes everything enlarge and swell inordinately. Little dogs become as large as buffaloes. Horses become the size of mammoths. People are transformed into giants. The little boy is caught and they take the powder from him and put it to good use. They mix it with dough and the loaf of bread becomes as big as a house. The 'magic powder' is yeast made by the Trekhgorny brewery."[29] We do not know if this particular film was produced, but its whimsy is typical of the filmmaker. In *Man With a Movie Camera,* for instance, the animated Debrie camera climbs out of its case, mounts itself on its tripod, and stalks away.

Commencing in 1924, the State Film Technicum began production of cartoons on a regular basis. This work was continued until 1927, when the studio was absorbed into Mezhrabpom, but the films have either disappeared or become unavailable to scholars.

Puppets and Silhouettes

Two independent animators stand out among the other Europeans and indeed are practically the only ones who escaped from the general anonymity. Significantly, they specialized in two fields relatively unexploited in America: the puppet film, of which Starevitch became the acknowledged master, and the silhouette film, developed by Reiniger.

Wladyslaw Starewicz (figure 87), whose date of birth is given variously as 1882 and 1890, was born in Poland and attended the Academy of Fine Arts in St. Petersburg.[30]

Figure 87.
Ladislas Starevitch, circa 1920.

There are contradictory accounts of his activities before the revolution. His first producer, Alexander Khanzhonkov, told how Starewicz had been a bookkeeper who had come to his attention through newspaper accounts of his prize-winning costume designs for the Christmas pageant in Vilna, Poland. Starewicz accepted Khanzhonkov's job offer and traveled to Moscow, where he quickly learned all the tricks of the trade, including animation.[31]

In a late interview with Charles Ford, Starewicz stated that he was named director of the museum of natural history in Kovno (Kaunas), Lithuania, where he made four short documentary films on the colorful local customs and a reconstructed battle between two animated stag beetles in *Lucanus Cervus* around 1910. Upon returning to Moscow, Starewicz made a parody of the popular Danish picture *The Four Devils* using animated frogs as actors. Of the eight animated films he completed in Russia, the best is *The Cameraman's Revenge*.[32] Khanzhonkov released this little masterpiece (figure 88) in 1912. It is essentially a love-triangle melodrama of the sort one might expect from Biograph or Vitagraph, but it is acted out entirely by animated insects. Mr. Beetle is philandering at his favorite cabaret. The grasshopper cameraman takes some through-the-keyhole footage of Beetle and his dragonfly paramour at a lovers' hotel. The sets and props are realistic in scale and lighting. In an exterior view of the hotel, for instance, we watch through a window as the two insects walk up the interior staircase arm in arm. Meanwhile, Mrs. Beetle is having an affair with a beret-wearing artist cricket. Mr. Beetle returns inopportunely while his wife and the cricket are on the sofa stroking each other with their twelve legs in a way both comic and obscene. Together Mr. and Mrs. Beetle visit an outdoor garden cinema operated by the grasshopper. The audience of assorted bugs watches the footage of Mr. Beetle's amorous adventure, breaking into

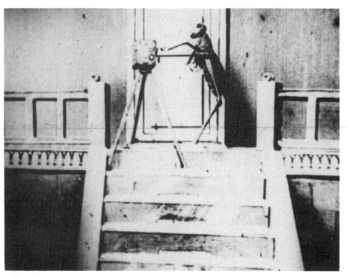

Figure 88.
Starevitch, *The Cameraman's Revenge* (Khanzhonkov, 1912).

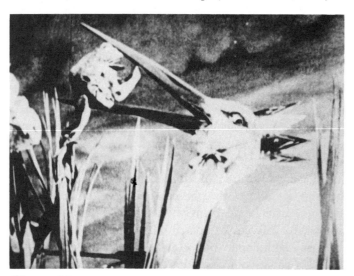

Figure 89.
Starevitch, *Les Grenouilles qui demandent un roi* (Polichinei, 1922–23).

Before Mickey

wild applause during the keyhole scene. Mrs. Beetle attacks her husband and heaves him through the screen. Their brawl causes the nitrate film in the projector to burst into flame. Then a title tells us that domestic bliss has at last been restored, and the film cuts to Mrs. Beetle berating her husband as they sit in a jail cell.

World War I interrupted Starewicz's work, and he moved successively to Josef Yermoliev, to Trofimov's Russ company, then to the government Skobelev Committee to produce patriotic features and advertisements. Starewicz directed about 60 live features, some of which were still playing in Moscow as late as 1922.[33] With the Revolution in October 1917 the film community fled to Yalta, which had become the Russian Hollywood. Starewicz—decorated by the czar for his 1913 *The Grasshopper and the Ant*—sided with the White Russians, as did most of the film people. By the time the Red Army took the Crimea in 1920, most of the cinéastes had already fled. Starevitch, as he would spell his name in French, arrived in Paris and helped establish a small but successful emigré company directed by Ermolieff (Yermoliev) and working out of Méliès's old studio. Many in this band drifted to Berlin or to Hollywood, but Starevitch, in 1922, retired to a villa in Fontenay-sous-Bois (near the present Bois d'Arcy Archives), where he devoted the rest of his life to independent production.

One of Starevitch's first French films was *Les Grenouilles qui demandent un roi* (*Frogland*) (figure 89). It was released in 1923 by Polichinei-Film and came from the same fable source as Paul Terry's 1921 *The Frogs that Wanted a King*. The plot is familiar. The peacefulness of the swamp is disturbed by one of the "croakers" who declares that democracy is "all wet" and asks Jupiter for a king. The god gives the frogs a lightning-struck stump for their ruler, but they beseech him for a replacement. This time the exasperated deity sends a stork, who during the coronation

festivities devours some of the population. Just before the original rabble rouser slithers down the stork's long neck, he delivers the moral: Let well enough alone. Oblivious Jupiter goes back to sleep. This fable might have carried allegorical overtones for Starevitch, as it had for La Fontaine. On a casual viewing, democratic values seem to be reasserted (as they had been in Terry's film). The reign of the despotic monarch, the stork, is obviously undesirable. Yet the democratic government pictured at the beginning was clearly unproductive, even decadent. Starevitch seems to be making a case for benign laissez-faire rule, as personified in the interregnum of the passive tree-stump king. His rule promoted no change, but precipitated no evil either. Perhaps for the expatriate White Russian still harboring bitterness and cynicism the message was that the best government is no government at all.

But Starevitch was no political activist, and the rest of his 1920s films—including the magnificent *La Voix du rossignol* (Pathé, 1923)—were far more lyrical than political.[34] The transition to sound came easily, and Starevitch continued to work in the same style in collaboration with his daughter Irène until his death in 1965.

In one respect Starevitch's early films are more interesting than his later ones because of the essential bestiality of the puppets, which were after all the corpses of bugs, birds, and animals. This total lack of "cuteness" was especially true of the unclothed insects in *The Cameraman's Revenge,* a film that surrealists would have loved.[35] Later this taxidermic quality was softened.

Lotte Reiniger (b. 1899) (figure 90) was, like Starevitch, passionately devoted to a single animation technique. Throughout her long career she has used two-dimensional shadow puppets to visualize picturesque fairy stories in the tradition of the "ombres chinoises" of the eighteenth and

Figure 90.
Lotte Reiniger working on *Prince Achmed,* Berlin, circa 1920.
Courtesy of the artist.

nineteenth centuries. Reiniger began in 1918 as an assistant on *The Pied Piper of Hamlin,* directed by Paul Wegener and Rochus Gliese. She learned animation by making wooden rats move through town during the film's high point. She also met influential film people and was admitted into the Institut für Kulturforschung in Berlin, where several young animators, including Toni Raboldt and Richard Felgenauer, were being sponsored. At the same time she did films for Pinschewer.[36]

In her own book *Shadow Theatres and Shadow Films* Reiniger traced the theatrical sources of her inspiration. But even filmed shadow plays had already been made in Europe. In March 1910, the English filmmaker Charles Armstrong released *The Clown and His Donkey,* produced by Urban. Over the next five years Armstrong completed at least three more films with silhouettes. Unfortunately, we do no know if these were entirely animated or not. In the United States, though, the "Bray-Gilbert Silhouettes" of 1916 and Sarg's shadow films (which lasted until 1924) definitely used animation.

At the Institut für Kulturforschung Reiniger made friends with several important filmmakers with like-minded interests. Walther Ruttmann was a former student of architecture and a fledgling painter just back from the war; Berthold Bartosch, not yet well known as an animator, was making socially motivated films. With their advice and the help of her cinematographer husband Carl Koch, Reiniger completed six one-reel subjects between 1919 and 1922. Then, during Germany's financial crisis, a stroke of incredible fortune came her way. A banker acquaintance had invested in a large quantity of raw film stock as a shelter from the wildly spiraling inflation. The gamble had not paid off, and to him the film became worthless; but to Lotte Reiniger it was a gift that made possible *Die Abenteuer des*

Prinzen Achmed, the first feature-length all-animated cartoon.[37]

Reiniger's *Adventures of Prince Achmed* (figure 91), which was photographed between 1923 and 1926 and opened in Paris at the Comédie des Champs-Elysées, had tinted scenes and a musical score by Wolfgang Zeller. The plot was a pastiche of Arabian Nights themes, with some influence discernible from Raoul Walsh's 1924 film *The Thief of Bagdad* (with Douglas Fairbanks), especially in a scene where a flying horse transports the prince from Bagdad to Waq Waq.[38]

Aware of the risk of boredom threatened by an hour (five reels) of moving silhouettes, Reiniger, Koch, Ruttmann, and Bartosch devised many ingenious background effects to divert the viewer. Their setup consisted of a large wooden frame (about 1½ by 2 meters) with a plate of glass set very close to the floor. A camera was mounted directly over the illuminated glass. The puppets were cut by Reiniger from thinly rolled sheets of lead and given wire joints. Assorted scrims, painted glass sheets, and gauzes could be inserted either between the light and the glass or between the puppets and the camera to produce atmospheric effects. In some scenes, three separate glass backgrounds moved at different rates to create a multiplane illusion. The great success of *Prince Achmed*[39] enabled Reiniger to continue prolifically until 1936, when she emigrated and settled in London. She was still doing television work there in the 1970s.

All Reiniger's films reveal the profound influence of German expressionism, the dominant style at the time of her first work. Even the fascination with shadows was shared generally by her expressionist colleagues, and her intricate spiky figures, misty landscapes, and fantastic plots all place her solidly in the tradition of Wegener, Wiene, and Murnau.

Figure 91.
Reiniger, *Die Abenteuer des Prinzen Achmed* (1926).

Before Mickey

Character Series

There were only a few efforts to develop American-style "continuity character" series. Most never left the ground; most of those that did were not successful enough to continue. Among the promising European "one shots" that never evolved into continuing series was *Wie Plimps und Plumps den Detektiv Überlisten (How Plimps and Plumps Fooled the Detective)*, animated in Germany by Otto Hermann in 1913 and patterned on Busch's *Max und Moritz*. Although the nineteenth-century albums might have provided inspiration for additional cartoons, Hermann never produced a sequel. But even as late as 1924, a series of Max and Moritz adaptations only ran for seven episodes.[40] Lotte Reiniger's 1927–28 "Dr. Doolittle" appeared in only three short installments.

The distinction of being the first cartoon series distributed in Europe belongs to the Cohl-McManus "Newlyweds" discussed above. Although the war brunted its full impact, this series was successful enough to excite France's leading children's artist Benjamin Armand Rabier to approach Cohl with the proposal for a film series based on his own characters. Rabier (1869–1939) had been the first to transform the nineteenth-century album popularized by Caran d'Ache into a form directed specifically toward a juvenile audience. His animal stories had firmly established his reputation by 1916, when he first contacted Cohl.[41]

Only two films were actually completed by Cohl and Rabier: *Les Aventures de Clémentine,* starring a mother duck and her brood, and *Les Fiançailles de Flambeau (Flambeau's Wedding)*, featuring a dog (figure 92). Both characters were adapted from Rabier's earlier graphic work. Cohl's and Rabier's personalities did not mesh. The two

men quarreled, and the series continued sporadically into the 1920s as "Benjamin Rabier's Animals" without a consistent cast. Only one specimen remains. The animation was directed by Rabier with an anonymous staff.

Another series directed by Cohl did use continuing characters. The influence of "Mutt and Jeff" on both the style and content of "The Adventures of Les Pieds Nickelés" is apparent. The source was a comic strip about a gang of amiable street types, drawn by Louis Forton, which since 1908 had outraged the Catholic press with its ribald slang dialect and provoked conservatives with its anarchistic content. Cohl began work on the Eclair series when Forton (who had just been mobilized) was at the height of his popularity. Now, only two short fragments remain of the five cartoons released between June 1917 and March 1918. They were critical successes, and the series would have continued had it not been for the intensification of the war and the conscription of the Eclair studios by the American army in August 1917.

After the war, Pathé began releasing a cartoon series drawn by O'Galop. At least four "Becasotte" films were completed, but their dates are uncertain. Although the general date of 1920 has been given, research shows that *Becasotte et son cochon (Becasotte and her Pig)* was already in distribution in September 1919. At the same time Pathé was also distributing an animated "Touchatout" series, which has never been documented and whose source is unknown.[42] Equally mysterious is the work of Albert Mourlan, who came to animation from advertising around 1918. In 1921, Paris trade papers announced three films in a "Potiron" series, distributed through AGC. Mourlan completed *Gulliver chez les Lilliputiens,* a feature combining puppets and live actors, in 1923.[43]

One of the most enduring character series came from an unexpected part of the world: Sweden.[44] The central figure

Figure 92.
Benjamin Rabier, advertisement for *Les Fiançailles de Flambeau,*
1917.

in Swedish animation was Victor Bergdahl, born in 1878. After an adventurous life at sea, he settled down in 1903 to the comparatively stable career of newspaper illustration and caricature. In 1910 he married an actress from the popular stage who, it is said, became the model for all the shrewish women in his comic strips and films.

Bergdahl was initiated into animation when the owner of a Stockholm cinema booked McCay's *Little Nemo* in 1912 and, curious about the process, asked the artist to make some similar drawings. When Bergdahl returned with his stacks of paper, the owner refused to pay to have them photographed. It was not until producer Charles Magnusson became interested in 1915 that a test was made and the film *Trolldrycken (The Demon Drink)*, which borrowed freely from McCay and Cohl, was finished. Magnusson was impressed, though, and urged Bergdahl to go on.

The following year, 1916, saw the birth of the "Kapten Grogg" character series. The protagonist's first appearance was in an animated prolog to Mauritz Stiller's comedy *Love and Journalism,* but his family tree grew from an earlier Swedish strip, "Kapten Groggs äventyr" (an unauthorized reprint of Charles Kahles's "The Yarns of Captain Fibb," which had run in *Judge*). By 1922, thirteen Kapten Grogg films had been released. In the only one available in the United States, *Kapten Grogg bland andra konstiga kroppa (Captain Grogg Among Other Strange Creatures,* 1920) (figure 93), Bray's influence is clearly visible, foremost in the use of doggerel intertitles. A lot of action is packed into the plot of this one-reeler, but briefly it is the story of the Captain's troubles with a centaur after he is caught wooing his wife. Bergdahl's drafting is highly representational, and the wild chase scene gives the impression of having been traced from motion-study photographs of running horses. Bergdahl also experimented with composition

Figure 93.
Victor Bergdahl, *Kapten Grogg bland andra konstiga kroppa*
(Svenska Bio, 1920).

in depth; this film has several moments of "deep focus," seldom visible in early animation.

Kapten Grogg was a distillation of Bergdahl's own personality. The artist's hard-drinking, henpecked private life was reflected in escapist fantasies of orgies and flights to foreign lands.

In the early 1920s Bergdhal's career fell victim to the onslaught of the American films and, as was often the case, he became bitter and despondent. He made a living animating the ubiquitous advertising films and completed his last project—a sex-education film commissioned by a gynecologist—in 1936, three years before his death. Bergdahl's work must have had considerable impact in Europe, because, as Jungstedt has shown, Svenska Bio sent many prints to Germany and the USSR. Further research shows that "Le Capitaine Grogg" made his first appearance in Paris on June 1, 1918, and reappeared at regular six-month intervals.[45]

The character series finally caught on in Britain in 1919. But, as on the continent, the characters too were ephemeral. Dyer's "Uncle Remus," Dudley Buxton's "Cheerio Chums," and Ernest Mills' "Zig Zags" each ran for only three episodes. But during the next few years the British animators came closer than anyone else in Europe to establishing a significant cartoon industry. One reason it was ultimately not successful was the abysmal level of narrative inspiration. In *Running a Cinema,* one of Buxton's 1921 "Memoirs of Miffy" series, the hero "performs in rapid succession the duties of manager, commissionaire and ticket seller"—hardly material for great cartoons. Lancelot Speed returned to the screen in 1921 with his "Pip, Squeak and Wilfred" series, which lasted for 26 installments. It was based on A. B. Payne's *Daily Mirror* strip.[46]

The closest British rival to the American cartoons, and the longest-running series there, was George Ernest

Studdy's "Bonzo the Dog," produced by W. A. "Billy" Ward and released by New Era Films approximately every other week from 1924 to 1926. The chubby pup was modeled on the cuddly creatures found in American animal strips and films. His relatives were the pets of Jerry on the Job, Farmer Al Falfa, and Bobby Bumps. The story in the first Bonzo film (figure 94) was told in two long scenes connected by a dissolve. In the first scene the maid places some sausages high out of the dog's reach. Bonzo tries to stack plates up high enough to reach them, but comes crashing down. In the second tableau, the location is evidently another corner of the kitchen. Frustrated Bonzo decides to drink the cat's milk. The cat, however, has other ideas and attacks. Bonzo sucks the animal into the stove bellows. When the maid returns, she swoons at the sight of the wildly leaping bellows, but Bonzo revives her and the film ends with them in an embrace.

Technically, the animation is comparable to the best American work of the period. There are some fine perspective effects as Bonzo sways atop the stack of dishes. However, for a film of three-quarters of a reel (eight minutes), there is remarkably little action. Bonzo's appeal as a character is just not strong enough to mask the lack of a story or of creative gags. The producers called in actor-writer-editor-director Adrian Brunel to do some salvage work, but he became frustrated by the constant tampering with his scenarios:

This was fascinating work, in which I had the inventive Jock Orton more than assisting me, and I was prepared to collaborate to the full, but discovered that [Sir Gordon] Craig's cartoon studios had got so behindhand with the delivery of their films that his small staff couldn't cope with the material I delivered in the fortnight . . . they had for producing each film, and so, after seeing how my first had been "simplified," I decided not to have

Figure 94.
George Ernest Studdy, *Bonzo* (New Era Films, 1924).

Before Mickey

the discouragement of seeing what became of my scripts, but to work on each and just imagine what it might look like![47]

The films for which Brunel received screen credit were unquestionably livelier. *Detective Bonzo and the Black Hand Gang* (13th in the series) had the dog foiling the kidnapping of a famous jockey. The 1925 *Topical Bonzette* (number 17) was a burlesque newsreel.[48] But Bonzo's rather phlegmatic character and the lugubrious pace of the animation could not win, given the diluted nature of Brunel's scripts.

··
European Techniques

The use of transparent cels, as in the Bray-Hurd process, was extremely rare in Europe until the 1930s. Postwar material shortages only partly explain the situation. The little evidence available suggests that alternative methods were employed as much out of choice as out of necessity.

In France the predominant system was the one pioneered by Emile Cohl. Paper cutouts of figures were combined with the retracing method for making one object transform itself into another. Variants of this system, which proved to be quite versatile in skilled hands, were used by Lortac, O'Galop, and others, many of whom knew Cohl personally. Cohl himself promoted this découpage technique in his lectures and in an important *Larousse Mensuel* article.[49]

Early English animation used a very similar system, described by Anson Dyer:

A little figure was made of cardboard or thin paper with the separate limbs, eyes and so on jointed at the back by paper fasteners which were invisible from the front. A separate half tone background was then made, sometimes a very elaborate one, and

a series of frames exposed showing the puppet in various stages of movement against it. A common practice was to begin the cartoons with rapid-drawing [that is, lightning sketching]; when the character was drawn the artist would find some pretext to cover it entirely with his hand; a clean sheet of paper and the puppet would then be slipped under his hand so that when this moved away it would seem to the audience that the figure sprang into life. Several items with the cut-out figures would complete a four or five hundred-foot issue.[50]

Close observation of *Bonzo* (1924) indicates that Studdy may have modified the cutout technique with some variant of Barré's slash system. It is often difficult to ascertain whether cutouts were used if the work was carefully done and if glass was placed over it during photography to keep it flat. This seems to have been the case with a German film by Paul Peroff, *Willi's Zukunftstraum (Willie's Nightmare)*, produced by Heliophan in the mid-1920s. The movements of Willi and his friend through a futuristic city resembling the sets of Lang's *Metropolis* are fairly supple and simulate depth recession by alteration of sizes of the cutouts. Their true two-dimensional status is belied only by the movement of their articulated joints. Although the fasteners are not visible, their limbs move only parallel to the picture plane.[51]

In Sweden, Victor Bergdahl used only retracing at first, then learned to use a printed background in a method resembling Bray's 1914 printing process. This knowledge might have been communicated by fellow Swedish animator Rodolf Liljekvist (who used it in his only film in 1916) or discerned though careful observation of Bray's early films. However, according to Bergdahl's former assistant, "He grew tired of that and started his system with cut-outs. It was a strange sight to see this big man cutting out paper dolls holding a pair of tiny embroidery scissors in his huge hands."[52]

Before Mickey

It appears that, with the obvious exception of the puppet and silhouette films, the découpage system was almost universally adopted. Why were cels eschewed even after celluloid became widely available and its application was well known? Bert Green's 1919 article "The Making of Animated Cartoons" had been translated into French, and Lutz's *Animated Cartoons* was published in London in 1920.[53] In his 1925 article Cohl described the use of cels but dismissed it: "Certainly the process is faster, but rather costly. It is an expense that for the moment only our former allies can bear."[54] But the argument that cels were too expensive ignores the savings to be realized from the creation of a competitive release schedule. And the Europeans must have known that cels were reusable. One might speculate that this was a creative bias related to the popularity of the puppet and shadow films. The traditions of the Guignol puppet stage and the "ombres chinoises" shadowplay were much more deeply rooted in Europe. Animators and audiences may well have responded more sympathetically to the established codes of their own culture than to those of the American popular graphic tradition. The ancient "imagerie d'Epinal," which was common throughout Europe, also proved to be extremely persistent. These strips, or more accurately comic sheets, tended toward nonrecurring casts (although there were exceptions), and more often retold proverbs, fairly tales, and classical legends rather than developing recurring protagonists.

If the Europeans did not succeed in establishing an economically viable animation industry, it is not because they did not try or because they were not interested. Among the leading filmmakers excited about animation were René Clair, who included a whimsical cartoon in *Paris qui dort (The Crazy Ray)* (1923) and some animated matches in the style of Cohl in *Entr'acte* (1924). Fernand Léger's animated Charlie Chaplin cutout in *Ballet Mécanique* (1923–1924)

recalled the several wartime Charlot cartoons. In 1929, when Jean Cocteau was planning *Le Sang d'un poète* (*Blood of a Poet*), his initial conception was to produce a monumental feature-length animated film.

Automated Art

During the American studio period, the pace of technical innovation slowed while the quantity of films increased dramatically. How are we to assimilate those thousands of cartoons produced by dozens of animators? Perhaps the very uniformity of the product can aid us. Although criticized for being repetitive and formulaic, the animated film of the teens and twenties was in fact consolidating its content to meet the demands of mass production. This meant developing and then adhering to generic codes. The assault-chase sequence, most typical of Nolan's "Krazy Kat" films, is one of many examples of the process of settling on an idea and then devising dozens of humorous variations.

Chronologically, the tendency of the period was toward a diminishing number of codes and forms until, by the late twenties, there was a much more rigorously and coherently defined genre than existed elsewhere in the live-action cinema. In particular, the emergence and refinement of the form called the continuity character series and the transformation of the protagonist's function mark a change in the basic metaphor of animation. The tendency was away from the literal figuration of the animator, in the direction of his implied or symbolic presence.

Nonseries Films Without Protagonists

Having a protagonist, or even being narrative, is not necessarily essential to the animated film. Emile Cohl's transformational fantasies are the prime example of singly produced nonprotagonist films, but before 1915 there were many, including advertising films of the type produced by Watterson Rothacker's Chicago company, which used animated effects as gratuitous one-time novelties. As a result, they tended to be inconsequential, contributed little to the genre, and disappeared with the coming of the studio era after World War I.

Nonseries Films With Protagonists

Animated films with a true protagonist (that is, featuring a character who initiated or was the object of the action of the film) preceded full-scale series production. Sometimes these were one-of-a-kind curiosities, such as *Gertie* and its undated plagiarism (figure 95), which was actually circulated for years as McCay's film although its graphic style and the cel technique suggest a Bray product. Many animators were apparently content to work with nonrepeating heroes. Otto Messmer's 1916 films included an assortment of Boomer Bills, Motor Mats, and Jitney Jacks. And Harry Palmer made public his preference for noncontinuous characters: ". . . the cartoonist who varies his subjects can score a higher percentage of hits than can the brother artist who is bound to a single series. He is not held in any one channel or confined by limitations that hamper his play of fancy. I vary my work by releasing 'Estelle' one week, perhaps 'Noisy Ned' the next, then switch to something

entirely different, and for the fourth week take another new track."[1] The best known example of Palmer's one-shots is *Professor Bonehead is Shipwrecked* (1917) (figure 96).[2]

Charles E. Howell, Lee Connor, and H. M. Freck, the animators of Keen Cartoons, also preferred one-time characters to continuing heroes and claimed that this strengthened the story lines: "Each release is a comic story, illustrated by characters originated for the story by one of the high class artists in the employ of the Keen Cartoon Corporation and, unlike the usual run of cartoon film, these stories are complete with plot and situations and are not secondary to the characters themselves. Rather, the characters are conceived with the object of bringing out in every detail the amusing conception of the authors."[3]

Among the oddities in this category was Terry's 1917 *20,000 Feats Under the Sea,* an 800-foot "cartoon burlesque" on Verne's novel inspired by Universal's eight-reel feature. There was also Bray's 1920 Brewster Color experiment, *The Debut of Thomas Cat.* Most intriguing is *The Flying Elephant,* a film of unknown authorship in the Natural Color Kelly Process distributed by Sering Wilson in April 1925. According to reviewer Charles Sewell, "It shows clearly the possibilities of color in cartoon work, for some of the effects used would be a complete flop in black and white. For instance where the little darkey paints a barber pole, and where the white elephant changes color after drinking the red circus lemonade. Not only is the color here attractive, but it would seem to open a new field in cartoon work."[4]

The first works of the puppet animator Willis O'Brien (1886–1962) fit in this category. After a varied career that included sports cartooning and an apprenticeship with a supplier of architectural stone, he began to tinker around by animating clay models of prehistoric creatures. Certainly

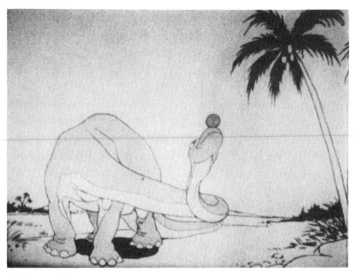

Figure 95.
(Attributed to Bray Studio), *Gertie the Dinosaur,* circa 1915.

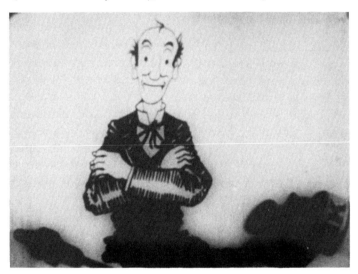

Figure 96.
Harry S. Palmer, *Professor Bonehead is Shipwrecked* (Gaumont-Mutual, 1917).

Before Mickey

Gertie must have provided some inspiration for *The Dinosaur and the Missing Link*. In 1916, O'Brien interested the Edison Studio and was provided with a small room at their Bronx facility. Eight shorts by O'Brien were released in 1917.[5]

Although (like Terry's Edison films of the same time) O'Brien's shorts were not widely distributed, because the studio was ailing, they did attract the attention of Herbert M. Dawley, who had attempted animating his own dinosaur models. With Dawley's backing, O'Brien made *The Ghost of Slumber Mountain*, a two-reeler distributed by World in 1919. Henceforth, Dawley was known for the "wonderful production of his prehistoric animal effigies which were released last year and created a sensation and incidentally made a fortune for Mr. Dawley."[6]

The smashing success of *The Ghost of Slumber Mountain* enabled O'Brien to convince Watterson R. Rothacker to film Arthur Conan Doyle's 1912 novel *The Lost World*. Work began on the closed sets of the First National lot, but it was halted when Dawley, after reading of Doyle's "sneak preview" of some test footage at a magicians' banquet, sued for infringement. Dawley had obtained patents on the models and the processes of *Slumber Mountain,* but in 1923 he dropped the suit when it became apparent that they were unenforceable. *The Lost World,* starring Lewis Stone, Wallace Beery, and Bessie Love, became one of the big hits of 1925. Most reviews marveled at "research and technical director" O'Brien's monsters, as in these examples:

This picture is an entirely new departure in the cinema art. It is a marvel of ingenuity, bringing to the screen as it does, gigantic prehistoric animals which have been extinct for millions of years. . . . Of course trick photography was done and how the animals were made to appear so lifelike is an absolute mystery to this reviewer at least.[7]

Automated Art

. . . it is difficult to believe that they have not really been photographed in some unexplored jungle. When [the explorers] get [the brontosaurus] as far as Liverpool he escapes and roams the streets. This of course must be done by double exposure, although it is not apparent. However we do not believe that the rest of the film was made that way. It baffles us.[8]

Robert E. Sherwood, writing in *Life,* made "a mental note to doff my first straw hat to those who were responsible for the animation of the reptiles."[9] Although the Kodascope abridgment in circulation today is only half as long as the original ten-reel release, O'Brien's intact animation is excellent, though not as polished as it would be in *King Kong* by 1933. The climactic scene on the South American plateau, with dozens of creatures shown in extreme long shot fleeing a red-tinted volcanic eruption, is still a memorable image—one certainly remembered by Disney in the "Rite of Spring" sequence of *Fantasia.*

Series Films Without Protagonists

A few other cartoon series seem transitional between non-protagonist films and more modern cartoon forms—for example, those written and directed by Rube Goldberg, animated by George Stallings at the Barré Studio in 1916, and distributed by Pathé as "The Boob Weekly."

Earl Hurd drew the only significant nonprotagonist cartoon series. In June 1924, Educational announced that thirteen of Hurd's "Pen and Ink Vaudeville Sketches" were forthcoming. The first, *Boneyard Blues,* anticipated Disney's *Skeleton Dance* by five years with its grotesque humor and gags like using ribs as a xylophone. Modern viewers find the slaughterhouse jokes difficult; perhaps early audiences did too, for "Pen and Ink Vaudeville" was not a

success. A review of the third film in the series implies that Hurd's tendency to string together unrelated gags was becoming tiresome: "Recent Earl Hurd 'Pen and Ink Vaudeville' cartoons have, in our opinion, been an improvement over earlier issues due to the concentration of interest and effort on only one subject." [10] By 1925, another factor in the failure of this series may have been the audience's growing preference for films with continuing heroes. Hurd's little vaudevilles, presented on a proscenium complete with rising curtain, were too old-fashioned.

Howard S. Moss' 1917 "Motoy Films," made with animated puppets, were produced in Chicago by Toyland Films and distributed by Peter Pan Films of New York. Different movie-star caricatures appeared prominently as heroes. For example, in the first release, "All the movie stars are burlesqued and Charlie himself cannot cavort in crazier capers than his doll imitator. Mary is always the heroine and appears in her pretty curls and coy manners to please her admirers." [11] In *Cracked Ice*, an undated print in the archives of the Film Center of the Art Institute of Chicago, the hero was a miniature Ben Turpin. [12]

Among the more archaic forms of the period were the movie shadow plays. John R. Bray had been very excited about the prospects of his associate C. Allan Gilbert's new "Silhouette Fantasies" of 1915–16, and had even rented him an entire studio. These films were "partly acted and partly penned; the spectator cannot tell where one begins and the other leaves off." Bray promised "a brand new sensation for photoplay patrons," called the films "revolutionary," and anticipated a five-reel feature. [13] Gilbert's cartoons were "serious" adaptations of Greek myths, staged in art nouveau arabesque tableaux. But Gilbert left the studio in 1916, so we may guess that the series did not fulfill Bray's expectations. The idea resurfaced in 1921 with "Tony Sarg's Almanach." Sarg was an illustrator who had

Automated Art

toured vaudeville with a marionette routine. He was well informed, and traced his sources back to Chinese shadow puppets and Caran d'Ache's performances at the Chat Noir cabaret "about eighteen years ago." Herbert Dawley, O'Brien's partner-turned-plaintiff, was the producer, the cameraman, and the animator. Dawley must have been influential in devising the plots as well, since they all had "stone age" themes (like *The Dentist,* the story of "the first tooth carpenter"). The only remaining print, *Adam Raises Cain,* shows that Sarg was gifted with his scissors. His (and/or Dawley's) expertise at coordinating complex simultaneous movements was one of the distinguishing features of the series: "Unlike other cartoons, whenever a group is shown, Mr. Sarg can afford to animate every single member of the group continuously. The individual movements of the figures are unusually good and in some cases resemble slow-motion photography."[14] In September 1921, Sarg joined the art department of Paramount to design posters. He continued to distribute his films independently through 1922, then released them through Educational in early 1923.

Series Films With Protagonists

Slowly, producers began to make films that reinforced audiences' desires to see the same hero in several films, as in the "regular" cinema. The topical caricaturists, though not as numerous in the United States as in England, might be regarded as transitional forerunners in that they promoted themselves as "stars" of continuity series. When Cohl departed from France in 1914, Carl Laemmle replaced him with Henry Mayer (figure 97), a caricaturist and author of picture stories for the various New York humor magazines

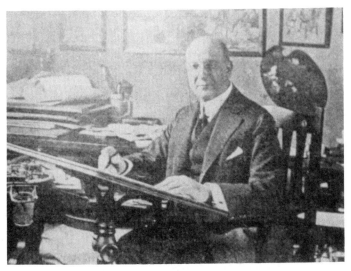

Figure 97.
Henry "Hy" Mayer, circa 1922.

since the 1890s. This unsung filmmaker would remain a constant producer of shorts for nearly two decades. Mayer was a gifted artist and as facile with the pen as McCay. He sketched freehand, without resorting to any common tricks like "bluing" (the use of blue pencil, which is invisible to orthochromatic film emulsions, to sketch the design on the paper before shooting). According to Otto Messmer, who assisted Mayer as one of his first jobs in the movies, Mayer was affable, quiet, and rather nondescript. His sketches appeared in the Universal Weekly from June 1913 through November 1916, when it became the Universal Screen Magazine, and ended in 1920. The format never varied from the way it was presented in a rare 1913 film preserved in the National Film Archive: "The Cartoonist . . . sketches a portrait of Queen Victoria; two thugs and a dog; a short sighted man addressing a hat rack instead of his thin wife; a British suffragette defying a policeman."[15] In June 1920, Mayer combined his drawing with live footage for a series of Pathé "Travelaughs," which he took to the Robertson-Cole company from 1922 through 1926. He returned to Pathé and remained there until sound made his films obsolete.

As it was for the English sketchers, 1916–17 was a banner season for the screen caricaturists—primarily because of the controversy generated by the intensifying European war. Harry S. Palmer, who had just lost his battle to animate "Keeping Up With the Joneses" using cels, explained why he was looking forward to returning to caricatural work with a new series for Gaumont/Mutual called "Kartoon Komics": "I am glad to say that now I am returning to my first work in the animated field. Being the father of three animated news cartoons, naturally I am delighted to find that we are to make them again. We found that 'Keeping Up With the Joneses' was entertaining, but we felt that there would be greater general interest in it [caricature] for

the artist, because there is the infinite variety which is not possible where week after week we are bound to scenarios of the Jones family."[16] Palmer quit Gaumont in March to form Harry Palmer, Incorporated, which released cartoons for a while through Educational (beginning with *The Rise of a Nation,* a patriotic war subject).[17]

Like Palmer, Wallace Carlson drew both caricatural and story cartoons. His "Canimated Nooz Pictorial," launched by Essanay in May 1916, was described as "photographic heads on pen and ink bodies."[18] The "Nooz," which Messmer still recalls as being as amusing as Mayer's films, continued weekly until Carlson left Essanay in mid-1917.

In the fall of 1916, Pathé-News formed a cartoon department to produce topical sketch films for their newsreel. The staff was primarily Bray dropouts Louis Glackens, Leighton Budd, and F. M. Follett, who were joined by John Terry, A. D. Reed, and (in 1917) Hugh M. Shields. Typical titles were *Independent Poland* (Glackens) and *In Verdun Forests* (Shields). They were duly licensed by Bray.

The Universal Screen Magazine was launched in November, and Mayer's weekly labors were relieved when his sketches began to alternate with Willie Hopkins's curious "Animated Sculptures," also known as "Miracles in Mud" (figure 98). In *Swat the Fly* three clay caricatural busts metamorphose into grimacing likenesses of public figures. In 1919, Universal added the famous Hearst cartoonist Tad and the former Bray staffer Leslie Elton to its roster of sketchers.

Although the war's end seemed to deflate the sails of the news caricaturists, as late as July 1921 Julian Ollendorf was beginning yet another series with his "Sketchografs" (distributed by Educational), while in Kansas City twenty-year-old Walt Disney was producing his short reels of caricatures and advertisements under the similar name of "Laugh-O-Grams" (figure 99). That this tradition had gone

Automated Art

Figure 98.
Willie Hopkins, *Swat the Fly* (Universal Screen Magazine, 1916).

Figure 99.
Disney, *Laugh-o-Gram,* circa 1921.

Before Mickey

about as far as it could was signaled by the bizarre series of "Animated Hair" cartoons drawn by former *Life* cartoonist Marcus. Actually, there was nothing bizarre about the metamorphic caricatures themselves. But the premise—that they grew out of a strand of hair—suggests that the artist was straining for novelties to keep the tradition vital. "Animated Hair" ran from November 1924 through 1925, and was distributed by Fleischer's Red Seal.

What might be considered the last hurrah of journalistic sketching occurred in *The Great White Way,* a 1924 feature produced by Hearst's Cosmopolitan Pictures. Meant to dramatize the men and mores of the Big Apple, this review included cameo footage of Harry Hershfield, George McManus, and Winsor McCay drawing cartoons and caricatures at their sketchpads.[19] The film was advertised with a cartoon with Flip and Little Nemo. Flip: "I say, Nemo, I dreamed, last night, that Winsor McCay was an actor!" Nemo: "He is an actor! He may be a bad one, but he is an actor, Flip."

Continuity Series With Protagonists

By the early 1920s most of these formats were being replaced gradually by films released under a series title and relating the exploits and developing the personality of the recurring protagonist. Beginning with the first series of this type—Cohl's "Newlyweds"—the comic strip served as a limited model, providing characters, formal devices like the speech balloon, and the concept of regular appearances as in the weekly or daily strip. Animation was part of film history in general, too, and similar structures were being developed in the live-action cinema. Actors like Pickford and Chaplin were establishing their characters during the

same period. In a sense the increasing emphasis on the character series in animation is the analog of Hollywood's emerging star system.

With industrialized techniques, series production was not simply made feasible; it became economically mandatory, and this affected the structure of the image. Specifically, generalized backgrounds were designed for reuse in several films. A horizon line with a few rocks and trees sufficed for "outdoors." Three converging lines denoted an interior corner of a room. Even more useful were the drawings of the hero's walk, poses, and reactions, which could be saved for other films. This not only resulted in great economy, but eventually helped to articulate a vocabulary of gestures which would contribute to the definition the character's personality. Equally important, these repeated gestures and compositions implied film-to-film consistency and encouraged the spectator to place the character in his fictive universe. Thus, when we think of Koko or Felix, we invariably associate them with the idiosyncratic visual environments we have come to recognize by viewing more and more of their films.

If one were to conduct an imaginary survey of the animated population from about 1915 to 1928, one would find a heterogeneous assortment of individuals, some derived from comic strips, others created specifically for movie cartoons. They coexisted, some stars ascending while others set. Nevertheless, it is possible to group the most prominent ones according to a "demographic profile" of the cartoon series.

The animated protagonists were either humans or animals; a shift in interest from the former to the latter was discernible in the 1920s. Foremost among the humans was Koko the Clown, the star of "Out of the Inkwell." He was a unique case and, rather surprisingly, had no imitators.

Before Mickey

He also had relatively few cinematic antecedents; the Pierrot-like clowns in several Cohl films and Blackton's clown in *Humorous Phases* are the only ones who spring to mind. But the clown does connect the films to the venerable spectacle of the circus, and Koko's costume is typical of late-nineteenth-century American types.

Other protagonists form a category we might call the Old Men. Bray's septuagenarian Colonel Heeza Liar (figure 100) was the first. Although the Colonel had a long screen career, his personality varied according to who was doing the animation. Gruff, aggressive, and slightly obnoxious, Heeza Liar began as an overt parody of Teddy Roosevelt, but his windy personality resembled that of the folkloric Baron Munchausen as well. Bray's conception of the character changed during the war, and in *Colonel Heeza Liar at Bat* (figure 101) he acts like a character in an editorial cartoon of the sort found in *Judge*. As an enlistee, he fends off a mortar attack by batting shells away from his trench as though he were a baseball star. When he discovers he has inadvertently helped the Germans, he recites

Don't care who I'm fighting for
But I've come here to stop this war.
Give me a chance to show my skill
By golly or the Germans will.

This ambivalent statement (for nonpartisan interventionism, perhaps), no doubt influenced by Mrs. Bray's ties overseas, demonstrates the character's essentially journalistic conception. In the hands of Elton and Stallings, the satiric qualities were deliberately eradicated, and the Colonel became a buffoon. However, the films were not without ideological consequences. In *Forbidden Fruit* (Stallings, 1923) the Colonel's solution to "the great banana famine" is an allegory of classic imperialism. He cajoles the queen of a cannibal island out of her country's entire banana crop by

wooing her, but as he departs he ungratefully knocks her out and leaves her behind, reneging on his promised trip to New York.

On the other hand, Farmer Al Falfa, Paul Terry's "old man," was untainted by the slightest political overtone. In contrast with the mercurial Heeza Liar, Al Falfa's personality remained remarkably consistent. He never aged, and indeed he seemed to become spryer and less scruffy as time went on. His physique even became more streamlined. He resembled "Foxy Grandpa," star of a favorite prewar comic strip by C. E. Schultze, more than he did Bray's Colonel. Grandpa was a mischievous, slightly senile gentleman who delighted in playing practical jokes on his grandchildren. Terry's creation might also have been influenced by vaudeville "rube" characters, the most famous of whom was Cal Stewart. The earliest films show Al Falfa as a real farmer, occupied with chores and trying to manage an unruly barnyard population. However, in his postwar appearances in "Aesop's Fables," the animals usually seemed to be winning the battle. In *Rats in His Garrett* (1927) (figure 102), Al Falfa and his dog are chased by rampaging rodents. In *Human Fly* (circa 1927) he becomes a passive participant in a fantasy of flying and falling. By this time the farmer has been completely estranged from his agrarian origins and has become a confounded but accepting resident in the modern world where the barnyard has been displaced by the city and the plow by the airplane.

A few of the other Old Men were remotely based on Terry's benign farmer—for example, Powers's "Fuller Pep," drawn by F. M. Follett in 1916–17.

Quite a few boys and one little girl were cartoon protagonists. This gang of preadolescents, most of whom seem to be ten-year-olds, came from a rich tradition of comic art and folklore. Little Nemo and Buster Brown are only the best known of a dozen minor "kid strip" heroes of the first

Figure 100.
Poster for *Colonel Heeza Liar's Frigid Frolic,* postdated (incorrectly) 1912. Courtesy of Bray Studio.

Automated Art

Figure 101.
a: Bray, *Colonel Heeza Liar Hobo* (circa 1915). **b:** Leslie Elton
(?), *Colonel Heeza Liar at Bat* (circa 1917). **c:** Vernon Stallings,
Colonel Heeza Liar's Forbidden Fruit (1923).

b

c

Automated Art

Figure 102.
a: Hugh Shields, *Rats in His Garret* (Paul Terry/Fables Pictures, 1927). **b:** Shields, *Two Slick Trappers* (Terry/Fables Pictures).

Before Mickey

decades of American comics, who had themselves evolved from Victorian popular literature. Those who made the transition directly into films, the Katzenjammer Kids and Jerry on the Job, remained the property of Hearst, and La Cava's International Film Service team paid lip service to the original models. The Katzies were suitably outrageous, and Jerry was tailored after the latest version of the strip. When Jerry was introduced in June 1916, his creator, 25-year-old Walter C. Hoban, was still a relatively unknown artist. Soon the strip would make him famous, though. When the strip began in 1913 Jerry was an adolescent office boy, but by time the films began Hoban had modified his character; it was this new ten-year-old Jerry that Walter Lantz directed. Eventually Jerry became the prototype for Lantz's "Dinky Doodles" (figure 103).

Boy characters were so popular that some animators were tempted to near-plagiarism. For example, "The Kelly Kid" who appeared intermittently in Barré's 1915 "Cartoons . . ." series was derived from the Newlyweds' Baby Snookums. "Sammy Johnsin," Pat Sullivan's short-lived 1916 series, was simply a renamed "Little Black Sambo."

Wallace Carlson's "Dreamy Dud" was a more important Boy character,[20] although today he is represented by only one remaining film. The film suggests that Carlson was as dependent on McCay for ideas as for technical inspiration, because the Dreamy Dud of *He Resolves Not to Smoke* (Essanay, 1915) (figure 104) was only a slightly transformed Little Nemo. There is even a "slumberland" plot, and his oneiric name suggests that dreams might have been a frequent narrative device. First, Dud is introduced, with his dog, who performs some well-animated tricks. Both are finely rendered on a glaring white background. The precise drafting is reminiscent of McCay. There are endearing details, like Dud's father's slipper repeatedly flipping off his foot as he snores. After Dud smokes his father's pipe, the

Automated Art

Figure 103.
Lantz, *Dinky Doodles in the Hunt* (Bray Studio, circa 1925).

Figure 104.
Wallace A. Carlson, *Dreamy Dud: He Resolves not to Smoke* (Essanay, 1915).

Before Mickey

Spirit of Smoke takes the boy to the moon, where he witnesses some Cohl-style hallucinations. It is a charming film, but Dreamy Dud does not seem to have acquired a following and the series ended in 1917.

Far more popular was "Bobby Bumps," Hurd's 1915 creation at the Bray Studio (figure 105). Bobby was a handsome Boy Scout type, dressed in short pants and a baseball cap. Although he was well-behaved, Bobby's speech was peppered with street slang, and the sometimes coarse homespun humor contributed to his personality, which for the period may have been the most highly individualized.

Among those animators impressed with Bobby Bumps was Walt Disney, while he was still in Kansas City. As though by a methodical survey of the field, Disney developed a character who was enough like the successful Boys to ensure popularity yet different enough to be novel. She was a girl, Alice, who it was hoped would embody some of Bobby's appeal. Noting the success of Koko's exploits in the world of humans, Disney also turned those tables and inserted his live Alice into the world of drawings. One senses the deliberateness of the formula in a letter Disney wrote to potential distributors:

We have just discovered something new and clever in animated cartoons! The first subject of this distinctly different series is now in production, and will require a few weeks more for completion. It is a new idea that will appeal to all classes, and is bound to be a winner, because it is a clever combination of live characters and cartoons, not like "Out of the Inkwell" or Earl Hurd's, but of an entirely different nature, using a cast of live child actors who carry on their action on [sic] cartoon scenes with cartoon characters.[21]

Alice's inspiration was clearly not a comic character but, as the first title *Alice in Cartoonland* made evident, Lewis

Automated Art

Figure 105.
Earl Hurd, advertisement for *Bobby Bumps' World "Serious"* (Bray Studio, 1915).

Figure 106.
a: Disney and Iwerks, *Alice Rattled by Rats* (Winkler, circa 1927).
b: Disney and Iwerks, *Alice Cans the Cannibals* (Winkler, circa 1924).

Carroll's Alice. First Virginia Davis, then Margie Gay, was groomed to resemble Tenniel's illustrations.

These girls (figure 106) might have looked somewhat like the original Alice in Wonderland, but there the similarity ended. Whereas Carroll's little girl was the aggressive protagonist of the adventures, Disney's Alice tended to watch the action in her animated wonderland, reacting with histrionic gestures. Some critics have read into Alice's rather phlegmatic personality and static acting an indication of Disney's creative immaturity. Richard Schickel wrote:

> It is difficult to imagine just what anyone saw in the "Alice" films. . . . Alice was nice and conventionally pretty, but she had no real character beyond a certain willingness to try anything and get into "situations.". . .There were no close-ups, no odd angles, few variations in the camera's basic point of view, which was well back from its subjects and observed them head-on. Since backgrounds were still being kept to a minimum, the over-all impression one gains on seeing an "Alice" film today is of tiny figures cavorting in a white void.[22]

Though it is true that the cartoon characters were more lively than the live one, one must realize that Disney was locked into an inflexible technique demanding precisely controlled performances. According to Mike Barrier, who interviewed Disney veterans, the girl was filmed first as she gesticulated with her invisible (in fact, nonexistent) acting partner. Ub Iwerks then supplied the animators with sketches he made from the rushes. Combining live and animated characters might first have been conceived of as an economy measure, but the chore of coordinating the shooting eventually grew to require more time than the "straight" animation of Iwerks's adept crew. As a result, in the later films such as *Alice Rattled by Rats* the live appearance functions as little more than a framing device.

Before Mickey

This is in contrast to *Alice Cans the Cannibals,* in which
Alice is more active. By 1926 (when FBO began distribut-
ing the biweekly Winkler-produced series) the Alice Com-
edies had become for all practical purposes an animal
series, and Disney was probably relieved when the oppor-
tunity to animate a true animal series, "Oswald," was
proffered.

Enlarging upon the notion of child protagonists, several
series took entire domestic groups as their subjects.[23]
George McManus was unquestionably the most influential
source of family material. His successful strip "Bringing
Up Father" was made into cartoons at IFS in 1916–17 by
Edward Grinham, who was hired especially for the job and
was supervised by Frank Moser and Bert Green.[24] There
were also several McManus imitations, which are readily
identified by their henpecked-husband characters. Raoul
Barré's "Bunkum's Boarding House" (included in his 1915
"Cartoons. . .") and Palmer's "Keeping up with the Joneses"
(Mutual, 1915–16) both had protagonist couples whose
physical statures were emblematic of their dominance: big
overbearing women and small uxorious men with preado-
lescent personalities (figure 107). Upon leaving IFS Frank
Moser animated a "Bud and Susie" series for Paramount in
1919, which in all likelihood was patterned on McManus
(no copies exist). Perhaps it is stretching a point, but
Fisher's "Mutt and Jeff" may also fit into this category,
despite the fact that they are not the typical nuclear family
unit but rather an "odd couple" relationship. The plots were
dependent on slapstick, and the chatty personable humor
of Fisher's strip never quite made it into the films, so the
characters were bland in comparison with the flophouse
style of the originals. For example, in *Hell Froze Over,* Mutt
and Jeff go searching for coal to heat their cabin and spy
a mysterious stranger who tells them "Hell is freezing
over." Naively they ask "What can we do?" and are whisked

Automated Art

Figure 107.
Barré, advertisement for "Bunkum's Boarding House" (Edison, 1915).

down to the hot place and charged with keeping the last small flame alive. The flame has a mischievous personality of its own and leads the pair on a wild chase—treating us to some superb animation, as when Jeff gives it a spanking. One would be surprised to find such a rollicking fantasy in Fisher's down-to-earth strip. The animators realized that action was more satisfying than talk. Hence, sight gags replaced characterization.

Animal protagonists, surprising as it now seems, were slow to emerge. Bray had attempted to transpose his popular bears from his strip to film, but had given up in frustration. It was not until around 1914 that animals began to play significant roles as the pets, sidekicks, or antagonists of the main characters. These were most often dogs, such as those that belonged to Jerry on the Job, Farmer Al Falfa, Bobby Bumps, the Kelly Kid, Dreamy Dud, and (in the late 1920s) Ko-Ko the Clown. Except for Dreamy Dud's Wag, who was drawn in a "realistic" style, these dogs were all remarkably similar—floppy ears, round cuddly body, and all white except for a few large black spots, one of which encircled an eye. (Weakheart, Dinky Doodles's sidekick, had the same form but was black.) Why animators chose this particular formulaic caricature is something of a mystery, but it became another arbitrary iconographic code.

As early as 1913 there were already animals who were heroes of their own series. During the run of "The Newlyweds," Robert Sidney Smith (1877–1935) (figure 108) became the first established comic-strip artist to realize an animated version of his own strip. "Old Doc Yak" was actually a goat, not a yak, and he had only been in the Chicago *Tribune* since 1912. (Previously the character had appeared as "Buck Nix" in the Chicago *Examiner*.) A few experimental Doc Yak reels were released by Selig Polyscope in July 1913, painstakingly animated by the McCay retracing method. Smith introduced the first one from his

Figure 108.
Robert Sidney Smith and Old Doc Yak, 1913.

Before Mickey

easel, but the artist did not appear again. In May 1914, a second Doc Yak series appeared. These films benefited from some streamlined technique—perhaps cels, as has been suggested.[25] It is possible that Charles Bowers, whom Smith had known on the *Tribune,* was in some way responsible for this second series. After a six-month interval, in June 1915, producer Rothacker announced Doc Yak's return as part of an elaborate promotional tie-in sponsored by the *Tribune.* Smith's participation seems doubtful. But five years later, when his "Gumps" strip had made him one of America's richest cartoonists, Smith returned to the movies and signed a two-year contract with Harry Grossman of Celebrated Players for thirteen scenarios. Primarily live action, these "Gump Cartoons" began in January and featured sequences animated by Wallace Carlson.[26] Alas, all the pioneering screen efforts of this comic-strip great, including "Doc Yak," have disappeared.

Also lost is the only animal series to emerge from the Bray Studio, "Police Dog." It was issued irregularly during 1914 and drawn by another gifted comic-strip artist: Carl Anderson (1865–1948), now remembered for "Henry." In 1914, Anderson was barely making a living doing freelance cartooning for the humorous journals. He considered his own career a failure, and would eventually retire in 1932 only to take it up again when the idea for "Henry" came to him. "Police Dog" was probably just hack work, but we cannot know until some samples are discovered.

Both "Doc Yak" and "Police Dog" ran before the debut of McCay's *Gertie.* Already the idea of sympathetic anthropomorphic animals serving as protagonists was well established as a desirable objective. In 1916, Harry Palmer reaffirmed this in reference to his film *Pigs*:

Now a pig naturally lends himself to the joyous mood, as witness Ellis Parker Butler's classic "Pigs is Pigs;" but when you come to

introduce the porcine actor to the camera you will find that he does not run true to form when considered as the hero of the story. The cartoonist however can take any pig from the little pig that went to market to the one that Tom the Piper's son stole and get a laugh out of him in a thousand ways. He can be made to climb a tree or swim a river or do some other thing that spectators recognize is quite impossible for a pig. Yet the very fact that the feat is impossible is a great aid in tickling their risibilities.[27]

Johnny B. Gruelle, who began animating "The Quacky Doodles Family" for Bray in 1917, concurred: "Easily the characters that strike the average person as being funniest are birds and animals humanized. In the pages of comic weeklies and supplements and the Sunday supplements of newspapers we laugh heartiest at the antics and expressions of such humanized animals. . . ."[28] Gruelle was known then for his *Herald* "Mr. Twee Deedle" strip but is better known now as the creator of Raggedy Ann in 1918. The Quacky Doodles were a family of ducks drawn in a clean curvilinear style that looks ahead to the Disney graphics of the mid-1930s. Only three releases are documented.

Some of Paul Terry's "Aesop's Fables" were enacted solely by animals; others starred Farmer Al Falfa. Terry announced his series with an amusing poster (figure 109) showing a rooster (Pathé's trademark) knocking out a duck (which perhaps alluded to Gruelle's "Quacky Doodles"). At first there was no central protagonist, only a horde of animals (which, since they were consistently drawn from the same model charts, achieved film-to-film continuity). The hero of *The Prodigal Pup* (1924) might be recognizable as an extra in the next week's film. In the 1920s Terry tried to sap some of Felix's popularity by introducing his Henry the Cat. But Henry never achieved stardom, and the Fables remained basically a repertory company of animals.

Henry the Cat was but one of several auxiliary animals

Figure 109.
Paul Terry, announcement for "Aesop's Fables," 1921.

appended to already existing series during the twenties. Ko-Ko the Clown, for example, acquired his own dog Fitz (drawn in the standard style), who eventually evolved into Bimbo, Betty Boop's companion (figure 110). (Betty was herself a canine character in her earliest appearances.) The trend toward animal leads was apparent to Carl Laemmle, head of Universal Pictures, who reportedly originated the idea of the "Oswald" series.[29] Tired and feeling constrained by "Alice," Walt Disney and Ub Iwerks worked feverishly during the winter of 1926–27 to develop a character that would satisfy Universal's reviewing committee. Not since McCay had a cartoon creation been subjected to such scrutiny, nor perhaps had one been so carefully planned and executed in a commercial studio. Disney may have even used "pencil tests," photographs of animators' sketches, to check movements. This was by no means a common studio practice in 1926.[30]

In retrospect, the derivative nature of the Oswald character (figure 111) is apparent. With his inked-in black body, he is essentially Felix the Cat with floppy ears. Like Felix he is anatomically resourceful—he uses his ears to bat away cannonballs in *Great Guns* and doffs them to a female rabbit in *The Mechanical Cow*. He also has a white girlfriend, like Felix. The major difference between them is that Oswald moves in a wonderfully plastic, boneless way, quite opposed to Felix's staccato gait.

The "Oswald" plots were sometimes modeled on Messmer's films. *Great Guns,* for example, was a remake of the undated Felix cartoon now circulated as *The Big Rain*: Oswald, as Felix had done, enlisted in the army when rats declared war, only to return home to find that his girlfriend was married and had a houseful of bunnies. There was also considerable influence from Paul Terry, particularly in Iwerks's graphic style. For instance, a favorite Terry device might be called the "equalization of volume" principle: one

Figure 110.
Max and Dave Fleischer, *Ko-Ko the Cop* (Inkwell Imps, 1927).

Figure 111.
Disney and Iwerks, advertisement for "Oswald," 1927.

Automated Art

figure grows larger in proportion to another one growing smaller. This was used by Disney during the first scene of *Mechanical Cow* when Oswald and the cow are seen in bed asleep. As one inhales, the other exhales, and their bodies inflate and contract rhythmically like balloons. The Disney "Oswalds" were as fast-paced and kinetic as the best of the "Fables."

Perhaps the aspect that most set Disney's series apart from his competitors' was the overtly libidinous (but presumably naive) content of the humor. Present audiences cannot help but be impressed by the extent to which phallic imagery informs the majority of gags, as in the unusual applications of Oswald's ears, in Oswald's girlfriend's ecstatic admiration of his bayonet expertise, or in the violent battles in which tumescent cannons fall into flaccid exhaustion after each blast.[31] Already Disney's interest in exposed posteriors, so well documented by Schickel, is abundantly in evidence. But these innocent preoccupations actually helped differentiate the Oswald character from his competitors, and audiences apparently enjoyed the unabashedly fetishistic humor.

The early Oswald films, despite their borrowed plots, are constructed much more tightly than any of Disney's previous work and more carefully than most other late-1920s cartoons (or live-action comedies, for that matter). *The Mechanical Cow* is structured "classically" in five separate parts: an introduction (Oswald and the cow), a comic episode (with Mrs. Hippo), a romance (when Oswald encounters the female rabbit), a chase (when a monster abducts the girlfriend), and a climax and dénouement (as Oswald and his friend are reunited). Individual gags are meticulously crafted. For example, in the second part, Oswald and the mechanical cow meet Mrs. Hippo and her baby. Supplying milk for the baby is presented as an elaborate gas-pump travesty. In a long shot, the cow salutes Mrs. Hippo.

Before Mickey

Oswald opens a trapdoor on the cow's back and erects a glass "tank," into which he pumps milk. In a closeup, Oswald checks the baby's "level" with a dipstick and sees it is on empty. Then, in a long shot, he stretches out an enormous teat and pumps milk into the baby. Mrs. Hippo departs, another satisfied customer. These ingenious applications of the "props" were the most characteristic forms of humor, and provide a way to distinguish Oswald from his rival Felix. If Felix's balletic movements and victimization by his environment are seen as derived from Chaplin's screen character, then Oswald may be viewed as closer to Keaton and his ability to transform the absurd mechanical environment of the modern world into something useful and humane.

After losing Oswald to Charles Mintz and Walt Lantz, Disney and Iwerks secretly formulated their new series after hours at the studio. The idea for "Mortimer Mouse" was not exactly a blinding flash of original genius; hundreds of similar-looking rodents had romped through 1920s animated films drawn by Terry, Messmer, Nolan, and Disney himself (figure 112). The initial sketches for the mouse character looked like the proto-Mickeys in *Alice Rattled by Rats*, who in turn seem to have been influenced by Herriman's Ignatz. But as yet there were no mouse film protagonists, so Iwerks went to work designing one.

An RKO biography from the early 1930s gives a charming (if apocryphal) account of the origins of the Disney mouse in Kansas City: "[Disney always liked mice.] Their bright eyes and quick movements fascinated him. He caught them in a cage where he would watch their antics. One of them, bolder than the rest, used to crawl all over his drawing board, and seemed to have a distinct personality of his own."[32] More appropriate for his increasingly individualized personality and softer curvilinear rendering, Mrs. Disney rechristened the mouse "Mickey."

Automated Art

Figure 112.
Proto-Mickeys. **a:** Shields, *Rats in his Garret* (Terry/Fables Pictures, 1927). **b:** Disney and Iwerks, *Alice Rattled by Rats* (Winkler, circa 1924).

Before Mickey

Although the character developed rapidly, the first Mickeys were strongly influenced by Felix and Oswald. In *Steamboat Willie* the mouse is the bosun on a little chugging ark full of barnyard animals, all drawn in what was then a typical cartoon style relying on high-contrast black-and-white effects and round hard-edge forms. Hyperkineticism prevails; everything moves. The "plot" is just an excuse for a minstrel concert, with a threatened disruption by a villainous forerunner of Pegleg Pete.

Again, Disney's infatuation with Keaton is apparent. Not only is the title reminiscent of *Steamboat Bill, Jr.,* but Keaton's ingenious adaptation for survival in that film and in *The Navigator* were probably models for Willie's brilliant transformations of his boat and its animal cargo.

The film—and the mouse—were hits, and the cult of Mickey began. However, Mickey's success was not exactly instantaneous. The London Film Society, reviewing the first handful of Mickey films, was impressed by Disney's use of synchronized sound and imaginative graphics but thought the Mouse's personality compared unfavorably to Felix's: "The personality of Felix is no doubt more individual than are those of the protagonists of 'Mickey Mouse,' but the drawings of the latter series are superior in fertility of invention."[33]

The twin successes of Mickey and Felix precipitated an invasion of animals. Unexploited species were pressed into service, as in Iwerks's "Flip the Frog," which he created for Powers after leaving Disney in January 1930. Soon it would seem as though only the Fleischers' Popeye and Betty Boop were holding aloft the banner of *Homo sapiens*—and even Betty had begun life as a dog.

Automated Art

Conclusion

From the broadest point of view, the hegemony of the cartoon "star" embodies assumptions that depart from those implicit in earlier forms. As we trace developments away from the lightning sketch genre, "Out of the Inkwell" may be seen as an interim phase in which the atavistic elements intermingle with the more modern elements of the character series. One must remember that Max Fleischer is only pretending to be the animator. In fact, he is the producer—a role nevertheless literalized by picturing himself "producing" Koko out of the inkwell. Dave is the actual animator, at least in the early films. But, owing to the unusual photographic origins of Koko, Dave manages to figure himself in the film too, cleverly disguised as the rotoscoped image of the clown. According to the fictional implications, part of the animator's status as a privileged being begins to rub off on the drawings. The playful struggle between the animator and his creation that typifies the plots of not only the Fleischer films but also those of Hurd and Carlson is an allegory expressing the shift in importance away from the artist to the work. The films with human characters and then the films with animal stars represent the progressive retreat of the animator behind the screen. The drawings seem to take on an independent life of their own. The "hand of the artist" disappears, its place now occupied by characters who become agents of his will and ideas and through which his presence is known. They are his amanuensis.

At first the characters were the filmmakers' human alter egos, Bray's Heeza Liar and Bergdahl's Kapten Grogg most obviously. The popularity of child and family protagonists may be seen as an invitation to the audience to share in this personal fantasizing. Viewers may project their own

concerns into these familiar domestic situations, while the animator casts himself in the role of progenitor or head of the household in an extension of the filial relationship implied between the artist and his drawings in the earlier forms. The tendency to make the process of identification as universal as possible culminated in the rising interest in animals, long established as empathy-arousing objects in Western culture. The animator opts for increasing invisibility while seeming to perform a service for the audience, entertaining them with these diverting adorable protagonists. But his invisibility does not mean he no longer exists. It is just that his function has changed. His statements are no longer about his relation to his drawings, but about concerns shared with his audience. He is representing himself as a fabulist. The animal series of the late twenties closely approaches the form of the literary apologue, short stories in which the actions or qualitites of animals are made to satirize the foibles of humans. In this new persona, the animator assumes the function and responsibility of social commentary. He is no longer a magician, but a narrator of moral tales.

Figure 113.
Otto Messmer (left) and Pat Sullivan, 1928.

"To me a mouse is a repulsive thing."
Otto Messmer

"Felix the Cat" was not the most lucrative silent animated series, nor the longest-running, nor the product of the largest studio. Nevertheless, it was the quintessential cartoon of the 1920s and the favorite of a growing number of aficionados of the medium. I have singled it out for closer study precisely because it typified the studio production methods of the 1920s, and was the series that best summarized the animator's ongoing enterprise of assimilating himself into the films and inviting the audience to do likewise.

Although the films and the comic strip derived from them were signed "Pat Sullivan," the original idea and the everyday chores of production should be credited to Otto Messmer (figure 113), born in Union City, N.J., on August 16, 1892. While Messmer was still a child his family moved to Fort Lee just when it was becoming the center of the burgeoning film industry.[1]

Intrigued, young Messmer took time out from his classes to visit the various studios and observe the actors and actresses. Eventually he was hired as a part-time scene painter's assistant at Universal. His nights were taken up by

commercial art classes at the Thomas School, where "famous" artists were given space in exchange for criticizing the eager students' work. Messmer found himself attracted to the cartoonists who worked there, and early on he decided on a career as a graphic humorist and illustrator.

Otto Messmer cannot remember when he was not a film buff. His regular visits to the nickelodeons brought him his first glimpses of animation. He is probably the only living person who can recall seeing Eclair's "Newlyweds" in its theatrical release. "Colonel Heeza Liar" convinced Messmer to ask his boss at Universal if he could try his own hand. The answer was no, but if he made a set of drawings the studio might photograph them.

In 1913, it was up to Messmer to build his own animation kit. His father assisted with the carpentry, and together they built a wooden frame for holding the paper in fairly consistent registration. As he recalls, "I just had a corner, and I fitted the paper in."

The first films starred "Motor Mat," an intrepid automobilist. The gags all centered around the assorted ways a flivver could break down. Mat, as Felix would later, always kept his cool; he would sit back and blow philosophical smokerings with his cigar. "Fearless Freddy" and other one-time-only characters came and went.

Messmer's work created quite a stir in the studio, where his animation stand was set up in the open between active sets. A technician (maybe even Arnaud or one of Cohl's former assistants on the Universal Weekly) explained single-frame cinematography. Like Cohl, but unlike many early animators, Messmer mounted the camera over the drawings vertically.

One day in 1914, Hy Mayer, on one of his weekly visits to make his newsreel caricatures, found some of Messmer's drawings in progress and asked manager Jack Cohen to inquire if the artist wanted to work with him. Of course

Otto jumped at the opportunity to collaborate with an internationally famous cartoonist. Mayer had animated commercials in mind, so Messmer did a series called *The Travels of Teddy* sponsored by Auerbach's Chocolates. As Messmer recalls, "[Mayer] was a great friend of Teddy Roosevelt's, a personal pal. And his studio on Central Park South was full of souvenirs of Roosevelt, like a museum. . . . So he used Teddy, a little caricature with an African looking hat, glasses and mustache, shortened him a little, and he would be off on hunting trips."[2]

In 1915, a bright young cartoonist called Pat Sullivan also saw Messmer's work when he brought some of his own drawings in to be photographed. (In those days, Messmer explains, anyone could use the studio's facilities for a small service charge. This accounts for the many anonymous one-shot productions that appear in the 1913–15 release lists.) Patrick O'Sullivan was a native of Sydney, Australia, born in 1887. He was something of a castabout, having been a commercial artist in London, a prizefighter in the States, and briefly an assistant to William Marriner on the popular strip "Sambo and his Funny Noises," based on *The Story of Little Black Sambo* by Helen Bannerman. After Marriner's death in 1914, Sullivan thought of making an animated version and approached Raoul Barré, who taught him the techniques and let him use the studio. In return, Sullivan did work on Barré's cartoons. In 1915 Sullivan opened his own studio, where he made various advertising shorts and continued the time-consuming work on "Sammy Johnsin" (changed from "Sambo" to avoid having to pay royalties to Bannerman or to Marriner's heirs). The drawings were being photographed at Universal when the talented Messmer came to Sullivan's attention. He offered Messmer a job and taught him the latest techniques as practiced at Barré's. "Now," Messmer remembers, "I knew how to use pegs—there were no celluloids yet—and

how to cut holes in cardboard for the moving parts. I worked on the Sambo [*sic*] Johnsins, and tried to bring creativity to the different stories because they all seemed to be inclined to the barnyard . . . a little incident of this and that and chasing a little villain—it got a little monotonous to me." Although the records are not altogether reliable, there seem to have been nine *Sammys* released between March and December 1916, as well as independent films by Messmer, like *Motor Mat and his Flivver.* They were produced by Pat Powers and distributed by Universal.

Sullivan gradually did less and less work, preferring to hire capable artists like Messmer and Glackens (who had trained with Bray). Sullivan's real talent as an entrepreneur began to show, and he was able—how, not even Messmer knows—to contract with Chaplin for a series based on his screen character. Working from films and photographs supplied by Chaplin, a dozen "Charlie" cartoons were produced and distributed by the New York *Herald* during 1916.

In 1917, Universal asked Sullivan for a two-reel comic short to use as a prolog for *Twenty Thousand Leagues Under the Sea.* Messmer complied with *Twenty Thousand Laughs Under the Sea,* a compendium of underwater gags, which found itself in competition with Terry's unauthorized two-reeler *Twenty Thousand Feats Under the Sea.* Messmer and Sullivan had a falling-out, and in April Messmer returned to work with Mayer, who was attempting to set up his own animation studio. But all his people were being drafted, and soon Otto Messmer's call came too. Meanwhile Sullivan hired Bill Cause to replace Messmer, but their "Box Car Bill" series flopped.

Messmer had a difficult time convincing his fellow soldiers in the Signal Corps in France that he had drawn the Sammy Johnsin and Charlie Chaplin cartoons that were projected evenings. Then his wife sent him a drawing from

Life signed "Otz Messmer" which proved that he was per- haps not a liar after all (figure 114). This cartoon (which appeared in the July 12, 1917 number) is a rare specimen of Messmer's early graphic style. The rounded figures, strong black and white contrasts, simplified background (consisting only of a suggestive horizon line), and gentle bucolic humor would rematerialize in the films. Furthermore, the tranquil peace of the country would become a frequently used foil for the wild exuberance of city life.

After the armistice, Messmer and Sullivan reunited and prepared to resume the Charlie series. But Earl Hurd, who was setting up the Paramount Screen Magazine, called Sullivan to say that the staff was falling far behind schedule, and asked if Sullivan could help them out. Sullivan said no, but he told Messmer that he was free to submit something if he wished to draw it in his spare time. Messmer says:

I made a little film for them about a cat. He was chasing some mice around and it was full of gags like a mouse running up a grandfather clock, taking the minute hand off, throwing it like a spear and nailing the cat's tail to the floor. The title was *Feline Follies*. Paramount said, "Make us another," so I did a second one called *Musical Mews*. The big gag was these four cats singing in a backyard. It should have had sound. And they became famous singers, and there was one gag showing a theater. An overcrowded bus pulls up and hundreds of people get off and stream into the theater. The fat bus gets skinnier and the building grows and starts stretching at the seams.

John King, of Paramount, was enthusiastic about the films, and especially about the cat, who did not yet have a name. He offered Sullivan a contract for a regular feature on the Screen Magazine and, recognizing a good deal, Sullivan signed it. *Moving Picture World* reported that "Cartoons are Feature of Paramount Magazine. . . . Pat Sullivan,

Figure 114.
"Otz" (Otto) Messmer, "Back to Nature," *Life,* July 12, 1917.

another well known cartoonist, will have a series in which animals will have an unusual amount of comedy."[3] Gradually the cat's character became more clearly defined and King coined "Felix," from felicity (for good luck) and feline (for cat). The name was copyrighted and trademarked for Bijou Films.

The following spring, Paramount extended the provisional contract, as noted in *Moving Picture World:* "Pat Sullivan, creator of 'Felix the Cat' and other animated comics, has signed a long-term contract with the Famous Players–Lasky Corporation to make cartoons for the Paramount Magazine. Outside of Bobby Bumps, Sullivan's cat, Felix, is among the best known character [*sic*] of the motion picture comics and its antics have a record run at leading houses throughout the country."[4]

The contract was for two years and specified a Sullivan cartoon once every four weeks. It seems as though the cat's personality was understood and appreciated almost overnight. The reviewer of the December 1920 release reported that "Pat Sullivan put Felix the Cat through some astonishing aquatic and marine adventures with fishes and sailors and ships from which 'Felix' emerges with his usual 'savoir faire.'"[5]

In 1922, Margaret Winkler—described by Messmer as "the great live-wire saleslady of Warner Brothers"—stepped in to pick up the series when it became known that the Paramount Magazine was going out of business. Sullivan was able to buy the rights to the title and the character. Unlike Paramount, Winkler would sell the films by state's rights, a potentially more profitable arrangement for independent cartoon producers. In less than a month, 60 percent of all the territories were sold. But the strong personalities of Sullivan and Winkler did not mesh smoothly; there was an initial argument over who would design posters, and Sullivan won.[6]

During the Winkler period, Felix appeared monthly and Messmer continued to do most of the drawing himself. The original Felix was—in a surprising contrast to Messmer's earlier work—rather spiky (figure 115). His facial features were harsh. He was, after all, an alley cat. This was in keeping with his sharp, sometimes malicious personality, which was very close to Chaplin's character in his Keystone films. Felix's mannerisms as well as his general behavior were closely patterned on the Chaplinesque movements Messmer had analyzed in his previous cartoons. Messmer's screen cat was not the first; Krazy Kat had premiered four years earlier at IFS. Messmer was certainly conscious of Herriman's comic strip, but there was little appreciable influence. The same is true of another prototype, "Tad's Cat," a character drawn by Tad Dorgan for one or two Universal films in 1919 (figure 116).

The success of the series was snowballing. *Felix in the Swim,* it was reported, kept the Strand Theater in continual laughter. According to the *Moving Picture World* review, "The 'plot' shows how Felix, the Cat, cleverly makes use of a mouse he has befriended. He persuades the mouse to bring three of his brothers who walk up and down over the piano keys while his friend, Willie, is supposed to be practicing. Meanwhile Willie and Felix go swimming. Willie's mother is so pleased with the improvement in his music that she starts to jazz and even the clothes on the line do likewise. A clever orchestral accompaniment helped to get many laughs." [7]

If in the movies imitation is the surest sign of a box-office hit, then Felix must have been a smash. Pseudo-Felixes began popping up everywhere. Although animal heroes were relatively infrequent in Bray releases, *The Debut of Thomas Cat,* the first color cartoon, was the story of

. . .an important event in the life of a kitten, when he finds out

Before Mickey

Figure 115.
Messmer, advertisement showing original design for Felix, 1920.

Figure 116.
Tad, advertisement for *Tad's Cat* (Universal, 1919).

Felix

that the winning of cheers is not quite as easy as it looks to be. It all happens on the day that his papa decides that his son and heir is big enough to learn to catch mice and papa demonstrates how easy it is to just sit quietly at a hole and watch for Mr. Mouse to appear, and then grab him neatly between two paws. The kitten left to shift for himself attempts to follow his father's footsteps, and it is then that he discovers that the neat little trick of nabbing the mouse is one of the most difficult that has yet come into his young life. After several futile attempts to catch the mouse, he breaks a pitcher, gets tangled up in the family wash, and finally decides to try all over again. This time a rat substitutes for the expected mouse, the kitten meets his Waterloo and ends up in the hospital, where he has sufficient time to digest "Father Tom on Mouse Catching."[8]

Competition appeared in 1920 from Frank Moser, whose "Scat the Cat" alternated with Felix on the Paramount Magazine. The only real differences were that Scat was lankier than Felix and was gray. Paul Terry began using a cat hero named Felix. In *The Cat's Whiskers,* "Felix gets his whiskers manicured." *The Cat's Revenge,* released a month later on September 15, 1923, also featured the pretender.[9] Encouraged (we may surmise) by a reminder from either Winkler or Sullivan, Terry changed the character's name to Henry and made him fatter than Felix (figure 117).

In March 1924 Winkler began selling Disney's "Alice" comedies, in which the animal lead was played by Julius the Cat. Julius was more of a near-Felix than Henry, a fact that may have prompted an argument so violent that Margaret Winkler later publicly stated "It affords me great pleasure to announce that the differences which have existed between Pat Sullivan, originator of the Felix Cartoon comics, and myself have been amicably adjusted."[10]

For 1924 the frequency of Felix releases was doubled, to

HENRY CAT DOES THE CHARLESTON FOR "LAUGH MONTH"—the feline dandy of "Aesop's Film Fables," the animated cartoon subject released by Pathe, caught by Paul Terry's facile pen in six characteristic movements in the Charleston Dance.

Figure 117.
Terry, "Henry the Cat," 1924.

Figure 118.
Sullivan and Messmer, *Flim Flam Films* (Educational), © 1927.

Felix

once every two weeks. Until then, Messmer did all the animation himself (with the usual assistants and camera operator); now it was necessary to hire additional help. William Nolan became the first "guest" animator, occupying the seat to Messmer's right. The studio moved for the third time, to 47 West 63rd Street.

Apparently the differences between Winkler and Sullivan were not completely smoothed out, because as soon as the contract expired Sullivan signed with Educational. Winkler, Messmer recalls, was heartbroken; if not for sentimental reasons, then because she was making a fortune with Felix. But Educational was in a position to make an irrefutable offer, and won Sullivan over.

The president of Educational, E. W. Hammons, had moved his company into preeminence in only a few years. Several animated series had already run under the company's logo "The Spice of the Program" since 1919, when the IFS films were briefly revived. When the Paramount Magazine folded in 1922, Hurd and Tony Sarg went to Educational. But no series was successful until Felix came aboard.

The studio was expanded, and one of the newcomers was Al Eugster, now an animator at a New York advertising agency who remembers life at the studio fondly. Sixteen-year-old Eugster was working by day, studying drawing at Cooper Union by night, and attending "continuation school" (required by the state then for those not finishing high school) when his friend George Cannata told him about his great job at Sullivan's. Eugster was interviewed by Messmer and put to work as a "blackener," the lowest ranking among what Taylor would have called the "cheap men" of the shop. His job was filling in Felix's outline on the paper and cels with an ordinary brush and Higgins india ink, hardly a demanding chore. (Next up in the pecking order were the inkers, who retraced the animators'

pencil drawings with the by-then-standard Gillot 290 pens. There were no in-betweeners at Sullivan's; the animators did that themselves.)

The studio was completely under Messmer's quiet authority. He took care of every major and minor detail, from thinking up scenarios to going to the bank for the payroll. According to Al Eugster,

There was never a script. Otto did everything in his head. A film would begin with an idea and a few sketches that he would give to the head animator. Everyone would talk it over and start drawing. As he worked, Otto would continually think out loud of new ideas, for this film or for the next one, and when an animator would finish roughing out a scene, he would bring it to Otto who would look at it and OK it. He was animating and thinking at the same time. I don't know how he did it.[11]

As if this were not enough to keep him busy, Messmer also drew the one-sheet posters and Sunday's Felix the Cat color comic strip. Eugster would run the pages over to King Features at Columbus Circle, invariably only minutes before the deadline. Like the films, the strip was signed "Pat Sullivan."

Bill Nolan was the head animator when Eugster arrived. Under his influence, Felix's body was reshaped into circular forms (figure 118). The motives were aesthetic and economic: the rounded shape made Felix seem more cuddly and sympathetic, and circles were faster to draw, retrace, ink, and blacken. The animators were intuitively aware of a process Gestalt psychologists call shaping: As forms are retraced, the natural tendency is for them to drift toward increasingly simple (circular) forms, regardless of how one strives to maintain the original shape.[12]

When Nolan left to revive "Krazy Kat" for Mintz in mid-1925, he was replaced by George Stallings, by Raoul Barré, by Burt Gillett, and finally by Dana Parker as successive

"guests." Each effected subtle changes of style in rendering Felix, but the cat's temperament, the stories, the gags, and the general ambience remained distinctly Messmer's.

A photograph of the studio reveals a perfectly schematic taylorized assembly line (figure 119). Al Eugster recalls that when the photograph was taken, in 1928, all the animators had to move down one chair when Sullivan came in to take the head seat, which was normally Messmer's. "Management" was definitely segregated from "labor."

At the end of the room was the camera area where Alfred Thurber exposed the drawings on an ancient Bell and Howell geared for single frames and equipped with an electric motor. A loud clack accompanied each exposure. If several frames were being repeated, Otto Messmer might look up thoughtfully from his drawing, respond to the camera's machine-gun racket ("Hmmm . . . that's a long hold. . . ."), and continue animating. On the right of the photograph is the stall that served as the private office. The nearby restroom was used for washing cels and developing photographs, in addition to the usual purposes. Out of sight, there was a screen—or rather, a piece of white paper taped on the wall—and an old projector which would be brought out to show the latest Felix.

There was a distinct generation gap at the studio. The head animators tended to work together and talk among themselves, developing gags while probably recalling the good old days of cartooning. The youngsters, like Eugster and Cannata, engaged in rambunctious horseplay and wastebasket basketball until finally even the taciturn Barré would demand a little silence. With the clacking camera, the barely controlled teenagers, and the animators barking out gags, the atmosphere was one of anarchic turmoil, but Messmer's films were never late.

The crew worked on only one film at a time, on a two-week schedule, but naturally there was a lag between the

Figure 119.
The Sullivan Studio in 1928. From left to right: Pat Sullivan, Otto Messmer, Raoul Barré, Dana Parker, Hal Walker, Al Eugster, Jack Boyle, George Cannata, Tom Byrne, and Alfred Thurber. Courtesy of Al Eugster.

Felix

Figure 120.
Display of Felix the Cat dolls, Liggett's Drug Store, Grand Central
Terminal, New York, 1926.

Before Mickey

various phases of production. The animators were ahead of the inkers and blackeners, and the cameraman might be behind a half film, or even finishing work on the previous one. This system differs from, say, those of the Terry or Fleischer studios, where subcrews worked on two or three films simultaneously. The reason is evident: The assembly line was essentially an extension of Messmer. It was linear so that he could control the operation completely and efficiently.

This system of production was largely responsible for the success of Felix, and represented a compromise between the totally individual approach of the first animators and the mechanized production lines of the other studios. In terms of technique, too, it was a meld of old and new. The animators usually chose the outdated paper retracing method over the cel process, but also used newer methods like perspective runs and repeat cycling (requiring cels) when they were called for.

Felix the Cat was well on his way to stardom. Among the early indications was a 1925 New York *Herald* article in which the cat danced the Charleston. By about 1926, he was perhaps the most popular screen character, living or animated, except Chaplin. In part this was due to Educational's advanced marketing concepts, which included placing ads in popular periodicals like the *Saturday Evening Post* and providing cardboard Felix cutouts and other promotional materials for theaters. Sullivan (or someone) created a "Felix revue" that could be used royalty-free by theaters as a live musical prolog.

Sullivan also licensed the use of Felix's image on any item any promoter brought into his office, from cigars to baby oil. In May 1926 the Felix doll (figure 120) was introduced, and it became a fabulous success. At first the dolls were distributed exclusively by Rexall drugstores and

Hearst's United Cigar chain, but soon theaters started selling them to their clamoring patrons.

Popular songs sprang up about Felix—pure Tin Pan Alley, but indicative of his mass appeal. "Felix Kept Walking" was inspired by the 1926 film of the same title. According to Messmer, it began

There's a funny little cat
with a tummy nice and fat.
He's won picture fame,
Felix is his name.
Got a funny little walk. . . .

An "official" Felix the Cat song was published by the Sam Fox Publishing Company in 1928.

As with Chaplin, Felix's success cut across class and age boundaries. In Missouri, theater owners were claiming that children and adults "tore the house up" when a Felix came on; while sophisticated New Yorkers could tomcat at a "Felix the Cat Night" in August 1926 at the McAlpin Roof Garden.[13] At the same time, composer Paul Hindemith was busy on a score for *Felix at the Circus* which he hoped to present at the 1928 Baden-Baden festival. (Unfortunately, the machine that was to synchronize his pianola-roll composition with the film projector failed to perform, and the score has since been lost.[14])

In 1928, head animator Dana Parker wrote whimsically of the pleasures and frustrations of working at the studio:

At least no one of the [animator's] cast will complicate matters with a fit of artistic temperament. Leave such things for the tiny steel pen points used in the drawing. Far more temperamental than any actor are these little nibs, flexible yet stubborn.

Often the question is put, "how is it done?" and any adequate answer seems so technical as to be likely to bore the questioner, who will regret his curiosity. Often, at the end of a painstaking

explanation of the uses of "cells," "slashes," "repeats," "pans" and "exposure sheets," the animator is greeted with the question: "Yes, I understand all that, but how do you make them move?"[15]

By this time, as Felix's tenth anniversary neared, the production formulas had long been established: a cycle of 9 drawings for Felix to take two steps; 54 drawings to take him completely across the screen; positioning the drawings 3/8 inches instead of 1/4 inch apart to make him run. But, in contrast with the situation at the Terry Studio, the Sullivan rules were made to be broken—and they often were, for the sake of varying the effects and keeping the films fresh and spontaneous.

In November 1928, when *Steamboat Willie* and *Gallopin' Gaucho* had made Walt Disney the talk of New York, Disney made the rounds recruiting the men he knew he would need to mount full-scale sound production. He was acquainted with Messmer through Margaret Winkler, and (as Al Eugster recalls) visited him repeatedly. Did Disney make a good offer? Messmer responds: "An offer! It was pressure! He begged and pleaded. But my home, family and roots were in New York. And besides, it looked like Felix would go on forever. He was at the height of his success."

Messmer did not realize that Felix was already nearing the end. Pat Sullivan's ambitions matched Disney's, but not his judgment. Felix had made him a millionaire, and when Messmer explained that Disney was amassing the finest camera equipment obtainable, switching to synch sound production, weighing the possibility of color, and hiring the best animators in the country, Sullivan said he simply was not interested in changing the status quo. By that time he had withdrawn completely from the affairs of filmmaking and had no understanding of the seriousness of Disney's challenge. When Educational was informed that the Sullivan studio would not convert to sound, the contract for the 1928–29 season was not renewed.

However, in early 1930, Sullivan had a sudden change of heart and went to California with the intention of setting up a studio for producing Felix cartoons in sound and color.[16] By this time, though, Sullivan was having such severe medical problems that he was unable to complete his project. Nevertheless, in 1930, producer Jacques Kopfstein (formerly a manager at the Bray studio) began distributing, through Copley Pictures, Felixes with postsynchronized music tracks and sound effects. But a film like *Oceantics* (1930), however visually interesting, was below the level of *Steamboat Willie* in terms of its soundtrack and could not compete with such Disney fare as the first "Silly Symphonies." As the cash drained away from the studio, so did the spirit.

Both Sullivan and his wife were living the hard-drinking jazz-age life that could be found only in New York at the end of the 1920s. The years of incredible luxury took their toll. In March 1932, while attempting to catch the attention of her favorite chauffeur, Marjorie Gallagher Sullivan fell from her apartment window to her death five floors below. Pat Sullivan was badly shaken by the incident and never fully regained his emotional stability. He died of pneumonia on February 15, 1933.

Sullivan's passing left the studio in a legal shambles that was not cleared up for years. Messmer recalls: "Everyone knew I was running the studio and what Sullivan's problems were. A lot of people didn't get along with him. Then all of a sudden people like Fox and MGM were coming by with terrific offers to take over Felix. I couldn't do a thing. No one understood I was only an employee. Felix belonged to Sullivan's heirs in Australia." The staff readily found jobs at the other studios. Animation was booming again, riding the crest Disney was creating. Messmer occupied himself with the comic strip. In retrospect, he feels no regret about not receiving credit for his work at

the time it was done. Unconsciously affirming the taylorist structure of the studio, Messmer says, "He was the boss, the businessman; I was the foreman, the employee." He has great pride in the Felix character and the films that he produced. After the wave of Disneymania in the 1930s, many viewed the Felix films as crude. Now that the simplicity and the elegance of the films are being appreciated again, Messmer proudly says, "We were the only studio that didn't imitate Disney."

An analysis of the Felix series must begin with the character. The rise of the character series, at the expense of such older forms as lightning sketches, gradually redefined the animated genre as an artificial folkloric tradition. Animals emerged as heroes. Felix was ruler of this bestiary, and to some extent it was his success that encouraged other animators to develop their own animal heroes.

One clue to the secret of Felix's appeal lies in the popularity of the dolls. The screen character instigates a desire for the viewers to physically possess him. For children the desire can be satisfied by a physical surrogate (the doll); for adults the desire becomes aestheticized; the character's movements and gestures invite identification and empathy. It is a tribute to Felix's complexity that his "personality" cannot be adequately expressed in only a few sentences any more than a human's can be. But we can make some simple observations.

Felix's physical appearance is calculated to elicit certain presumed responses from the viewers. He is, after all, a cat, a domesticated creature which the audience is likely to be both familiar with and predisposed to like. Our culture has for ages attributed special status, sometimes even magical powers, to cats (and many other animals). The earliest Western art, sacred and secular, incorporated cats into its iconographic systems.[17] Nineteenth-century romantics regarded cats as mysterious alien visitors from the night, a

palpable connection with the unknown transcendental Other. Their elaborate mating performances also elicited metaphorical comparisons to human behavior. Edouard Manet's 1869 poster "Le Rendez-vous des chats" (figure 121) shocked Parisians with its implicit eroticism, precisely because they read into it references to human behaviors that were taboo in public. Like Felix, Manet's male cat is black, sly, streamlined, and endowed with expressive tail and ears. Like Felix's girlfriend, Manet's female cat is white and simultaneously aloof and provocative. It is significant that the poster was for *Les Chats* by Champfleury, a stylish book of cat lore that is partly an anthology of myths and partly a *roman à clef,* with disguised allusions to real people. Clearly, in the nineteenth century cats in art were understood as foils and exemplars of human behavior. In a literary representation like Carroll's Cheshire Cat, we see an embodiment of the fantastic, a tantalizing creature in which the cat's mythical half-human half-bestial status was concretized into a "lovable monster" image. Similarly, Felix is almost always associated with the imagination and its limitless boundaries.

Like Manet's black cat, Felix is often an erotic creature. When he is not pursuing his white friend, he likes nothing better than to participate in a nocturnal serenade with the boys. This lusty aspect of his character is one of the traits that differentiates him from Krazy Kat. Although in the interests of bourgeois clarity and propriety Krazy was depicted as a female on the screen, the comic-strip Krazy was androgynous, explicitly designated by Herriman as male but tending toward the female and infatuated with a male mouse. In his 1924 essay on the strip, Gilbert Seldes spoke of "Krazy, the most tender and the most foolish of creatures. . . ."[18] For the masculine Felix, no description would be farther afield.

Before Mickey

Figure 121.
Edouard Manet, "Le Rendez-vous des chats," lithograph, 1869.
Courtesy of New York Public Library. Astor, Lenox and Tilden
Foundations.

Felix

Sullivan and Messmer claimed that the original inspiration for Felix came from Rudyard Kipling's "The Cat that Walked by Himself," one of the *Just So Stories for Little Children* published in 1902. Kipling's fable is a mythopoeic account of how various farm animals were domesticated through the cunning of a cavewoman. Only the cat resisted and, by his own wit, was able to reap the rewards of domestication while avoiding captivity. He tricked the woman into letting him live in the cave. He could lie by the fire and drink milk, yet he could say "I am the Cat who walks by himself, and all places are alike to me." Kipling's marvelous story evokes the essentials of catness. Cats live with humans, yet seem ultimately to be unpossessible and untamable. As Kipling wrote, "He will kill mice, and he will be kind to Babies when he is in the house, just as long as they do not pull his tail too hard. But when he has done that, and between times, and when the moon gets up and night comes, he is the Cat that walks by himself, and all places are alike to him. Then he goes out to the Wet Wild Woods or up the Wet Wild Trees or on the Wet Wild Roofs, waving his wild tail and walking by his wild lone."[19] Kipling's illustration for his story showed an independent black cat walking in a grove of trees, swishing his expressive black tail (figure 122). This cat looks forward to the animated one who craftily gets his way 20 years later, as in *Felix in Hollywood* when he devises a scheme to finance his way west by ruining pedestrians' shoes with gum and then receiving kickback payments from a cobbler.

The drafting of Felix helped convey his dual feline nature. In proportion to the humans who frequently appear in the films, he is small—less than a foot tall, like a real cat (figure 123). He appears soft, cuddly, and vulnerable. His body invites picking up and stroking. His rounded form and his solid black figure can be read easily as spherical masses. Yet these teddy-bear qualities, as we are always

Figure 122.
Rudyard Kipling, "The Cat that Walked by Himself," © 1902.

Felix

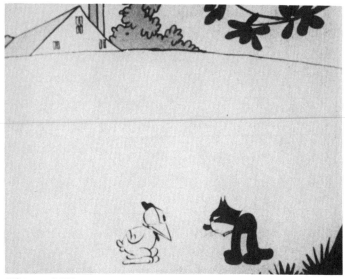

Figure 123.
Sullivan and Messmer, *Felix Dines and Pines* (Educational), ©
1927.

aware, are deceptive. Felix would never tolerate smothering human affections—except perhaps as the price of a good meal. When we see him by himself, in closeup, we usually perceive him as having the stature of a human.

Felix's motions and gestures place him solidly in the Cheshire Cat's demiworld. Often he is fully anthropomorphized, as in his famous worried pacing (figure 124). His "creature comforts" are usually human: a warm house, pipes and cigars, a night on the town. But he is also disturbingly an animal who flashes rows of sharp carnivorous incisors with each smile, walks on all fours, procreates offspring by the litter, eats mice and garbage, is chased by dogs, and has nine lives.

Felix's blackness, obviously a response to the exigencies of mass production, is also a vestige of barely articulated racial stereotyping. As much as Felix's personality was influenced by Messmer and Sullivan's Chaplin cartoons, his immediate predecessor Sammy Johnsin was also a factor in the original conception. According to the accepted, humorously intended racism of the time, black children were portrayed as witty, wide-eyed naifs who experienced feats of the imagination presumably denied white children. Marriner's Little Black Sambo is the definitive example. Furthermore, blacks were frequently regarded as talented extroverts and as having innate advantages over whites as entertainers. Many of these same qualities were subtly transfused into the Charleston-dancing Felix, although he was never overtly identified as a black.

Perhaps the most appealing aspect of Felix was his use of expressive body parts—a tail that forms gratuitous curlicues when he walks, or ears that click together like scissors. The unexpected appearance of these mannerisms is part of their attraction. Often they have no function except as signs of Felix's (and Messmer's) nervous energy. But usually Felix puts his somatic anomalies to productive use.

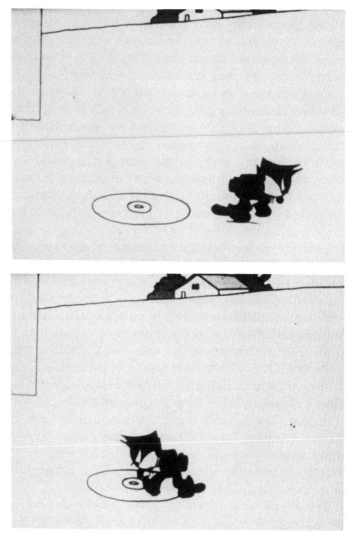

Figure 124.
Sullivan and Messmer, *The Non-Stop Fright* (Educational), ©
1927.

Before Mickey

He can mold himself into a mantel clock and have his nose mistakenly wound up; his tail can be an umbrella, a sword, a clarinet, or Chaplin's cane. He can use the tail as a bow to play a tune on his whiskers, then take one of the rising notes and use it for a door key. His skin is detachable. In *Felix Trifles with Time* (1925), a tailor flays him, then outfits a client with his pelt. When the man goes swimming, "naked" Felix retrieves his hide from the beach.

This polymorphous plasticism extends to the environment as well. Felix cannot see to read his newspaper: From a nearby sign saying "478 miles," he takes the 4 and makes it into a chair. The 7 becomes his pipe. With the 8 as spectacles, he may now read the paper. Felix needs to escape: He uses his tail to move a manhole into the path of a man with sandwich boards; when the man falls in, Felix puts the boards on as wings and soars away. Even punctuation marks are at his disposal: Question marks function as ladders for scaling castle walls; exclamation points make fine swords.

Themes

Close viewing of about 20 films made between 1923 and 1930 shows that, despite the large number of individual stories, a relatively small number of themes formed their dramatic basis. Among them are the following.

Felix the outsider. About half the films are premised upon the cat's ejection from a state of domestic equilibrium and his being forced to embark on a series of picaresque adventures to return. In *The Oily Bird* (circa 1928), a burglarizing chicken causes Felix to be suspected of stealing the mistress' jewels, and he goes out to recover them. Often the routine of putting the cat out at night motivates the

Figure 125.
Sullivan and Messmer, *Pedigreedy* (Educational), © 1927.

Figure 126.
Sullivan and Messmer, *Sure-Locked Homes* (Educational, circa 1927).

Before Mickey

plot, as in *The Non-Stop Fright* (1927), in which he is swept into a dustpan, and *One Good Turn* (1929), in which strings of hotdogs chase him out of his own house. Sometimes Felix's denial of domestic peace is the result of overt discrimination, as when he is the target of anticat ordinances in *Felix Revolts* (1924) and when he is confronted with "No Cats" signs at the ogre's apartment complex in *Felix in Fairyland* (1923) and at the cinema in *Flim Flam Films* (1927). *Pedigreedy* (1927) finds Felix barred from the "400 Club" (figure 125). A Herriman-style cat throws him out, telling him "only those with unquestionable lineage are eligible to membership here." Felix finally gains admission by faking a family "tree," but in many of the films he remains an outcast.

Felix threatened. Basically a pacifist who, like Kipling's cat, wants only a warm fire and a bowl of milk, Felix is the victim of countless conspiracies that threaten his very existence. Usually his antagonists are animals, such as the fencing mosquitoes in *Felix in Hollywood* (1923) and a wonderful Raoul Barré–originated chicken who appears in *Felix Dines and Pines* (1927), *Felix Trumps the Ace* (1927), and *The Oily Bird*. Sometimes humans try to take advantage of the cat, like the furrier in *Felix Trifles with Time*. Sometimes these villains are ostensibly supernatural, but turn out to be human. In *Sure-Locked Homes* (circa 1927), spooky shadows are traced to a baby with a lamp (figure 126); however, because the shadows go where "real" shadows could not, the film is open to the same "criticism" an unappreciative reviewer made regarding *Ghost Breakers* in 1923: "Felix, unawed by ghostly manifestations, succeeds in disclosing that the supposed ghost is a real estate shark who wishes to buy the farmer's land at a sacrifice price. Mr. Sullivan has created considerable merriment with the clever stunts in this picture which gives considerable rein to the imagination; however a weak point is the fact that

the supposed ghost does many things that would be impossible for him to do, such as disappearing through walls."[20]

Felix starving. Felix is almost always interested in food, but in a few films animal hunger provides the central motive. In *Felix Gets the Can* (1924), *Felix Trifles with Time,* and especially *Felix Dines and Pines,* a succession of food-oriented gags propel the action (figure 127). Felix steals spaghetti and uses it to siphon punch from a second-story window; he wrings a bowl of soup from a restaurant patron's beard; and so on.

Felix hallucinates. This experience—presented ambivalently as pleasant but not to be repeated—is brought on by indigestion, delirium tremens, or magical spells. For example, after Felix eats a shoe in *Felix Dines and Pines* he sees Santa Claus turning into an ugly crone and other visions which unfold in a bizarre Herriman-like landscape (figure 128). The hallucinations sometimes involve magical transportation to Fairyland or into the past. These moments provide Messmer with the opportunity for such formal experiments as pyrotechnic alternating positive-negative frames, dizzying spiral tunnel effects, and strange distortions of space.

Felix as good samaritan. Doing good deeds and returning favors are among Felix's favorite activities—along with getting revenge for injustice. He repeatedly intervenes in *Felix in Fairyland* to rescue Miss Muffet from the spider and to find better housing for the Old Lady Who Lived in a Shoe. That he could go to Fairyland at all was made possible by his saving the life of a fairy stuck to flypaper. Twice he is the benefactor of a circus fat lady: In *Felix Wins Out,* when she is having a romance with a human skeleton he says "I wish I could help that girl; nobody loves 'em fat." He finds a magic flute and makes her shimmy until skinny. In *Felix Trumps the Ace,* he finds a tent that is just her size

Figure 127.
Sullivan and Messmer. **a:** *Felix Gets the Can* (Winkler, 1924). **b:**
Felix Dines and Pines (Educational), © 1927.

Felix

a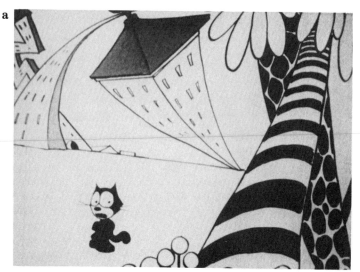

Figure 128.
a: Sullivan and Messmer, *Felix Dines and Pines* (Educational),
© 1927. **b:** *Felix Trifles With Time* (Educational), © 1925.

b

Felix

so she can have a gown for the ball. *One Good Turn* is one of the most overtly aesopian Felixes: A fox saves him from a bear, and later Felix saves his new friend from a pack of dogs. This moral aspect was very important for Messmer, who said

> I tried a little bit of education and human feelings. For instance, Felix was fishing one day and he caught a cute little fish. Close up, the fish was crying and, you know, Felix starts to cry a little bit too and says, "I can't do it." He lets him free. Later on, Felix is in a boat sinking or something and he's swimming and a big giant shark is coming after him—big trouble—then this other giant fish comes and knocks the shark out, saying, "I am that little fish you saved. Ride on my back to safety." Things like that gave me satisfaction and did some good. The Teachers Association of America sent letters saying this is good; we use some of these because they say it pays to be kind.[21]

Felix philanderer. Felix was after all a cat, and yielded to the pleasures of the feline flesh. In these films he has married the white mate and become the henpecked father. His children mischievously record him kissing a bathing beauty in *Flim Flam Films*. In *Why and Other Whys* (1927) an explanation is demanded when Felix arrives home at 4 A.M. His desperate excuses relate many strange adventures of the evening. Similarly, in *Felix Woos Whoopee* (1928), Mrs. Cat keeps a clockside vigil while inebriated Felix is out watching lampposts turn into dragons. Always his punishment is the same; she wields a rolling pin with the dexterity of Maggie or Mama Katzenjammer.

Felix insurrectionist. When faced with oppression, Felix becomes a rebel. In *Felix Wins Out* he exhorts fleas to stampede a stable of circus animals. The most political film is *Felix Revolts* (1924) (figure 129). Starving Felix complains "They're treating us cats like dogs." The last straw comes when the city fathers say "Cats are useless. Cats are

Figure 129.
Sullivan and Messmer, *Felix Revolts* (Winkler, 1924).

a nuisance. So let 'scat the cat' be our motto." Felix declares "I'll get the gang and we'll see about this." A rally in the town square gains solid support. Bearing a flag of truce, Felix approaches the mice and tells them "The town is yours; we're on strike." Then "the ruthless rodents run rampant." Finally the townspeople cry out "bring back those cats," and the mayor proclaims that all cats will be treated with the utmost courtesy and have free access to all kitchens and garbage cans. Kipling's Cat that Walked by Himself would have purred with pleasure.

Only by viewing dozens of Felix films does one come to understand that Felix's special attraction arose not from the clever gags (although they were very important), but primarily from the consistency and individuality of the character. Unavoidably one sees Felix as a living being, whereas his only competitor in this respect, Koko, seems real because his motion is to a greater degree an index of real motion. Felix's movement, on the contrary, is abstract and choppy. With Koko, as it had been with Gertie, one is aware of the pull of gravity on the body. Felix is innocent of any such mimetic tendencies. Instead, he is an index of a real personality. After meeting Otto Messmer, one realizes that the personality is that of the creator.

With Felix, the quest for self-figuration reaches its end. Messmer no longer feels obliged to physically enter the image (although in *Comicalities* he did briefly toy with the "hand of the artist" convention). Instead, he enters the film through total identification with the character.

Messmer described the process of thinking up stories as a return to his own childhood curiosity about his environment: "I tried to think of the way it was when I was a little boy. You know, when you're a boy you wonder about things, and I thought the audience might wonder too. 'I wonder where that thunder's coming from up there.' 'I wonder

what is down below the sea.' 'How is it up at the North Pole?' Things like that. I'd make him go there. These ideas took Felix to many places."

In many ways, Felix's uniqueness derives from his metaphorical expression of fleeting childhood concerns, which Messmer was able to articulate in images and simple allegories. Many of the themes of the rudimentary analysis above can be interpreted as basically infantile desires: the intense needs for food, for libidinous gratification, for shelter and security. The villains in the films deprive Felix of these needs, and cause him to be cast out from tranquil domesticity into a cold and dangerous world. These most fundamental concerns, shared by Felix and his audience, help account for the universality of our identification with his desires and threats.

Even more important, Felix's adventures provided Messmer with an opportunity to indulge in flights of fancy, rendered by his animators in images verging on modernist abstractions (figure 130). It is surprising that early literal-minded critics did not like or even understand the splendidly illogical world pictured in the films. Messmer delighted in this aspect of his cartoons. His comments on Hurd's Bobby Bumps are revealing: "Bobby was beautifully drawn, but plain. Hurd was content to show him climbing up on a roof. Me, I would have him jump off or fly or something. Then people would say, 'You can't do that.' " Repeatedly Felix tests the limits of the imagination, and tries them as seriously as any nineteenth-century decadent poet might. Grotesque monsters, exotic landscapes, and impossible disjunctions of time and space are "normal" recurring motifs in Felix's world, and he accepts them with aplomb. In many respects Messmer was, more than anyone else, a successor to Cohl's Incoherent cinema.

Messmer delighted, as Cohl did, in exploring the strange worlds of the unconscious that one sometimes enters when

Figure 130.
a: Sullivan and Messmer, *Felix Dines and Pines* (Educational, © 1927. **b:** Sullivan and Messmer, *Sure-Locked Homes* (Educational, circa 1927).

Before Mickey

Figure 131.
Sullivan and Messmer, *Felix Woos Whoopee* (Educational), © 1927.

Felix

the rational mind is dulled by alcohol. *Felix Woos Whoopee* (figure 131) at times takes on the appearance of a Cohl homage, complete with metamorphic sequences in which apes and cars turn into elephants. This film also demonstrates the ability of the animator to portray mental states subjectively. While Felix is making merry with a tableful of kitties in a speakeasy, the room, the building, and finally the entire Manhattan skyline are shown throbbing rhythmically to the jazz beat in Felix's head.

One seldom finds explicitly oneiric states in Felix films. This is indeed one of their distinguishing features, and the reason is clear: Felix's everyday world is already in excess of anything one might find in a dream. To show him awakening at the end of a film would be superfluous. When other animators indulged in irrational imagery, they seemed to feel compelled to draw back from accepting its consequences. The dream-framing device, one of the most important animation codes, acts to establish the limits of rational thought. In American cartoons, as in American art in general, the demarcation between fact and fantasy was usually heeded scrupulously. Felix, however, never shies away from the irrational. He accepts it as ordinary.

Messmer's personal definition of Felix involves a romantic mingling of his own consciousness with the cat's. Many of Felix's most distinctive gestures were originally Messmer's habits. The walk, the "eureka" gesture (slapping fist into palm while winking), the sly look out of the corners of the eyes—Al Eugster remembers Otto demonstrating all these to the staff, much as a silent director would perform for his players.[22] One can also surmise from the slang language of the title cards that, if we could hear Felix speak, he would have a New Jersey accent.

One wonders whether the cartoons might not have reflected Messmer's concerns even more than he realized. To what extent did the everyday preoccupations of running

the studio enter into the content of the films? *Felix in*
Hollywood, for example, ends with Cecil B. DeMille hand-
ing Felix "one of those long term contracts," just when
Sullivan and Winkler were haggling over renewal and Ed-
ucational was presumably making its overtures. Did the
increasing frequency of the philandering and alcoholic
themes in the late 1920s have any relation to the private
life of the boss, Sullivan? Did the somewhat paranoid world-
view stem from Messmer's unexpressed worries about his
tenuous position in the studio and, more profoundly, his
relation to a character who had become his alter ego but
over whom he had no legal rights?

In "Out of the Inkwell" and many other silent cartoons,
the animated characters usurp the powers of the creator by
taking the pen and making drawings or inking themselves
in. We find a similar idea in Felix, but again it is expressed
with extreme subtlety and, characteristically, as a meta-
phor. In *Oceantics,* Felix solves the problem of obtaining
food by using the sharpened point of the tail to draw a
trapdoor through which he can enter a grocery store (figure
132). The solution is to become a kind of animator, to use
a pencil to make a representation which then becomes
"real." The most perfect expression of Felix's tendency to
become the animator (and vice versa) is in *Pedigreedy* (fig-
ure 133). Felix awakes. It is the special moment between
sleep and full consciousness. He emerges from a barrel into
the cold, white and shivering. He pulls on his fur as though
he were dressing in pants and a sweater. But metaphori-
cally, he is also filling in his white outline with black,
performing the function of the studio blackeners. He puts
on his ears as though they were a hat, and screws his tail
into place. The independent, detachable nature of his limbs
acknowledges that these parts actually exist separately as
sheets, cels, and cutouts. Felix's allegory of self-creation is

Figure 132.
Sullivan and Messmer, *Oceanantics* (Kopfstein), © 1930.

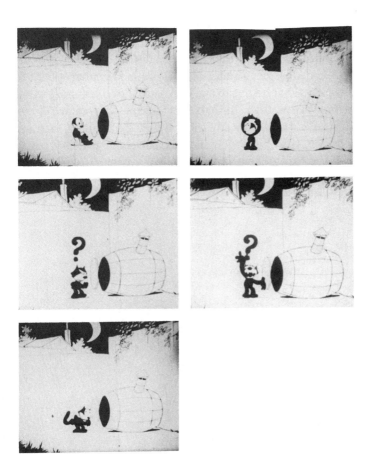

Figure 133.
Sullivan and Messmer, *Pedigreedy* (Educational), © 1927.

Felix

emblematic of the animator's creation of the cat out of the elemental materials of ink and paper.

One of Gilbert Seldes's comments on Krazy Kat holds true for Messmer's Felix as well: "It is Herriman's bent to disguise what he has to say in creations of the animal world which are neither human, nor animal, but each *sui generis*."[23] Specifically, Messmer injected his animal creation not only with his statements and ideas but with his whole self, breaking down the distinction between animator and animated.

Conclusion

The development of the animated cartoon from 1898 to 1928 was anything but orderly. Haphazard and serpentine are most apt characterizations. Like the history of the period, the films themselves present a welter of confusing plots, protagonists, and visual styles. Does this mean that early animation was meaningless and incomprehensible? No. In fact, the situation was quite similar to the corpus of Russian folktales described by Vladimir Propp in 1928: ". . . the number of functions is extremely small, where the number of personages is extremely large. This explains the twofold quality of a tale: its amazing multiformity, picturesquesness, and color, and on the other hand, its no less striking uniformity, its repetition."[1] Taken as an integral whole, animation exhibits this same twofold nature. Although locally quite diverse, the general development over the first thirty years of its history was toward the refinement of a relatively small number of codes having as their primary function the figuration of the animator.

The enterprise of self-figuration was not constant, but drifted away from simple overt representations toward increasingly complex and symbolic manifestations. At first it seemed that animators were intent on keeping this almost mystical capability of cinema to themselves, but later they asked the audience to participate vicariously in the ritual.

They made it as easy as possible by providing animal heroes.

Anthropologist Roy Willis studied three African tribal groups and concluded that their animal imagery, valued highly in their civilization, functioned as a "self-translation into an alien universe."[2] Although the animal species revered differed among groups, the function was the same: a medium for transcendence out of the individual self into communalism. In our culture, movies in general, cartoons in particular, and especially cartoons with lovable animal heroes, promote similar social and personal rituals.

Almost all the animated films discussed begin by establishing an "alien universe" into which the spectator may project himself. Although the creators of the first animated films were not surrealists or even cognizant of that movement, they inadvertently made films that demonstrated a disregard for everyday existence, normal logic, and causality, and a propensity for dreamlike action which André Breton and his followers admired. The affinity between cartoons and the emerging antirealist aesthetic of the 1920s was first voiced in a 1925 article written by Gus Bofa, a French caricaturist who was trying his hand at animation. Bofa promised that the cartoon would succeed in the elusive quest of pure cinematic rhythm, and claimed that "film gave man the power finally to create something new in the world."[3]

The increasing use of animals as vehicles of what the anthropologist called "self-translation" can also be understood better in terms of surrealist motives. For both the animator and the spectator, animals provided codified channels by which, through personal identification, the dream world on the screen could be entered. The first "Felix the Cat" films did not appear in France until 1927, but the cat was almost immediately linked with surrealism by Marcel Brion, later a member of the Académie Française

and historian of abstract painting. In an essay tellingly entitled "Felix le chat, ou la poésie créatrice" Brion promoted Messmer's animal as a *sur-chat,* a super cat of mythology far removed from the reality of everyday cats. Although Felix existed only on paper and celluloid, he paradoxically had more personality than "real" movie stars. His removable tail expressed the two creative faculties of the mind, surprise and curiosity, by forming itself into the punctuation marks ! and ?. In Felix's self-created world the lack of boundaries between real and imagined objects produced an oneiric state; Brion wrote that "this creative power of the dream and this surrealist formation of the object give to these fantastic images the means by which the mind enjoys free play."[4]

These European intellectuals recognized the surrealist potential of animation relatively late in its evolution, but this attraction had been felt by sensitive viewers from the beginning. Were not the first experiments by McCay praised for their power to transport the viewer to Slumberland? And in *Gertie,* we actually saw the animator (or more accurately his simulacrum) enter into the picture and be carried away by the animal. In the end, it is this transportive function, the implicit "sentimental journey" in all early animation, that made it gratifying and compelling and that established the expectations and desires of the audience long before Mickey boarded that first steamboat.

Conclusion

Notes

Introduction

1. Robert E. Sherwood, "The silent drama," *Life,* November 22, 1922.

2. Of the many pictorial surveys, the best remains Ceram (Marek), *The Archaeology of the Cinema.* For scholarly discussions of protocinematic devices see Deslandes, *Histoire comparée du cinéma,* vol. I, and Centre Nationale de la Cinématographie/Le Conservatoire National des Arts et Métiers, *Image et magie du cinéma Français.*

3. Gilbert Seldes, *The New Republic,* June 8, 1932.

4. Panofsky, "Style and medium in the motion picture."

Chapter 1

1. *Moving Picture World,* March 30, 1907; February 8, 1908.

2. *Photo-Ciné-Gazette,* February 15 and April 15, 1907.

3. Talbot, *Moving Pictures,* p. 242.

4. Issues of *L'Orchestre* and other Paris trade publications, 1907–08; *Le Fascinateur,* February 1908.

5. Victorin Jasset, "Etude sur la mise en scène," *Ciné-Journal,* October 8, 1911.

6. *Phono-Ciné-Gazette,* April 15, 1907.

7. Gustave Babin, "Les Coulisses du Cinématographe," *L'Illustration,* March 28 and April 4, 1908.

8. Arnaud and Boisyvon, *Le cinéma pour tous,* p. 73.

9. Smith and Koury, *Two Reels and a Crank,* p. 51. There are no surviving examples of these early animated films.

10. Eileen Bowser, "The Brighton Project," *Quarterly Review of Film Studies* IV, no. 4 (fall 1979), p. 534.

11. Carlos Fernandez Cuenca, *Segundo de Chomón, Maestro de la fantasia y de la tecnica.* I am grateful to Donna D. Clarke for

translating this monograph for me. Cuenca's admittedly tentative research has been supplemented by Francisco Aranda. Louise Beaudet organized a Chomón retrospective at the 1978 Ottawa International Animated Film Festival. The filmmaker is the subject of a film being produced by Juan-Gabriel Tharrats, *Cinematografo 1900; Homenaje a Segundo de Chomón.* See Beaudet, *Ottawa 78,* pp. 22–27.

12. *Moving Picture World,* December 19 and December 26, 1908.

13. *Phono-Ciné-Gazette,* April 15, 1908; *Moving Picture World,* June 27, 1908.

14. "A world-favored 'trick' subject. Life-like portrait sketches produced by the Hand; a coster and his 'Donah' magically come to life, embrace and dance a cakewalk. Other surprising effects follow in rapid succession, the Hand of the Artist repeatedly producing new wonders. After each subject plays its part, the Hand crumples up the paper and disperses it in the form of confetti." (Charles Urban Trading Company *Catalogue,* 1909.) The film was released in the United States on April 6, 1907.

15. *Moving Picture World,* June 22, 1907.

16. "By the Hand of the Artist. Amusing, amazing and entrancing magic. By reason of its beauty and grace and fascination of the beings created by the scissors, which come to life and skillfully perform, this film will enchant audiences of every class." (Charles Urban Trading Company *Catalogue,* 1908.)

17. *Moving Picture World,* July 27, 1907.

18. G. de Pawlowski, "La Faillite des fées," *Comoedia,* August 16, 1908.

19. Blackton, introduction to Phillips's *The Photodrama* (see Blackton listings in bibliography below).

20. *Moving Picture World,* November 28, 1908.

21. *MPW,* February 20, 1909.

22. Georges Méliès (and the editors), "Les Coulisses du cinématographe: Doit-on le dire?," *Phono-Cinéma Revue,* April 1908.

23. *Phono-Ciné-Gazette,* April 15, 1908.

24. François Valleiry, "Doit-on le dire; réponse à M. Méliès," *Phono-Ciné-Gazette,* June 15, 1908.

25. Anonymous, "Les Trucs du cinématographe," *Lectures Pour*
Tous, June 1908. The only Gaumont film I have identified called
La Statue was released in December 1905. If that is the film,
then animation was known at the studio before *The Haunted
Hotel.*

26. "Stop camera tricks," *Kinematograph and Lantern Weekly,*
April 30 and June 11, 1908. The latter article appeared in French
translation in *Filma,* September 1908.

Chapter 2

1. "Humorous Transformations," McAllister catalog, 1892, 1896.
Thanks to Robert Herbert for calling this to my attention.

2. Kunzle, *History of the Comic Strip,* vol. I. For discussions of
the relationship between comics and cinema, see Francis Lacas-
sin, "Bande dessinée et langage cinématographique," *Cinéma 71,*
September 1971 (reprinted in *Pour un neuvième art: La Bande
dessinée,* translated by David Kunzle in "The comic strip and film
language," *Film Quarterly,* fall 1972); Pierre Couperie, *Bande
dessinée et figuration narrative* (translated as *A History of the
Comic Strip*); John Fell, *Film and the Narrative Tradition;* Maur-
ice Horn, *Seventy-Five Years of the Comics;* Gérard Blanchard, *La
Bande dessinée; histoire des histoires en images.* Other papers on
the subject were read at the 1981 Ohio Film Conference.

3. Niver, *Motion Pictures From the Library of Congress Paper
Print Collection, 1894–1912.* The two 1906 American Mutoscope
and Biograph films were *Looking for John Smith* and *Wanted—A
Nurse.*

4. Exceptions to this generalization are discussed in Barry Salt,
"Film form: 1900–1906; "*Sight and Sound* 47, no. 3 (summer
1978), pp. 148–162; Jon Gartenberg, "Camera movement in Edi-
son and Biograph films, 1900–1906," *Cinema Journal* XIX, no. 2
(spring 1980), pp. 1–16; John Fell, "Motive, mischief and melo-
drama: The state of film narrative in 1907," *Film Quarterly*
XXXIII, no. 3 (spring 1980), pp. 30–37.

5. Marshall Deutelbaum, "Structural patterning in the Lumière
films," *Wide Angle* III, no. 1 (1979), pp. 28–37.

6. Georges Sadoul, in the course of his research into nineteenth-
century juvenile literature, discovered a picture story by Hermann
Vogel in an 1887 *Album Quantin* [reproduced in *Histoire générale*

354 *du cinéma,* vol. I (1973 edition only), pp. 296–297]. Another version by Sorel, "Fait divers," can be found in *La Caricature,* March 12, 1887. Sadoul interviewed the man who played the gardener in the film in 1946 and discovered that the "scenario" originated with Antoine Lumière's ten-year-old son, Edouard. However, aging Auguste Lumière no longer recalled the origins. (Sadoul, vol. I, p. 198.)

7. "Our 'Hooligan' bounced through some frivolous antics in a new series of Vitagraph pictures filmed on the roof [of the Morse Building in New York]. It never occurred to us to obtain a release from the owners of the comic character. The artist and newspaper presumably regarded it as a compliment and something of an advertisement. 'Hooligan' acted against the crude backdrop on the roof for the 'interior' scenes; the exteriors were photographed in public streets and parks. Each picture in this series was seventy-five feet long and ran one and one half minutes." (Smith and Koury, *Two Reels and a Crank,* pp. 49–50.)

8. The titles are derived from Niver's list. Probably additional films were never copyrighted.

9. Outcault's *Electrical World* sketches are reproduced in Hendricks's *The Kinetoscope* under the name James R. Outcault. See "R. F. Outcault" in Sheridan, *Comics and Their Creators* and the introduction to Derleth's *Buster Brown.*

10. *Moving Picture World,* May 2 and May 24, 1913; July 4, 1914.

11. *MPW,* June 3, 1911.

12. *MPW,* May 4, 1912.

13. "The dearth of comedy," *MPW,* June 10, 1911.

14. Guy, *Autobiographie d'une pionnière du cinéma,* p. 79; Jasset, "Etude sur la mise en scène," *Ciné-Journal,* October 28, 1911.

15. Blackton, lecture given at University of Southern California, February 29, 1929 (see Blackton listing in bibliography below).

16. Slide, *The Big V.*

17. Blackton, *Hollywood with its Hair Down,* unpublished manuscript, Academy of Motion Picture Arts and Sciences. I am grateful to Anthony Slide for this information.

18. Blackton, "A glimpse into the past," *Moving Picture World,* March 10, 1917.

19. Furniss, *Our Lady Cinema,* p. ix.

20. George Pratt, "Early stage and screen: A two-way street," *Cinema Journal* (winter 1974–75), pp. 16–19.

21. Gifford, *British Film Catalogue, 1895–1970.*

22. Méliès, *Star Film Catalogue,* nos. 37, 57, 61, 73. See Hammond, *Marvellous Méliès,* pp. 134–136 and Frazer, *Artificially Arranged Scenes.*

23. Smith and Koury, *Two Reels and a Crank,* pp. 29–30.

24. New York *Telegraph,* June 22, 1906; New York *Herald-Tribune,* July 27, 1934, p. 13.

Chapter 3

1. I am grateful to Madame André Courtet and to Pierre and Suzanne Courtet-Cohl for making this and other documents available.

2. This story originated in an article by Jean-Georges Auriol, "Les premiers dessins animés cinématographiques: Emile Cohl," *La Revue du Cinéma,* January 1930, pp. 12–19. According to Auriol, the plagiarist borrowed a story of a worker installing a hanging lamp who drives a large screw into the ceiling. It penetrates the floor above and fixes a trunk in place. I have indeed located such a drawing, "The Thin Ceiling; or,—a Lodging House Mishap," published in London in 1891. However, a Gaumont film corresponding to this scenario has yet to be identified.

3. The title was a reminder of Robertson's "Fantasmagorie," a magic-lantern spectacle that projected eerie hovering images of spirits. *L'Hôtel hanté*'s French subtitle was "fantasmagorie épouvantable."

4. J.-B. de Tronquières (pseudonym of Emile Cohl), "Dessins animés," *Larousse Mensuel,* August 1925.

5. Jules Lévy, "L'Incohérence, son origine, son histoire, son avenir," *Le Courrier Français,* March 12, 1885.

6. Spehr, *The Movies Begin.*

7. *Moving Picture World,* February 22, 1913.

8. Only one American Cohl film exists: the recently discovered *Bewitched Matches,* released May 4, 1913.

356 9. "We will present the comedy HIT of the year—a series of animated cartoons based on the famous Newlywed pictures of George McManus." (*Moving Picture World,* February 15, 1913.)

10. *Moving Picture News; Moving Picture World,* quoted in *Eclair Bulletin* 39, April 1913.

11. L.-R. Dauven, "En Visite chez M. Emile Cohl qui inventa les dessins animés," *Pour Vous,* August 1933.

12. *Moving Picture World,* December 19, 1908.

13. *MPW,* March 27, 1909.

14. L. Gardette, "Teaching history by motography," *The Nickelodeon* [*Motography*], October 4, 1909, pp. 119–20. A similar article appeared in *La Nature,* June 19, 1909.

Chapter 4

1. Montgomery Phister, "People of the stage: Winsor McCay," Cincinnati *Commercial Tribune,* November 18, 1909; "Began as a scene painter," Pittsburgh *Post,* April 4, 1907; Winsor McCay, "Movie cartoons," *Cartoons and Movie Magazine,* April 1927, pp. 11–14; "Winsor McCay: Artist, inventor and prophet," undated manuscript, Gelman collection; Obituaries in New York *Herald-Tribune, Evening Journal,* and *American,* July 27, 1934.

2. Barnett Phillips, "The record of a sneeze," *Harper's Weekly,* March 24, 1894; Gordon Hendricks, "A new look at an 'old sneeze,'" *Film Culture* 22–23 (summer 1961), pp. 90-95.

3. Canemaker, *Remembering Winsor McCay.* The drawing "animated" by Canemaker was reproduced in Michael Patrick Hearn, "The animated art of Winsor McCay," *American Artist* 39, 394, May 1975, p. 27.

4. Marc Klaw, quoted in Waters, *Victor Herbert,* p. 322.

5. McCay, "Movie cartoons," 11, quoted in Judith O'Sullivan, "In search of Winsor McCay," *American Film Institute Report* 5, no. 2 (summer 1974), p. 7.

6. "Moving pictures that move," New York *Telegraph,* April 12, 1911.

7. *Moving Picture World,* February 4, 1911.

8. *MPW,* April 15, 1911.

9. *Ciné-Journal,* June 3, 1911.

10. Cohl, "Sur les dessins animés," *Ciné-Tribune,* July 15, 1920.

11. *MPW,* April 15, 1911.

12. Synopsis of the 1916 rerelease under the title *Winsor McCay and His Jersey Skeeters, MPW,* October 28, 1916. The original length in Europe was 163 meters (a full reel), much longer than the remaining fragment. (*Ciné-Journal,* May 24, 1913).

13. New York *Telegraph,* August 12, 1912.

14. John Canemaker, "Reminiscing with John A. Fitzsimmons, assistant to Winsor McCay," *Millimeter,* April 1975, pp. 14–16.

15. Ashton Stevens, "McCay on Stage," Chicago *Examiner,* February 9, 1914; reprinted in Blackbeard, *Dream Days,* p. xi.

16. Cohl, quoted in Arnaud and Boisyvon, *Le Cinéma pour tous,* pp. 82–83. For another eyewitness account see Claude Bragdon, "Mickey Mouse and what he means," *Scribner's,* July 1934, pp. 40–43.

17. Animator Shamus Culhane told me that the cartoon apple was tinted bright red.

18. *MPW,* November 14, 1914.

19. Allen, *Vaudeville and Film 1895–1915,* p. 298.

20. McCay's comic strips are known almost exclusively from reproductions in anthologies: *Dreams of the Rarebit Fiend* (F. A. Stokes, 1905; reprinted Dover, 1973), *Little Sammy Sneeze,* (Stokes, 1905), *Little Nemo in Slumberland,* (McCay Features Syndicate, 1945), *Winsor McCay's Dream Days: An Original Compilation, 1904–1914* (Hyperion Press, 1977); *Little Nemo in Slumberland,* second edition (Nostalgia Press, 1974), *Little Nemo, 1905, 1906* (Nostalgia Press, 1976). Original drawings are in the Moniz Collection and in many institutions, especially the Museum of Cartoon Art at Port Chester, N. Y.

21. Buster Keaton, quoted in Blesh, *Buster Keaton,* p. 220.

Chapter 5

1. I am indebted to John Canemaker's unpublished manuscript of his interview with Bray conducted on March 25, 1974. For the published version, see "Profile of a living animation legend: John

358 Randolph Bray," *Filmmakers Newsletter* VIII, no. 3 (January 1975), pp. 28–31. Bray was a sound but aged man at the time. The dates must be regarded as "ballpark" figures. There are many discrepancies in dating Bray's early career. He told Canemaker, for instance, that he went to New York at the age of 18, or in 1897; studio biographies gave the date of 1900.

2. Canemaker, ibid. Hereafter, all Bray statements are from this interview unless otherwise noted.

3. *Judge,* April 6, 1907.

4. *Moving Picture World,* July 21, 1917.

5. *MPW,* January 10, 1914.

6. For Pathé: *Colonel Heeza Liar's African Hunt,* January 14, 1914; . . . *Shipwrecked,* March 18; . . . *in Mexico,* and *Col. Heeza Liar, Farmer,* both April 22. For Eclectic: *Colonel Heeza Liar Explorer,* August 22; . . . *in the Wilderness,* September 26; . . . *Naturalist,* October 24.

7. Terry's last Bray film was *Farmer Alfalfa's Blind Pig,* according to Harvey Deneroff's unpublished interview.

8. Denig, "Cartoonist Bray with Paramount," *MPW,* December 11, 1915.

9. Léon Gaumont, "Système de production de bandes cinématographiques reproduisant des événements, actualités ou autres, par la représentation de déplacements simulés d'objets, corps, masses quelconques, troupees [*sic*] en actions, navires, etc.," French patent 296.016, 1900.

10. Earl Hurd, U.S. patent 1,143,542, granted June 15, 1915.

11. Lutz, *Animated Cartoons,* p. 70.

12. Denig, "Cartoonist Bray with Paramount."

13. J. R. Bray, "Development of the animated cartoon," *Moving Picture World,* July 21, 1917.

14. Ibid.

15. Unidentified clipping, circa December 1915, Bray Studios archives.

16. Denig, "Cartoonist Bray with Paramount."

17. For interesting remarks about Lederer, see Joe Adamson,

"From this you are making a living?: Joe Adamson talks with Richard Huemer," *AFI Report* V, no. 2 (summer 1974), pp.10–17.

18. *MPW*, January 9, 1918.

19. *Motion Pictures Today*, September 4, 1926; *MPW*, September 11, 1926. Bray's litigations continued throughout the life of his patents. See *Motion Picture News*, April 1, 1927. As late as 1930 he was still selling licenses (*Motion Picture News*, January 4, 1930).

20. *Motography*, January 1, 1916, pp. 19–20.

21. In the "state's rights" scheme, producers sold exclusive territorial rights to various regional distributors; each contract was negotiated separately.

22. Denig, "Cartoonist Bray with Paramount."

23. William J. Reilly, "From morgue artist to humorist," *MPW*, August 30, 1919.

24. "Goldwyn has controlling interest in the Bray Pictures Corporation," *MPW*, February 7, 1920.

25. Paul Bray, Jr., interview by the author, 1979.

26. *MPW*, June 21, 1919.

27. *MPW*, August 23, 1919; "Short Stuff," *Wid's Year Book*, 1919.

28. *MPW*, January 31, 1920. The film was included on the Goldwyn-Bray Pictograph, no. 7023.

29. "Goldwyn has controlling Interest in the Bray Pictures Corporation," *MPW*, February 7, 1920.

30. *Variety*, May 12, 1922; November 11, 1921; *MPW*, March 10, 1924.

31. Emerson, *The Twelve Principles of Efficiency*, pp. x–xi.

32. Copley, *Frederick W. Taylor, Father of Scientific Management*. I am especially indebted to Kakar's *Frederick Taylor* and Haber's *Efficiency and Uplift*.

33. Taylor, *The Principles of Scientific Management*, p. 7.

34. J. R. Bray, U.S. patent 1,107,193, August 11, 1914.

35. Earl Hurd, U.S. patent 1,143,542, June 15, 1915.

36. Taylor, *Shop Management*, p. 21.

37. Paul Bray, Jr., and Shamus Culhane, interviews by the author, 1979.

38. Lutz, *Animated Cartoons,* p. 66.

39. "The inkwell man," *New York Times,* February 22, 1920.

Chapter 6

1. Each of the two brothers, who later had a falling out, claimed to have invented the rotoscope process. According to Dobbs, Dave Fleischer's importance has been overemphasized. See "Betty Boop's Biographers," *Funnyworld,* no. 21 (fall 1979), pp. 44–48.

2. Max Fleischer, unpublished autobiographical press release, paraphrased in Cabarga, *The Fleischer Story,* p. 6; Dave Fleischer, "Where can I get a good corned beef sandwich?," unpublished interview by Joseph Adamson, UCLA-AFI Oral History, 1968, UCLA Theatre Arts Library, Los Angeles.

3. "Fleischer advances technical art," *Moving Picture World,* June 7, 1919.

4. "The inkwell man," *New York Times,* February 22, 1920.

5. *MPW,* July 24, 1920.

6. *MPW,* October 14, 1916.

7. *MPW,* October 21, 1916.

8. *MPW,* December 9, 1916.

9. *MPW,* August 23, 1919.

10. "The inkwell man," *New York Times,* February 22, 1920.

11. Some data presented in Cabarga's *Fleischer Story* filmography may now be corrected. *Perpetual Motion* is datable after August 1920, because of a wall calendar displaying that date in one of the scenes. It was still a Bray release. On December 17, 1921, a *Moving Picture World* ad gives Winkler's address for the series (room 606, 220 W. 42nd Street). This is two years earlier than Cabarga's dating. In November 1922, Winkler announced that a second series of 13 were available for state's-rights booking. *Flies* was released September 16, 1922, not January 20, 1923. In 1923, several films were being distributed by "Rodner," including *Modelling,* which is usually dated 1921. (These may have been rereleases.) Warners, strictly speaking, was not the primary dis-

tributor of "Out of the Inkwell," but only the owner of the New York and New Jersey territories, which had been purchased through Winkler.

12. *MPW*, March 29, 1924. (Cabarga's citation of the Circle Theater has not been substantiated.)

13. *MPW*, September 5, 1925. There is no record of the Phonofilm releases in the trade literature.

14. Joe Adamson, "Working for the Fleischers: An interview with Dick Huemer," *Funnyworld*, no. 16 (winter 1974–75), pp. 23–28.

15. *MPW*, March 27 and April 17, 1926.

16. *MPW*, April 15, 1916.

17. Interview with I. Klein, 1979. See also Klein, "The I. Klein story," *IATSE Official Bulletin* (autumn 1967); "A vision of Katzenjammers," *Funnyworld*, no. 14, 1972.

18. *MPW*, September 9, 1916.

19. Swanberg, *Citizen Hearst*, pp. 315, 485; *MPW*, February 17, 1917. The newsreel had been taken over by Pathé in January 1917.

20. Koenigsberg, *King News*, pp. 454 ff.

21. *MPW*, April 10, 1920. This information may not be trustworthy, owing to the inexplicable presence of the names of La Cava and Fleischer.

22. Bray Pictures Corporation minutes, June 18, 1920.

23. *Daily Variety*, May 3, 1978. InterComm Public Relations Associates, "Biography of Walter Lantz," April 26, 1976, courtesy UCLA Lantz archives.

24. *Variety*, May 27, 1921; Bray Studio documents.

25. *MPW*, January 6, 1923.

26. *MPW*, August 15, 1925.

27. Shamus Culhane, interview by the author, 1979.

28. I. Klein, "Cartooning down Broadway," *Film Comment* XI, no. 1 (January–February 1975), p. 62.

29. "How Pathé's 'Aesop's film fables' are made," *MPW*, June 6, 1925.

30. I am indebted to André Martin's monograph "Barré l'introuvable," published on the occasion of the 1976 International Animated Film Festival at Ottawa.

31. The New York Public Library holds pressbooks for *Cartoons in a Seminary, . . . in the Barbershop, . . . in the Country, . . . in the Hotel, . . . in the Kitchen, . . . in the Laundry, . . . in the Parlor, . . . on a Yacht,* and *Cartoons on Tour.*

32. Blackbeard, introduction to *A. Mutt;* Blackbeard, "Mutt and Jeff," in Horn, *World Encyclopedia of the Comics,* pp. 250–251, 508–509.

33. Joe Adamson, "From this you are making a living?: Joe Adamson talks With Richard Huemer," *AFI Report* V, no. 2 (summer 1974), pp. 10–17.

34. *MPW,* May 19, June 9, and July 7, 1917.

35. Fox News Service, "Mutt and Jeff visited at their studio," mimeographed news release, February 16, 1917, Museum of Modern Art collection.

36. I. Klein, interview by the author, 1979.

37. Adamson, "From this you are making a living?"

38. *Variety,* February 18, 1921.

39. Charley Bowers arranged for a new film series of "Camera Miracles" to be distributed by Joseph P. Kennedy's FBO in November 1926. Apparently these used prisms to produce humorous split screen effects and "puzzle the experts." In 1927, it was announced that Bowers, "the wizard of Long Island," was departing with his secret process for California, where he would make comedies—as an actor—for Educational. See Dick Huemer, "Huemeresque," *Funnyworld* 19 (fall 1978), pp. 35–36, and I. Klein, "Charles Bowers, pioneer animation producer," *Cartoonist Profiles,* nos. 25–27 (March, June, and September 1975), for anecdotes about the colorful Bowers.

40. Croy, *How Motion Pictures are Made;* McCrory, *How to Draw for the Movies;* Bert Green, "The making of animated cartoons," *Motion Picture Magazine* XVII, no. 4 (May 1919), pp. 51 ff.; Gregory, *A Condensed Course in Motion Picture Photography;* Lutz, *Animated Cartoons.*

41. Lutz, *Animated Cartoons,* p. 58.

42. Disney's biography has been detailed in Finch, *The Art of Walt Disney;* Schickel, *The Disney Version;* and Thomas, *Walt Disney.*

43. David R. Smith, "Ub Iwerks," *Funnyworld,* no. 14, 1972.

44. David R. Smith, "Up to date in Kansas City," *Funnyworld,* no. 19 (fall 1978), pp. 22–34.

45. *MPW,* March 10, 1924.

46. Freleng, interview by the author, 1979.

47. *MPW,* March 12, 1927.

48. *MPW,* April 28, 1928.

49. *MPW,* August 18, September 1, and November 17, 1928.

50. Walt Disney, letter to Roy Disney and Ub Iwerks, quoted in Thomas, *Walt Disney,* pp. 91–92 (no date cited).

51. *MPW,* November 17 and 24, 1928. *Oswald's Ragtime Band* was scheduled for release in November, but was held up until December 1928. In January 1929 Mintz announced that all Oswalds were being produced in two negatives—one sound, one silent. (*MPW,* January 12, 1929.)

52. *MPW,* June 21, 1919.

53. Disney's cartoon seems to be the first commercial exploitation of Cinephone. In December it was reported that *White Lilacs,* a Shubert play, was being recorded. (*MPW,* December 8, 1928.)

54. *MPW,* November 24, 1928. This article gives November 20 as the date of the first showing, Schickel cites November 19, and Finch and Thomas say November 18.

55. John McCrory, "The animated cartoon," *MPW,* March 26, 1927.

Chapter 7

1. Lo Duca, *Le Dessin animé,* p. 34.

2. *Ciné-Journal,* March 18, 1916.

3. *Le Film,* August 12, 1916.

4. *Ciné-Journal,* March 25, April 8, and June 17, 1916.

5. *Le Film,* June 10, September 2 and November 25, 1916; *Ciné-*

364 *Journal,* July 8, October 28, August 26, December 9, and December 30, 1916.

6. *Ciné-Journal,* April 19, 1919.

7. Booth also directed early experiments with synchronized sound recordings for the Kineplastikon Co. in 1913. He was most likely the director of the "Kineto War Maps" discussed in Low, *The History of the British Film,* vol. II, pp. 171–172. There is no filmography, but Booth's films are listed in Gifford, *The British Film Catalogue, 1895–1970.*

8. Clark, "Early Pioneers," p. 8.

9. An Anglo-Indian performer named Frank Leah was still releasing "straight" lightning-sketch films as late as 1914.

10. Harry Furniss, "Breaking into the film game," *The Kinetogram,* April 15, 1912, pp. 17–18; Low, *The History of the British Film,* vol. II, p. 169.

11. [British] National Film Archive *Catalogue,* vol. II, p. 45. See also Low, vol. II, p. 170.

12. Low, vol. II, p. 171; Clark, "Anson Dyer."

13. [British] National Film Archive *Catalogue,* vol. III, p. 103.

14. Denis Gifford, *The Enchanted Drawing;* Edera, *Evocation synoptique des origines et des pionniers du film d'animation en Europe, 1888–1928,* pp. 16–27; Clark, "Anson Dyer."

15. [British] National Film Archive *Catalogue,* vol. III, p. 103.

16. O'Galop's original drawing submitted to the Michelin brothers showed a rotund man lifting a glass and toasting "Nunc est bibendum!" ("Now is the time to drink!"). In the Paris-Amsterdam auto race the driver Théry was the first to nickname André Michelin "Bibendum," and the name thereafter became attached to O'Galop's tire man.

17. *Ciné-Journal,* June 14, 1913. See also *Film-Revue,* June 12, 1913. Lortac's authorship of the *Dumont Satire* is probable, but not verifiable. In a 1966 unpublished interview with André Martin, Lortac recalled selling some shorts to Eclair before the war, but the old animator's memory was far from reliable. I am grateful to Raymond Maillet for showing me the Martin interview.

18. *Ciné-Journal,* May 26, 1917. This film, previously undocu-

mented, was labeled "dessin animé de Robert Lortac," but no description was published.

19. Marcel Lapierre, *Les Cent Visages du cinéma*, p. 314.

20. Raymond Maillet, "Les Pionniers français de l'animation," *Ecran 73* 11 (1973), pp. 20–28.

21. Bruno Edera, "Histoire du cinéma suisse d'animation," *Travelling* (Lausanne) 51–52 (spring 1978), Freddy Buache, "Films independants et d'avant-garde," ibid. 55 (spring 1979).

22. London Film Society *Programme,* May 30, 1926.

23. Jean Mitry, *Histoire du cinéma,* vol. III, p. 241.

24. Bernhard Diebold, "Eine neue Kunst; Die Augenmusik des Films," *Frankfurter Zeitung,* April 2, 1921, quoted in O'Konor, *Viking Eggeling,* p. 249. There are synopses of five Ruttmann-Pinschewer films in Buache, "Films independants et d'avant-garde."

25. William Moritz, "The films of Oskar Fischinger," *Film Culture* nos. 58–60 (1974), pp. 37–188. See also John Canemaker, "Elfriede! On the road with Mrs. Oskar Fischinger," *Funnyworld* 18 (spring 1978).

26. Fischinger came to the United States to work for Paramount in 1936, but had many disappointments, including an ill-fated stint on *Fantasia.* He continued his independent projects and, as Moritz has shown, influenced the post–World War II American avant-garde film movement on the west coast.

27. Jay Leyda dates *Soviet Toys* 1923 in *Kino* (p. 274). Ivanov-Vano dates it 1924 in *Rysovannyi Film/Osobyi Vid Kinoiskussiva.* For a listing of known Soviet animated films see Edera, *Evocation synoptique des origines et des pionniers du film d'animation en Europe, 1888–1928,* pp. 24–28.

28. Dziga Vertov, "Nous," in *Articles, Journaux, Projets,* p. 19.

29. Vertov, "Ciné-Reclame," ibid, p. 39. Vertov noted that his scenario would be suitable for either animated drawings or puppets.

30. Maillet insists without quoting a source that Starevitch was born on August 6, 1882. ("Les Pionniers français de l'animation," p. 23); Starevitch told Charles Ford that he was born on August

6, 1890 (Ford, "Ladislas Starevitch," *Films in Review,* April 1958, p. 190).

31. Alexander Khanzhonkov, *The First Years of Russian Kinematography,* paraphrased in Leyda, *Kino,* pp. 66–67.

32. *Mest' kinematografičeskogo operatora,* first released here with the title *Revenge of the Kinematograph Cameraman.*

33. Leyda, *Kino,* p. 163. He also describes the filmmaking milieu in southern Russia. For a romanticized account, see the Soviet film *A Slave of Love* (Mikhalkov, 1978).

34. Turning the tables, *The Voice of the Nightingale* became one of the few European animated films to gain distribution in the United States (by Fox).

35. See William L. Pressly, Jr., "The praying mantis in surrealist art," *Art Bulletin* 55 (December 1973), pp. 600–615.

36. Reiniger, *Shadow Theatres and Shadow Films,* pp. 82–84; Deutsch, *Lotte Reiniger.*

37. "The films of Lotte Reiniger," *Film Culture,* no. 9 (1956); White, *Walking Shadows.*

38. For a synopsis see Jean Frick, in *Mon Ciné,* reprinted in *Travelling* (Lausanne) 55 (spring 1979), pp. 87–88.

39. Members of the London Film Society voted in 1926 for the two titles they would most like to see: *Potemkin* and *Prince Achmed.* Although *Prince Achmed* was well-known in Europe, its American release was delayed, apparently because the production company, Comenius-Film, sold exclusive rights to the University Film Foundation of Harvard, which did not actively promote it. Two benefit screenings were given in New York in 1931, about which Mordaunt Hall wrote "It may not be exactly new to perceive silhouette figures on the screen, but it is quite another matter as they are offered here." (*New York Times,* February 27, 1931.) The "official" American premiere did not take place until 1942 (*New York Post,* January 19, 1942).

40. The origins of the "Max und Moritz" films, one of which is available in the United States, are unknown.

41. Cohl-Rabier unpublished correspondence, Mme. André Courtet collection.

42. *Ciné-Journal,* September 20, April 12, and June 21, 1919. Perhaps this was a Paul Terry import.

43. *Ciné-Journal,* January 22, 1921. Maillet's "Les Pionniers français de l'animation" reproduces a *Gulliver* still on p. 23. It is unclear whether the film was ever released.

44. Torsten Jungstedt has brought the Swedish animated film to light in a short film and a remarkable book, *Kapten Grogg och hans Vänner.* I am grateful to Caroline Bruzelius for translating it for me, and to Jungstedt for his correspondence.

45. *Ciné-Journal, Le Film,* 1918-20.

46. [British] National Film Archive *Catalogue,* vol. III, p. 113; Gifford, *The Enchanted Drawing;* Edera, *Evocation synoptique . . . ;* Low and Manvell, *The History of the British Film,* vol. IV, p. 284.

47. Adrian Brunel, *Nice Work,* pp. 110–111.

48. [British] National Film Archive *Catalogue,* vol. III, p. 135.

49. Cohl, "Les Dessins animés et à trucs, causerie faite au Ciné-Club le 12 juin, 1920," *Le Journal du Ciné-Club,* n.d.; "Dessins animés," *Larousse Mensuel,* August 1925, pp. 861–864.

50. Anson Dyer, paraphrased in Low, vol. III, pp. 170–171.

51. Animators used a variety of materials, even including chewing gum, for joining the limbs of the figures. Not all European animators relied exclusively on cutouts. Fischinger notably used retracing, primitive rotoscoping, and a variety of other techniques at the Seel studio (Moritz, "The Films of Oskar Fischinger").

52. Einar Norelius, quoted in Jungstedt, *Kapten Grogg och hans Vänner* (English synopsis), p. 21.

53. Bert Green, "Dessins animés," *Ciné-Tribune,* June 24, 1919; reprinted in *Ciné Pour Tous,* May 8, 1920. Lutz's book did not appear in German (as *Der Gezeichnete Film*) until 1927.

54. Cohl, "Dessins animés," *Larousse Mensuel.*

Chapter 8

1. *Moving Picture World,* October 7, 1916.

2. Although now distributed as a Cohl film, Palmer's film was

368 incontrovertibly documented in *MPW*, January 6, 1917, where it was included in Gaumont's "See America First" newsreel number 68: "A comic cartoon entitled *Mr. Bonehead Gets Shipwrecked* finishes the reel."

3. *MPW*, January 6, 1917. Despite this apologia, the critics' reception was only lukewarm: ". . . the humorous stories are acted by the animated pen-and-ink characters . . . visualized in much the manner as are motion picture comedies with human characters. . . . The animation in these cartoons is fair, although a bit 'jumpy' at intervals. The drawing as a whole is acceptable." (*MPW*, October 28, 1916.)

4. *MPW*, April 25, 1925.

5. I am indebted to Don Shay's biography and detailed filmography "Willis O'Brien, Creator of the Impossible," *Focus on Film*, no. 16 (autumn 1973), pp. 18–48.

6. *MPW*, May 21, 1921.

7. New York *World*, February 9, 1925.

8. *Women's Wear Daily*, February 9, 1925.

9. "The Silent Drama," *Life* 85, 2209, March 5, 1925, p. 24.

10. *MPW*, March 7, 1925.

11. *MPW*, February 24, 1917.

12. Cook, *Trickfilm / Chicago '75*, pp. 30–31 (includes a tentative filmography). At least three additional "Motoys" are in the collection of the British National Film Archive.

13. *MPW*, December 11, 1915; J. R. Bray, "Bray-Gilbert silhouette pictures," *Motography*, January 22, 1916.

14. *Exhibitor's Trade Review*, May 21, 1921.

15. "Cartoons by Hy Mayer" (Imp, 1913), [British] National Film Archive *Catalogue*, p. 194.

16. *MPW*, March 11, 1916.

17. *MPW*, June 30, 1917.

18. *MPW*, May 6, 1916.

19. *MPW*, February 23, 1924. The film was directed by E. Mason Hopper.

20. Messmer and Huemer both recalled Carlson as an important influence.

21. Walt Disney, letter to Margaret Winkler, reproduced in David R. Smith, "Up to date in Kansas City," *Funnyworld* 19 (fall 1978), p. 33.

22. Schickel, *The Disney Version,* pp. 86–87. Disney was acutely aware of the lack of camera variation, and was reminded constantly of it by Charles Mintz. As a result, most later films do contain closeup inserts and the other elements of live-action cinema that Schickel found lacking. Dark backgrounds were sometimes used, as in the magnificent storm of *Alice Cans the Cannibals.*

23. Here as elsewhere in my classification arises the possibility of overlapping categories; for example, the Katzenjammer Kids films are Family as well as Boy films.

24. *MPW,* March 3, 1917.

25. Lahue, *World of Laughter,* p. 45. The possibility of a "Chicago school" of animation should be explored. Since the city was so important for both film and journalism, it comes as no surprise that cartoonists (for example, Wallace Carlson, Sydney Smith, and Charles Bowers) should have become interested in film. Rothacker's advertising agency produced early animated trailers there, and Howard Moss's Motoy Films was based in Chicago. As this book was going to press, George Hagenauer discovered a cache of original films and art work by cartoonist Harold Charles "Andy" Hettinger from 1915–16 that promises to add to our store of knowledge about Chicago animation.

26. *MPW,* June 19, 1920, January 15, 1921; Horn, *The World Encylopedia of the Comics,* pp. 160, 625–626.

27. *MPW,* October 7, 1916.

28. *MPW,* February 17, 1917.

29. Thomas, *Walt Disney,* p. 83. Remember that Universal's publicity department tended to credit all developments within the organization to the founder's genius.

30. Mike Barrier's interviews with former Disney workers have not substantiated the claim that pencil tests were used in 1927.

31. Bruce Conner exploited this erotic aspect of early Disney cartoons in his collage films, such as *Cosmic Ray.*

32. RKO, "Biographical Sketch of Walt Disney," n.d. (Museum of Modern Art collection).

33. *The Film Society Programme,* November 10, 1929.

Chapter 9

1. Much of the material in this chapter, including direct quotes unless noted otherwise, is from a series of interviews of Messmer by the author in the summer of 1979.

2. It was this "Teddy" series that cost Max Fleischer his first job at Pathé.

3. *Moving Picture World,* August 2, 1919.

4. *MPW,* March 20, 1920.

5. *MPW,* December 18, 1920.

6. *MPW,* March 4, April 1, and April 8, 1922.

7. *MPW,* July 29, 1922.

8. *MPW,* March 21, 1920.

9. *MPW,* October 6, 1923.

10. *MPW,* March 10, 1924. We do not know for certain that this caused the disagreement. It might also be related to Winkler's marriage to Mintz and his exertion of control over the business.

11. Interview with Al Eugster, 1979.

12. See Arnheim, *Visual Thinking,* pp. 194–200.

13. *MPW,* August 7, 1926.

14. Skelton, *Paul Hindemith,* pp. 91–92. The Hindemith specialist Luther Noss informs me that the composer was a Felix fanatic in the 1920s.

15. *Theatre Magazine,* January 1928, pp. 32 ff.

16. *Motion Picture News,* January 25 and March 8, 1930.

17. Klingender, *Animals in Art and Thought to the End of the Middle Ages.*

18. Gilbert Seldes, "The Krazy Kat that Walks by Himself," in *The Seven Lively Arts,* p. 217.

19. Kipling, "The Cat that Walked by Himself," p. 195.

20. *MPW,* April 7, 1923.

21. The film described could have been *Felix Braves the Briny* (1926).

22. Messmer's "Felix walk" has been filmed by John Canemaker and is one of the most memorable moments in Canemaker's *Otto Messmer and Felix the Cat.*

23. Seldes, "The Krazy Kat that Walks by Himself," p. 209.

Conclusion

1. Propp, *Morphology of the Folktale,* pp. 20–21.

2. Roy Willis, *Man and Beast,* p. 47.

3. Gus Bofa, "Du Dessin animé," *Les Cahiers du Mois* 16–17 (1925), p. 53.

4. Marcel Brion, "Félix le chat, ou la poésie créatrice," *Le Rouge et le Noir,* July 1928.

Afterword, Errata, and Update

When this book was published in 1982, I knew that, like all scholarship, it was work in progress. But I thought it was fairly thorough. Reading it again for this reprint edition gives me pause, because I now perceive the book as barely a beginning, an outline, or perhaps crib notes for a larger (still unwritten) history of pre-1929 animation.

This perception is due to the mind-boggling amount of information about animation that has enveloped us in the last decade. Through conference papers, scholarly debates, published books and articles, course curricula, and especially festivals and exhibits showcasing cartoons—many newly restored by archives—the world has learned on a massive scale about silent-cartoon production.

There are societies that specialize in the study of animation and publish newsletters, notably the Society for Animation Studies, 4729 Lankershim Boulevard, North Hollywood, California 91602–1864. In Europe there is CICA (Centre International du Cinéma d'Animation), B.P. 399, 74013 Annecy Cedex, France).

Maureen Furniss has founded and edits *Animation Journal* (AJ Press, 2011 Kingsboro Circle, Tustin, California 92680–6733). It publishes articles on historical, social, and theoretical issues, as well as research on production techniques and national origins.

The Whole Toon Catalogue (P.O. Box 369, Issaquah, Washington 98027) attempts to facilitate access to all kinds of animation materials, including books, video cassettes and discs, and memorabilia.

Many films mentioned in this book and more from the period are distributed in 16mm by Em Gee Film Library, 6924 Canby Avenue, Suite 103, Reseda, California 91335 (phone 818-881-8110). Another 16mm source, with a smaller selection, is Kit Parker Films, P.O. Box 16022, Monterey, California 93942–6022 (phone 800-538-5838).

The John Canemaker Animation Collection has been inaugurated at the Bobst Library of New York University and promises to become a major resource.

Many people have corresponded with me and offered their suggestions and corrections. In particular I'd like to thank Harvey Deneroff (some of whose corrections are mentioned below), David Henry, Peter Adamakos, Don Swift, Elias Savada, and H. D. Bailey, Jr.

There is not enough space in these few pages to accomplish a complete review of the subject, but I can offer the following comments and sources, some of which amplify and correct my arguments.

Introduction

The most ambitious general history to appear recently is Charles Solomon, *Enchanted Drawings: The History of Animation* (New York: Knopf, 1989). He devotes forty of his three hundred pages to pre-1929 animation, a much higher proportion than appears in earlier publications of this sort.

Yves Rifaux (directly) and David Robinson (indirectly) have challenged my exclusion of the animation made for "optical toys." In *A propos de l'invention du cinéma d'animation* (Annecy: JICA Diffusion, 1990) Rifaux claims that "as soon as they were born, cartoons were the art of childhood." He illustrates his catalogue with dozens of 35mm strips of animated images (nonphotographically produced) and magic-lantern apparatuses.

Picking up on this theme, David Robinson's exhibition catalogue "Masterpieces of Animation 1833–1908," *Griffithiana* 14, no. 43, December 1991, proposes "that the art of animation has its own history, independent of that of the cinematograph proper." He has an essay on Plateau, Stampfer, Cruikshank, et al. Robinson also illustrates some 35mm film loops which were printed with lithographic images. Both Rifaux and Robinson are correct in calling these artifacts animation. The quibble is where to draw the line defining the "animated film." Rather than argue about technical versus social definitions of cinema—an essentialist debate to begin with—I will just point out the most important fact deriving from these discoveries: the filmstrips demonstrate how obvious and widespread was the knowledge of techniques for synthesizing movement frame by frame. They are specimens of "toy cinema" that show that, by the turn of the century, there was really nothing "mysterious" about how animation worked.

Before Mickey

For more on Reynaud, see Glenn Myrent, "Emile Reynaud, First Motion Picture Cartoonist," *Film History* 3, no. 3, 1989, 191–202.

Chapter 1

The question of who made the first commercial projected animation film still has not been satisfactorily answered. My current opinion is that the search for a "missing link" implies a misleadingly linear concept of historical development which is definitely not demonstrated in other areas of technological change. Certainly an area still needing further research is the work of Arthur Melbourne-Cooper, whose filmography is uncertain. Barry Salt, in "Vitagraph Films—A Touch of Class" (in *Vitagraph Co. of America: Il cinema prima di Hollywood,* edited by Paolo Cherchi Usai [Pordenone, Italy: Edizioni Studio Tesi, 1987], 171–202), wrote, "All European efforts in true animation of both kinds [drawings and objects], such as those by Segundo de Chomón and Arthur Melbourne-Cooper, were inspired by the films mentioned [by Blackton and Porter], and done subsequently to seeing them" (author's original manuscript). This may be true, but the evidence continues to mount that animation was "in the air," was an international phenomenon; and we may still discover some surprises.

For a study of Babin's articles, see Roland Cosandey, "Cinéma 1908, films à trucs et Film d'Art: Une campagne de *l'Illustration,*" *Cinémathèque,* no. 3, Spring-Summer 1993, 58–73.

Our knowledge of Chomón has been expanded by Juan-Gabriel Tharrats in *Los 500 Films de Segundo de Chomón* (Zaragoza, Spain: Universidad de Zaragoza, 1988). Tharrats corrects some information, adds some new facts, and refines his filmography in *Inolvidable Chomón* (Murcia, Spain: Filmoteca Regional de Murcia, 1990). He includes some frames from *Une Excursion incoherente,* which appears to be a 1909 Pathé film using animated silhouettes.

Chomón's film *Le Théâtre du Petit Bob* has caused considerable confusion since, as Carlo Montanaro pointed out ("The Strange Case of *Le Théâtre du Petit Bob,*" *Griffithiana,* no. 32–33, September 1988, 278–80), there are two quite different versions in circulation, one probably from 1906 and one from 1909.

Chapter 2

The second volume of David Kunzle's *History of the Comic Strip* (*The Nineteenth Century*) was published by the University of California Press in 1990.

Animated Painting (cited as Anonymous) was directed by Edwin S. Porter.

Chapter 3

Please refer to my *Emile Cohl, Caricature, and Film* (Princeton: Princeton University Press, 1990) for a monograph on the animator. Also see a dossier by Roland Cosandey and Carlo Montanaro, *Catalogo ragionato dell'opera conservata di Emile Cohl* (Pordenone: Le Giornate de Cinema Muto, 1990). This carefully researched work addresses some unanswered questions about Cohl and corrects some errors in my filmography.

A second American Eclair film, *He Poses for His Portrait,* has been discovered.

Chapter 4

Winsor McCay: His Life and Art (New York: Abbeville Press, 1987), by John Canemaker, not only documents McCay's animated and other art with consummate detail, it is also the most beautiful book on an animator ever published. Canemaker's research reveals astonishing facts about McCay's private life, his career as a Hearst artist, and his film productions. He shows that Bray sued McCay for patent infringement, but that McCay not only defended himself, *he* subsequently collected royalties, albeit small ones, from the Bray-Hurd Process Company.

Chapter 5

The texts of six patents (including illustrations) by Bray and Hurd, 1914–27, are reproduced in Richard Koszarski (ed.), "Bray-Hurd: The Key Animation Patents," *Film History* 2, no. 3, September-October 1988, 229–66.

Harvey Deneroff contributes these tidbits: Paul Terry had his own animation patent and was put into the Bray-Hurd company in exchange for a license. Bray Studio records indicate that they had an option on Wells's *The Outline of History,* not the rights per se. D. W. Griffith visited Bray after his visit with Wells and they

agreed that Griffith would do the live-action and Bray the ani- **377**
mated parts. The option was never exercised. The Brayco was a
filmstrip projector which Bray eventually sold to the Encyclopae-
dia Britannica.

Chapter 6

On Koko's early anonymity: *Moving Picture World,* March 19,
1921, opined that "if this little performer is to be in many more
such entertainments, he should be given a name."

Deneroff notes that early Bray catalogues listed the first Koko
films as *Experiment #1* and *Experiment #2*.

For a specialized study of the Fleischer studio, see Harvey R.
Deneroff, *Popeye the Union Man: A Historical Study of the
Fleischer Strike,* Ph.D. dissertation, UCLA, 1985. Though this fo-
cuses on the sound period, it is full of useful information, for ex-
ample stressing the nepotism of the Fleischer "family" studio and
the roots of labor unrest at Fleischer and Van Beuren in the 1930s.
Many sources are interviews with studio veterans.

The definitive study of Alice, Oswald, and the silent Mickeys is
by Russell Merritt and J. B Kaufman, *Walt in Wonderland: The
Silent Films of Walt Disney* (Pordenone: Edizioni Biblioteca
dell'Immagine, 1992; Berkeley: University of California Press,
1993). Among its many features are a close study of films and
documents and a detailed filmography. The authors discovered
that there were four actresses who portrayed Alice, and offer the
intriguing theory that it was Margaret Winkler who insisted on
the addition of the Felix-like cat protagonist. See also Kathy Mer-
lock Jackson, *Walt Disney: A Bio-Bibliography* (Westport, Conn.:
Greenwood Press, 1993).

Chapter 7

Considerable information has been published regarding Stare-
vitch (whose name is properly spelled three different ways, de-
pending on the writer's language), promoted by his granddaugh-
ter, Béatrice Martin. Many of his films have been newly restored
by French and Russian archives. See Jayne Pilling (ed.), *Stare-
wicz 1882–1965* (Edinburgh: 37th Edinburgh International Film
Festival, 1983); and Jean-Pierre Pagliano, "Starewitch au Pays des
Merveilles," *Positif,* no. 352, June 1990. The most encompassing
exhibition has been Annecy 1991, in which films, puppets, and

other artifacts were displayed. The correct details of the birth and childhood of Ladislaw Starewicz are that he was born August 8, 1882, in Moscow, into a family of Polish expatriates who had left their home in Lithuania. The boy was raised by his grandmother in Kovno, Lithuania, and attended secondary school in Dorpat, Estonia.

The important Argentine filmmaker Quirino Cristiani should have been mentioned. Facts about this neglected pioneer were brought to light by Giannalberto Bendazzi in *Due volte l'Oceano: Vita di Quirino Cristiani, pioniere del cinema d'animazione* (Pavia, Italy: La Casa Usher, 1983). Cristiani was born in Santa Giuletta, Italy, in 1896 and died in 1984. Immigrating with his family to Buenos Aires in 1900, as a teenager he published political caricatures. Beginning in 1916, with Federico Valle he coproduced a newsreel that included his drawings. Cristiani taught himself the cutout method of animation by studying a print of an Emile Cohl film. With the backing of a movie theater owner, Cristiani embarked on a political satire, *El Apóstol* (The Apostle), which ran one hour and ten minutes. It was first screened November 9, 1917, and is said to have been made solely with animated cutouts. A second feature, *Sin dejar rastros* (1918), was confiscated by the government and never shown. He continued to make cartoons, but on a modest scale—commercials and educational shorts. In 1927 Cristiani worked in the Buenos Aires publicity office of M-G-M and embarked on a third feature, *Peludópolis,* another political satire. Unfortunately for the satirist, the subject, Yrigoyen, was toppled by a coup, then died and became a hero by the time the film was completed in 1931. It was screened once and withdrawn. Nevertheless, it appears to have been the first animated feature released with a synchronized music soundtrack. He made three shorts in 1938, 1941, and 1943 before retiring. None of his films is known to exist.

For an in-depth look at the production of *Monsieur Vieux bois,* Lortac and Cavé's adaptation of Töpffer's picture story, see "Histoire de Monsieur Vieux-Bois (1921)," by Roland Cosandey, in *Langages et imaginaire dans le cinéma suisse d'animation* (Etagnières, Switzerland: Groupement suisse du film d'animation, 1988), 64–76.

For Pinschewer, whose work ranged from 1911 through the 1950s, see Roland Cosandey, *Julius Pinschewer: Cinquante ans*

de cinéma d'animation (Annecy: JICA Diffusion, 1989). It includes a thoroughly annotated filmography, a bibliography, and many illustrations.

For a more detailed survey of world animation, see Giannalberto Bendazzi, *Le Film d'animation, du dessin animé à l'image de synthèse*, vol. 1, translated from the 1978 Italian edition by Geneviève Vidal (Grenoble: La Pensée Sauvage/JICA, 1985).

Lotte Reiniger died in Germany in 1981. See Alfio Bastiancich, *Lotte Reiniger* (Turin: Assemblea Teatro/Compagnia del Bagatto, 1982). Deneroff points out that *Prince Achmed* was already in production at the time of *Thief of Baghdad*'s release. A more likely source was Fritz Lang's *Der müde Tod* (*Destiny*), 1921.

For a meticulously detailed study of the United States' domination of international distribution during the period, refer to Kristin Thompson, *Exporting Entertainment: America in the World Film Market 1907–1934* (London: British Film Institute, 1985).

Chapter 8

For more on the history of lecturers and topical monologuists, see Charles Musser and Carol Nelson, *High-Class Moving Pictures: Lyman H. Howe and the Forgotten Era of Traveling Exhibition, 1880–1920* (Princeton: Princeton University Press, 1991). In particular, see the information on animators Paul Felton and Archie Griffith, who produced films for Howe's programs beginning in 1912. Also see X. Theodore Barber, "The Roots of Travel Cinema: John L. Stoddard, E. Burton Holmes and the Nineteenth-Century Illustrated Travel Lecture," *Film History* 5, no. 1, 1993, 68–84.

Deneroff reminds us of some other human protagonist series: Tom and Jerry, Toonerville Trolley, Farmer Al Falfa, Oil Can Harry, Egghead, The Little King, etc.

For more on Gruelle, see Patricia Hall, *Johnny Gruelle, Creator of Raggedy Ann and Andy* (Gretna, Louisiana: Pelican Publishing, 1993).

Charles R. Bowers was rather unfairly dismissed; besides his producing career for Barré and Fisher, his own post-1924 films, which combined animated puppets and live action (using the "Bowers Process"), are brilliantly funny and deserve more attention. Retrospectives were curated in Montreal and New York by Louise Beaudet in 1983.

For an interesting essay on the relation of "comic narrative" and

live-action cinema, see Brian Henderson, "Cartoon and Narrative in the Films of Frank Tashlin and Preston Sturges," in Andrew S. Horton (ed.), *Comedy/Cinema/Theory* (Berkeley: University of California Press, 1991), 153–73. Henderson states, "The subject is, to be sure, a difficult one, requiring as it does a prior theoretical analysis of cartoons and, indeed, of live-action cinema itself. Such a satisfactory analysis of cartoons does not exist; whether one of live-action cinema does is a matter of current debate" (154).

Chapter 9

Otto Messmer died in 1983 at the age of 91. John Canemaker's carefully researched and lavishly illustrated *Felix: The Twisted Tale of the World's Most Famous Cat* (New York: Pantheon, 1991) is the standard reference on Sullivan, Messmer, and the felicitous feline. His photographic portrait of the aged Margaret Winkler Mintz is a touching surprise.

Margaret Winkler's scrapbooks have been deposited by her relatives at the Museum of Modern Art Film Study Center.

For a more systematic application of Propp's motif and function analysis (though not to silent animation), see Richard J. Leskosky, "The Reforming Fantasy: Recurrent Theme and Structure in American Studio Cartoons," *The Velvet Light Trap*, no. 24, Fall 1989, 53–66.

Selected Bibliography

Adamson, Joe, "From this you are making a living?: Joe Adamson talks with Richard Huemer." *American Film Institute Report* V, no. 2 (summer 1974), pp. 10–17.

———. "Of mice and cats." *Take One,* November 1975.

———. "Suspended animation," in G. Mast and M. Cohen, *Film Theory and Criticism* (New York: Oxford University Press, 1974), pp. 391–400.

———"Working for the Fleischers: An interview with Dick Huemer." *Funnyworld,* no. 16 (winter 1974–75), pp. 23–28.

Alberti, Walter, *Il Cinema di animazione, 1832–1956.* Turin: Edizione Radio Italiana, 1957.

Allen, Robert C. "Vaudeville and film 1895–1915: A study in media interaction." Ph.D. dissertation, University of Iowa, 1977.

Amengual, B. "Le Cinéma d'animation, expression privilégiée du surréalisme à l'écran." *Etudes Cinématographiques* 40–42, 1965.

American Film Institute. *Factfile: Animation.* Washington, D.C.: AFI, 1977– (updated periodically).

Anonymous. "Fleischer advances technical art." *Moving Picture World,* June 7, 1919.

———. "Gaumont Kartoons [by H. S. Palmer] are popular." *Moving Picture World,* July 15, 1916.

———. "Goldwyn has controlling interest in the Bray Pictures Corporation." *Moving Picture World,* February 7, 1920.

———. "How Pathé's 'Aesop's Film Fables' are made." *Moving Picture World,* June 6, 1925.

———. "The films of Lotte Reiniger." *Film Culture,* no. 9 (1956).

———. "The inkwell man." *New York Times,* February 22, 1920.

———. "La Technique du dessin animé trent ans après son invention." *La Nature,* October 1, 1938, pp. 201–210.

———. "Les Trucs du cinématographe." *Lectures Pour Tous,* June 1908.

———. "Stop camera tricks." *Kinematograph and Lantern Weekly,* April 30, 1908.

Arnaud, Etienne, and Boisyvon. *Le Cinéma pour tous.* Paris: Garnier, 1922.

Arnheim, Rudolph. *Visual Thinking.* Berkeley: University of California Press, 1969.

Auriol, Jean-Georges. "Les Dessins animés avant le cinéma: Emile Reynaud." *La Revue du Cinéma,* December 1929.

———. "Les Premiers Dessins animés cinématographiques: Emile Cohl." *La Revue du Cinéma,* January 1930, pp. 12–19.

Babin, Gustave. "Les Coulisses du cinématographe." *L'Illustration,* March 28 and April 4, 1908.

Bain, David, and Bruce Harris. *Mickey Mouse: Fifty Happy Years.* New York: Crown, 1977.

Barrier, Mike. "Of mice, wabbits, ducks and men: The Hollywood Cartoon." *American Film Institute Report,* summer 1974, pp. 18–26.

Barry, Iris. "The cinema: Lesser glories." *The Spectator,* March 6, 1926, p. 415. Reprinted in Pratt, *Spellbound in Darkness* (Greenwich: New York Graphic Society, 1973), pp. 414–415.

Beaudet, Louise (ed.). *Ottawa 78.* Program notes, Ottawa International Animated Film Festival, 1978.

Bennett, Colin. "Animated cartoons." *The New Photographer,* February 14, 1927.

Bessy, Maurice. "Dessins animés: Koko, Mickey, Félix and Co." *CinéMagazine,* February 1930, pp. 28–30.

Blackbeard, Bill. "Introduction," in Harry C. Fisher, *A. Mutt. an Original Compilation: First Collection of the Complete First Years*

of the Daily Strip, 1907–1908 (Westport, Conn.: Hyperion, 1977), pp. v–xiv.

———. "Mutt and Jeff," in Horn, *World Encyclopedia of the Comics*, pp. 250–251, 508–509.

Blackton, James Stuart. "A Glimpse into the Past." *Moving Picture World*, March 10, 1917.

———. "Introduction," in Henry A. Phillips, *The Photodrama* (New York: Stanhope-Dodge, 1914).

———. "Hollywood with its Hair Down." Unpublished manuscript, Academy of Motion Picture Arts and Sciences.

———. Lecture given at University of Southern California, February 29, 1929, published in *Introduction to the Photoplay*, reprinted in R. Koszarski (ed.), *Hollywood Directors: 1914–1940* (New York: Oxford University Press, 1976), pp. 16 ff.

Blanchard, Gerard. *La Bande dessinée; histoire des histoires en images.* Verviers: Marabout University, 1969.

Blesh, Rudi. *Buster Keaton.* New York: Macmillan, 1966.

Bofa, Gus. "Du Dessin animé." *Les Cahiers du Mois* 16–17 (1925), pp. 50–56.

Borde, Raymond. "Notes sur l'histoire du dessin animé." *Positif,* July–August 1963, pp. 15–23.

Bowser, Eileen. "The Brighton project." *Quarterly Review of Film Studies* IV, no. 4 (fall 1979).

Bragdon, Claude. "Mickey Mouse and what he means." *Scribner's,* July 1934, pp. 40–43.

Bray, John Randolph. "Bray-Gilbert silhouette pictures." *Motography,* January 22, 1916.

———. "Development of the animated cartoon." *Moving Picture World,* July 21, 1917.

Brion, Marcel. "Félix le chat ou la poésie créatrice." *Le Rouge et le Noir,* July 1928.

Brunel, Adrian. *Nice Work: The Story of Thirty Years in British Film Production.* London: Forbes Robertson, 1949.

Buache, Freddy. "Films independants et d'avant-garde." *Travelling* (Lausanne) 55, spring 1979.

Cabarga, Leslie. *The Fleischer Story.* New York: Crown, 1976.

————. "Out of the inkwell." *Rolling Stone,* January 18, 1973.

Canemaker, John. Drawings for Animated Films. Exhibit catalog, Drawing Center, New York, 1976.

————. "Elfriede! On the road with Mrs. Oskar Fischinger." *Funnyworld* 18, spring 1978.

————. "Otto Messmer and Felix the Cat." *Millimeter,* September 1976, pp. 32 ff.

————. *Otto Messmer and Felix the Cat* (Film). 1976. Distributed by Phoenix Films, Images Film Archive.

————. "Pioneers of American animation: J. Stuart Blackton, Winsor McCay, J. R. Bray, Otto Messmer, Disney." *Variety,* January 7, 1976.

————. "Profile of a Living Animation Legend: John Randolph Bray." *Filmmakers Newsletter* VIII, no. 3 (January 1975), pp. 28–31.

————. *Remembering Winsor McCay* (film). 1976. Distributed by Phoenix Films, Images Film Archive.

————. "Reminiscing with John A. Fitzsimmons, Assistant to Winsor McCay." *Millimeter,* April 1975, pp. 14–16.

————. "Winsor McCay." *Film Comment,* January–February 1975, pp. 44–47.

Carlson, Wallace A. "The Animated Cartoon." *Movie Pictorial,* December 1915, pp. 5–7.

Centre Nationale de la Cinématographie/Le Conservatoire National des Arts et Métiers. Images et Magie du Cinéma Français. Exhibit Catalog, Paris, 1980.

Ceram, C. W. (pseud. Kurt Marek). *The Archaeology of the Cinema.* Trans. R. Winston. New York: Harcourt, Brace and World, 1965.

Charles Urban Trading Company. *Catalogue.* London: 1908, 1909.

Clark, Ken. "Anson Dyer." Program notes, Cambridge (England) Animation Festival, 1979.

———. "Early Pioneers." Program notes, Cambridge Animation Festival, 1979.

Cocteau, Jean. *Professional Secrets.* New York: Farrar, Straus and Giroux, 1970.

Cohl, Emile. "Dessins animés." *Larousse Mensuel,* August 1925, pp. 861–864.

———. "Les Dessins animés et à trucs, causerie faite au Ciné-Club le 12 juin, 1920." *Le Journal du Ciné-Club,* n.d.

———. "Sur les Dessins animés." *Ciné-Tribune,* July 15, 1920.

Collin, P. L'Evolution dramatique du dessin animé. Unpublished manuscript, IDHEC, Paris, 1952.

Cook, Camille (ed.). Trickfilm/Chicago '75. Exhibit catalog, Film Center of the Art Institute of Chicago, 1975.

Copley, Frank B. *Frederick W. Taylor, Father of Scientific Management.* New York: Harper and Brothers, 1923.

Couperie, Pierre. Bande dessiné et figuration narrative. Exhibit catalog, Musé des Arts Décoratifs, Paris, 1967.

Crafton, Donald. "Animation Iconography: The 'Hand of the Artist.'" *Quarterly Review of Film Studies* IV, no. 4 (fall 1979), pp. 409–428.

Croy, Homer. *How Motion Pictures are Made.* New York: Harper and Brothers, 1918.

Cuenca, Fernandéz-Carlos. *El Mundo del dibujo animado.* San Sebastian: 1962.

———. *Segundo de Chomón, Maestro de la fantasia y de la tecnica (1871–1929).* Madrid: Editora Nacional, 1972.

Dauven, L. R. "En Visite chez M. Emile Cohl qui inventa les dessins animés." *Pour Vous,* August 1933.

Denig, Lyle. "Cartoonist Bray with Paramount." *Moving Picture World,* December 11, 1915.

Derleth, August. *Buster Brown, Early Strips in Full Color.* New York: Dover, 1974.

Deslandes, Jacques. *Histoire comparée du cinéma,* vol. I. Paris/Tournai: Casterman, 1966.

Deslandes, Jacques, and Jacques Richard. *Histoire comparée du cinéma,* vol. II. Paris/Tournai: Casterman, 1968.

Deutelbaum, Marshall. "Structural patterning in the Lumière films." *Wide Angle* III, no. 1 (1979), pp. 28–37.

Deutsch, Werner. *Lotte Reiniger.* Berlin: Deutsche Kinemathek/Rainer Verlag, 1969.

Dorfman, Ariel, and Armand Mattelart. *How to Read Donald Duck: Imperialist Ideology in the Disney Comic,* trans. David Kunzle. New York: International General, 1975.

Edera, Bruno. *Evocation synoptique des origines et des pionniers du film d'animation en Europe, 1888–1928.* Mimeograph, Tournée Internationale d'animation, Annecy, 1971.

———. "Histoire du cinéma suisse d'animation." *Travelling* (Lausanne) 51–52, spring 1978.

———. "Les Pionniers européens de l'animation," *Ecran 73* 11 (1973), pp. 12–19.

Emerson, Harrington. *The Twelve Principles of Efficiency.* New York: The Engineering Magazine, 1912.

Fell, John L. *Film and the Narrative Tradition.* Norman: University of Oklahoma Press, 1974.

———. "Motive, mischief and melodrama: The state of film narrative in 1907." *Film Quarterly* XXXIII, no. 3 (spring 1980), pp. 30–37.

Field, R. D. *The Art of Walt Disney.* London: Macmillan, 1944.

Finch, Christopher. *The Art of Walt Disney.* New York: Harry N. Abrams, 1973.

Fisher, Bud. "Here's How!" *Photoplay,* July 1920.

Fleischer, Dave. "Where can I get a good corned beef sandwich?" Interview by Joseph Adamson. UCLA-AFI Oral History, 1968. UCLA Theatre Arts Library, Los Angeles.

Ford, Charles. "Ladislas Starevitch." *Films in Review,* April 1958, pp. 190 ff.

Fox. J. "Felix remembered." *Films and Filming,* November 1974, pp. 44–51.

Frazer, John. *Artificially Arranged Scenes: The Films of Georges*
Méliès. Boston: G. K. Hall, 1979.

Furniss, Harry. *Our Lady Cinema; How and Why I Went into the Photoplay and What I Found There.* Briston: Arrowsmith, 1914.

Gardette, L. "Teaching history by motography." *The Nickelodeon* [*Motography*], October 4, 1909, pp. 119–120.

Gartenberg, Jon. "Camera movement in Edison and Biograph films, 1900–1906." *Cinema Journal* XIX, no. 2 (spring 1980), pp. 1–16.

Gaumont, Léon. "Système de production de bandes cinématographiques reproduisant des événements, actualités ou autres, par la représentation de déplacements simulés d'objets, corps, masses quelconques, troupees [*sic*] en actions, navires, etc.," French patent no. 296.016, 1900.

Gianeri, Enrico. *Storia del cartone animato.* Milan: Omnia, 1960.

Giedion, Siegfried. *Mechanization Takes Command.* New York: Oxford University Press, 1948.

Gifford, Denis. *The British Film Catalogue, 1895–1970.* London: Newton Abbot, David and Charles, 1973.

————. *The Enchanted Drawing.* London: British Cartoonist Association and National Film Archive, n.d.

Gomery, Douglas. "The coming of sound to the American cinema: The transformation of an industry." Ph.D. dissertation, University of Wisconsin, Madison, 1975.

Gomez-Mesa, L. *Los Films de dibujos animados.* Madrid: 1929.

Green, Bert. "The making of animated cartoons." *Motion Picture Magazine* XVII, no. 4 (May 1919), pp. 51 ff.

Gregory, Carl. *A Condensed Course in Motion Picture Photography.* New York: Institute of Photography, 1920.

Guy, Alice. *Autobiographie d'une pionnière du cinéma.* Paris: Denoël, 1975.

Haber, Samuel. *Efficiency and Uplift: Scientific Management in the Progressive Era.* University of Chicago Press, 1964.

Hammond, Paul. *Marvellous Méliès.* New York: St. Martin's, 1975.

388 Hanson, Anne C. *Manet and the Modern Tradition*. New Haven, Conn.: Yale University Press, 1979.

Hawthorne, J. "Walt Disney, inventeur de Mickey Mouse." *Revue du Cinéma* 25 (1931).

Hearn, Michael Patrick. "The animated art of Winsor McCay." *American Artist* 39, no. 394 (May 1975), p. 27.

Hendricks, Gordon. "A new look at an 'old sneeze,'" *Film Culture* 22–23 (summer 1961), pp. 90–95.

————. *The Kinetoscope, America's First Successful Motion Picture Exhibitor*. New York: Beginnings of the American Film, 1966.

Heraldson, Donald. *Creators of Life: A History of Animation*. New York: Drake, 1975.

Hobbs, Michael. "Betty Boop's biographers. *Funnyworld* 21 (fall 1979), pp. 44–48.

Hoffer, Tom W. "From comic strips to animation: Some perspective on Winsor McCay." *Journal of the University Film Association,* spring 1976, pp. 23–32.

Horn, Maurice. Seventy-Five Years of the Comics. Exhibit catalog, New York Cultural Center, 1971.

————. *World Encyclopedia of Cartoons*. Detroit: Gale Research Co., 1980.

————. *World Encyclopedia of the Comics*. New York: Avon, 1977.

Huemer, Richard. "Huemeresque." Continuing column, *Funnyworld,* 1976–80.

Huxley, Aldous. "Where are the movies moving?" *The Film Yearbook,* New York: Film Daily, 1926.

Ivanov-Vano, I. P. *Rysovannyi Film/Osobyi Vid Kinoiskussiva*. Moscow: Gosfilmfond, 1956.

Jasset, Victorin. "Etude sur la mise en scène." *Ciné-Journal,* October 8, 1911.

Jungstedt, Torsten. *Kapten Grogg och hans Vänner*. Stockholm: Sveriges Radios Forlag/Svenska Filminstitutet, 1973.

Kakar, Sudhir. *Frederick Taylor*. Cambridge, Mass.: MIT Press, 1970.

Before Mickey

Karr, Kathleen. "Early animation: The movement begins," in American Film Institute (ed.), *American Film Heritage* (Washington, D.C.: Acropolis, 1972), pp. 56–60.

Kipling, Rudyard. "The Cat that Walked by Himself," in *Just So Stories for Little Children* (London: Macmillan, 1902).

Kish, Frances. "Watch 'em move [Krazy Kat]." *Photoplay,* September 1920.

Kitson, Clare (ed.). Fifty years of American animation. Program notes, American Film Institute, Washington, D.C. 1972.

Klein, Isadore. "A vision of Katzenjammers." *Funnyworld,* no. 14, 1972.

————. "Cartooning down Broadway." *Film Comment* XI, no. 1 (January–February 1975), pp. 62–63.

————. "Charles Bowers, pioneer animation producer." *Cartoonist Profiles,* nos. 25–27, March, June, and September, 1975.

————. "The I. Klein story." *IATSE Official Bulletin,* autumn 1967.

Klingender, Francis. *Animals in Art and Thought to the End of the Middle Ages.* Cambridge, Mass.: MIT Press, 1971.

Kneitel, R. F. "Out of the inkwell." *World of Comic Art* 2 (1967).

Koenigsberg, Moses. *King News.* Philadelphia: F. A. Stokes, 1941.

Kunzle, David. *History of the Comic Strip.* Volume I: *The Early Comic Strip, 1450–1825.* Berkeley: University of California Press, 1973.

————. Supplementary note to Francis Lacassin, "Comic strip and film language," *Film Quarterly,* fall 1972, pp. 19–23.

Lacassin, Francis. "Bande dessinée et langage cinématographique." *Cinéma 71,* September 1971, reprinted in *Pour un neuvième art: La Bande dessinée,* translated by David Kunzle in "The comic strip and film language," *Film Quarterly,* fall 1972, pp. 19–23.

————. "Notes sur les apparitions de Félix le chat dans les bandes dessinées." *Giff-Wiff,* September 1965.

Lahue, Kalton C. *World of Laughter; The Motion Picture Comedy Short 1910–1930.* Norman: University of Oklahoma Press, 1966.

Langlois, Henri. "Notes sur l'histoire du cinéma." *Revue du Cinéma,* July 1948, pp. 2–15.

Lapierre, Marcel (ed.). *Anthologie du cinéma.* Paris: La Nouvelle Edition, 1946.

———. *Les Cents Visages du cinéma.* Paris: Grasset, 1948.

Lawder, Standish. *The Cubist Cinema.* New York University Press, 1975.

Le Maire, Eugène. "L'Industrie du dessin animé." *Bulletin de la Société pour l'encouragement pour l'Industrie Nationale,* March–April 1937, pp. 151–175.

Lescaboura, Austin C. *Behind the Motion Picture Screen.* New York: Scientific American Publishing Co., 1919.

Lescaboura, Santos-Angel. *Cine y dibujos animados.* Caracas: Editorial universitaria, 1949.

Lévy, Jules. "L'Incohérence, son origine, son histoire, son avenir." *Le Courrier Français,* March 12, 1885.

Leyda, Jay. *Kino.* New York: Collier, 1960.

Lo Duca, Giuseppe. "Du Dessin animé à la plastique animée." *La Nature,* May 1939, pp. 314–319.

———. *Le Dessin animé; histoire, esthétique, technique.* Paris: Prisma, 1948.

———. "L'Industrie du dessin animé." *Génie Civil,* October 31, 1936.

Lo Duca, Giuesppe, and Maurice Bessy. *Méliès mage.* Paris: Prisma, 1948.

Low, Rachel. *The History of the British Film, 1914–1918.* London: Allen and Unwin, 1971.

———. *The History of the British Film, 1918–1929.* London: Allen and Unwin, 1971.

Low, Rachel, and Roger Manvell. *The History of the British Film, 1896–1906.* London: Unwin, 1948.

Lutz, Edwin G. *Animated Cartoons: How they are Made, their origin and Development.* New York: Scribner, 1920.

(T.H.) McAllister Co. *Catalogue.* New York: 1892, 1896.

McCay, Winsor. "Movie cartoons." *Cartoons and Movie Magazine,* April 1927, pp. 11–14.

McCrory, John. "The animated cartoon." *Moving Picture World,* March 26, 1927.

──────. *How to Draw for the Movies; or, the Process of Cartoon Animation.* Kansas City: Features Publishing, 1918.

Maillet, Raymond. "Emile Cohl." *L'Anthologie du Cinéma* X, no. 98 (1978), pp. 221–244.

──────. "Les Pionniers Français de l'animation." *Ecran 73* 11 (1973), pp. 20–28.

Maltin, Leonard. *Of Mice and Magic; A History of American Animated Cartoons.* New York: McGraw-Hill, 1980.

Manvell, Roger. *The Animated Film.* London: Sylvan, 1954.

Margadonne, E. M. "Felix, Mickey, Oswald and Co." *Il Convegno* 3–4, 1930.

Martin, André. "Arbre généologique de l'origine et l'âge d'or du dessin animé américain de 1906 à 1941" (wall chart). Montréal: Cinémathèque Canadienne, 1967.

──────. Barré l'introuvable. Pamphlet, Festival International du cinéma d'animation, Ottawa, 1976.

──────. "De Michel Ange à Walt Disney, coup d'oeil aux origines." *Cinéma chez soi* 25–26, 1959.

──────. Exposition mondiale du cinéma d'animation. Exhibit catalog, Cinémathèque Canadienne, Montréal, 1967.

──────. The origins of the American animated film. Program notes, Museum of Modern Art, New York, 1969.

Mast, Gerald. "Kracauer's two tendencies and the early history of film narrative." *Critical Inquiry,* spring 1980, pp. 455–476.

Méliès, Georges (and the editors). "Les Coulisses du cinématographe: Doit-on le dire?" *Phono-Cinéma Revue,* April 1908.

Mitry, Jean. *Histoire du cinéma* (5 volumes). Paris: Editions Universitaires, 1967–1980.

Moritz, William. "The films of Oskar Fischinger." *Film Culture,* nos. 58–60 (1974), pp. 37–188.

National Film Archive. *Catalogue* (3 volumes). London: British Film Institute, 1960, 1965, 1966.

Niver, Kemp. *Motion Pictures From the Library of Congress Paper Print Collection, 1894–1912.* Berkeley, Calif.: Locare Research, 1967.

Norling, J. A., and J. F. Leventhal. "Some developments in the production of animated drawings." *Transactions of the Society of Motion Picture Engineers,* May 3, 1926, pp. 58–66.

Ohms, Marcel. "Les frères Fleischer." *Les Cahiers de la Cinémathèque,* summer-autumn 1980, pp. 132–134.

O'Konor, Louise. *Viking Eggeling 1880–1925; Artist and Film-Maker; Life and Work.* Stockholm: Almqvist and Wiksell, 1971.

Osborne, A. "Father of Kong." *Cinema Papers,* July 1974, pp. 210–215.

O'Sullivan, Judith. "In search of Winsor McCay." *American Film Institute Report* 5, no. 2 (summer 1974), pp. 3–9.

Panofsky, Erwin. "Style and medium in the motion picture." Lecture given at Princeton University, 1934; published in *Critique* I, no. 3 (January–February 1947), reprinted in Daniel Talbot (ed.), *Film: An Anthology,* second edition (University of California Press, 1966), pp. 15–32.

Parker, Dana. "Making comic cartoons move." *Theatre Magazine* XLVII, no. 322 (January 1928), pp. 32 ff.

Pawlowski, G. de. "La Faillite des Fées." *Comoedia,* August 16, 1908.

Peary, Gerald, and Danny Peary. *The American Animated Cartoon.* New York: Dutton, 1980.

Phillips, Barnett. "The record of a sneeze." *Harper's Weekly,* March 24, 1894.

Phister, Montgomery. "People of the stage: Winsor McCay." Cincinnati *Commercial Tribune,* November 18, 1909.

Poncet, Marie-Thérèse. *L'Esthétique du dessin animé.* Paris: Nizet, 1952.

———. *Etude comparative des illustrations du moyen âge et des dessins animés.* Paris: Nizet, 1952.

———. *Walt Disney, 1901–1966*. Paris: Anthologie du Cinéma, 1967.

Pratt, George. "Early stage and screen: A two-way street." *Cinema Journal,* winter 1974–75, pp. 16–19.

Pressly, William L., Jr. "The praying mantis in surrealist art." *Art Bulletin* 55, December 1973, pp. 600–615.

Propp, Vladimir. *Morphology of the Folktale* (ed. L. A. Wagner, tr. L. Scott), second edition. Austin: University of Texas Press, 1968.

Reilly, William J. "From morgue artist to humorist." *Moving Picture World,* August 30, 1919.

Reininger, Lotte. *Shadow Theatres and Shadow Films.* New York: Watson-Guptill, 1970.

Rondolino, Gianni. *Storia del cinema d'animazione.* Turin: Einaudi, 1974.

Sadoul, Georges. "Entretien avec Louis Lumière." *Cahiers du Cinéma,* October 1964.

———. *Histoire générale du cinéma.* 5 volumes. Paris: Denoël, 1973.

———. "Le Cinéma et les bandes dessinées." *Les Lettres Françaises,* July 6, 1966.

———. "Sur le huitième art." *Cahiers du Cinéma,* June 1962, pp. 8–13.

Salt, Barry. "Film form: 1900–1906." *Sight and Sound* 47, no. 3 (summer 1978), pp. 148–162.

Schenkel, Thelma. "Exploring the cinema of figurative animation." Ph.D. dissertation, New York University, 1977.

Scheuer, P. K. "Walter Lantz draws his cartoons just for laughs." Los Angeles *Times* ("Calendar" section), November 23, 1969, p. 24.

Schickel, Richard. *The Disney Version.* New York: Avon, 1968.

Seeber, Guido. *Der Trickfilm in seinen grundsätzlichen Möglichkeiten.* Berlin: Filmtechnik, 1927.

Seldes, Gilbert. "The Krazy Kat that walks by himself," in *The Seven Lively Arts.* New York: Harper and Brothers, 1924.

394 Shay, Don. "Willis O'Brien, Creator of the Impossible." *Focus on Film*, no. 16 (Autumn 1973), pp. 18–48.

Sheridan, Martin. *Comics and Their Creators*. Boston: Hale, 1942.

Sherwood, Robert E. "The silent drama." *Life,* November 22, 1922.

Skelton, Geoffrey. *Paul Hindemith, the Man Behind the Music.* London: Gollancz, 1975.

Slide, Anthony. *The Big V: A History of the Vitagraph Company.* Metuchen, N.J.: Scarecrow, 1976.

Smith, Albert E., and Phil A. Koury. *Two Reels and a Crank.* Garden City, N.Y.: Doubleday, 1952.

Smith, Conrad. "The early history of animation: Saturday morning TV discovers 1915." *Journal of the University Film Association* XXIX, no. 3 (summer 1977).

Smith, David R. "Up to date in Kansas City." *Funnyworld,* no. 19, (fall 1978), pp. 22–34.

Spehr, Paul. *The Movies Begin; Making Movies in New Jersey, 1887–1920.* Newark, N.J.: The Newark Museum/Morgan and Morgan, 1977.

Stephenson, Ralph. *Animation in the Cinema.* London: Zwemmer and Barnes, 1967.

Strauss, Theodore. "Mr. Terry and the Animal Kingdom." *New York Times,* July 7, 1940.

Swanberg, William A. *Citizen Hearst; A biography of William Randolph Hearst.* New York: Scribner, 1970.

Talbot, Frederick A. *Moving Pictures: How They Are Made.* Philadelphia: Lippincott, 1912.

Taylor, Frederick W. *The Principles of Scientific Management.* New York: Harper and Brothers, 1911.

———. *Shop Management.* New York: Harper and Brothers, 1911.

Terry, Paul. "Eighteen artists and four thousand sketches for an eight-minute laugh." Newark *Sunday Call,* June 10, 1923.

———. "They all laughed." *Parade,* April 13, 1952.

Thieson, Earl. "The history of the animated cartoon." *Journal of*

the *Society of Motion Picture Engineers,* September 1933, pp. 242 ff.

Thomas, Bob. *Walt Disney: An American Original.* New York: Simon and Schuster, 1976.

———. *Walt Disney: The Art of Animation.* New York: Simon and Schuster, 1958.

Tronquières, J. B. de (pseudonym of Emile Cohl). "Dessins animés." *Larousse Mensuel,* August 1925.

Valleiry, François. "Doit-on le dire; réponse à M. Méliès." *Phono-Ciné-Gazette,* June 15, 1908.

Vertov, Dziga. *Notes, Projets, Journaux,* tr. S. Mossé and A. Robel. Paris: Les Cahiers du Cinéma/Union Générale d'Editions, 1972.

Waters, Edward. *Victor Herbert: A Life in Music.* New York: Macmillan, 1955.

White, Eric Walter. *Walking Shadows, An Essay on Lotte Reiniger's Silhouette Films.* London: Woolf, 1931.

White, Kenneth. "Animated Cartoons." *The Hound and the Horn,* October-December 1931.

Willis, Roy. *Man and Beast.* London: Hart-Davis, MacGibbon, 1974.

Wilson, H. "McCay Before Disney." *Time,* January 10, 1938, p. 4.

Wright, Milton. "Inventors who have achieved commercial success" [Max Fleischer], *Scientific American,* April 1927.

Index